Hidden and Triumphant

The Underground Struggle to Save Russian Iconography

Hidden and Triumphant

The Underground Struggle to Save Russian Iconography

Irina Yazykova Translated by **Paul Grenier**
Foreword by **Wendy R. Salmond**

PARACLETE PRESS
Brewster, Massachusetts

Hidden and Triumphant: The Underground Struggle to Save Russian Iconography

2010 First Printing

Copyright © 2010 by Irina Yazykova

ISBN: 978-1-55725-564-8

Scripture quotations are taken from the Synodal translation of the Bible; translated into English by Paul Grenier.

Library of Congress Cataloging-in-Publication Data

Yazykova, I. K. (Irina Konstantinovna)
 Hidden and triumphant : the underground struggle to save Russian iconography /
Irina Yazykova ; translated by Paul Grenier ; foreword by Wendy Salmond.
 p. cm.
 Includes bibliographical references.
 ISBN 978-1-55725-564-8
 1. Icons, Russian—20th century. 2. Icon painting—Russia (Federation)—History—
20th century. 3. Art and society—Russia (Federation)—History—20th century. I.
Grenier, Paul. II. Title. N8189.R9I295 2010
 704.9'4820947—dc22 2009049400

10 9 8 7 6 5 4 3 2 1

Published by Paraclete Press
Brewster, Massachusetts
www.paracletepress.com

Printed in the United States of America

THIS BOOK IS DEDICATED TO
THE RUSSIAN ICONOGRAPHERS
WHO PRESERVED THIS GREAT TRADITION
DURING THE TIME OF PERSECUTION.

CONTENTS

FOREWORD

t is one of the many ironies of the past century that the celebration of Russian icons went hand in hand with a determined effort to eradicate the art of icon painting. In exchange for the icon's physical survival, Soviet ideology demanded a purging of its theological meaning and function, filling the void with content more palatable to a secular age. Histories written during that era tacitly accepted this state of affairs, taking for granted that the icon's home was now the museum and its relevance largely aesthetic and historical.

In this important new history of the Russian icon, Irina Yazykova challenges this familiar picture in the light of our own historical moment. Far from withering away during the Soviet years, she affirms, the practice of painting icons survived underground and with the fall of Communism has emerged triumphant. The icon now stands on the threshold of a new epoch, and we are witnesses to the fervent search for an iconic language that reflects the realities of our own experience.

So that we may see the icon once more in its entirety, the author invokes the centrality of the canon, the tradition of a precise language of visual signs by which the Orthodox believer experiences the presence of God. The icon preserves the canon by standing at the border between two worlds, awakening the viewer's spiritual vision through the workings of the physical eye. All icons are canonical when outer form and inner content harmonize, bringing the viewer face to face with the world of spirit in a state of prayerfulness. Like a heartbeat, eternal time flows through such icons, undisturbed by the restlessness of human time reflected in the history of continual stylistic change.

Unlike other histories that make us passive observers of icons from a lost golden age, this book suggests that we take a more active engagement with icons if we are to reach a fuller understanding of their role in the past and their relevance for the future. The author teaches us to discern in all icons that state of equilibrium between the eternal and human, past and present, aesthetic and theological, that was temporarily disturbed by the upheavals of the last century. At once scholarly and impassioned, this wonderful book is more than another updated history. It is a guide to understanding the fullness of the icon's meaning by expanding the limits of our own vision, spiritual as well as physical.

Dr. Wendy Salmond is Professor of Art History, Chapman University, and author of *Russian Icons at Hillwood* and *Tradition in Transition: Russian Icons in the Age of the Romanovs.*

ne of the peculiarities of Russian scholarship is an occasional casualness when it comes to details about sources. While it is true that many Russian scientists are just as punctilious as their Western counterparts in this regard, in many other cases—especially in the humanities, and including the present work—one fairly regularly comes across quotations without detailed information as to the source.

In large part this "lack" can be explained by the two-fold relationship of the Russian writer both to her audience and to tradition. First of all, there is the assumption that the audience is aware of a certain cultural tradition— for example, that "everyone" has read certain books. In such a context, providing too much information can at times be not only superfluous but even impolite.

Those familiar with continental writing styles will be aware of another source of this difference in authorial styles. In Russia, as in France, Germany, and elsewhere on the continent, the author (like the professor) has a different stature than in the United States. Rather than being a sort of service provider, she is an authority. There is not the expectation, either on the part of the reader or the author, that "everything must be provided."

Incidentally, this often means that a scholarly text in these other countries will be almost impossibly dense. It is well known, for example, that a French student will often pick up an *American* text if what is wanted is a perfectly clear explanation of some difficult subject. Fortunately, the present text, in this respect at least, is sufficiently American.

This cultural gap represented one of the many challenges in translating this first-rate work of Russian scholarship. References in the text that were unlikely

to be transparent to a non-Russian-speaking audience I have attempted to contextualize—most often by means of a content footnote (all the longer and more involved ones are my own), or, when it seemed unavoidable, even with in the text itself. The reader is entering into a different tradition here, and the only way to fully comprehend it is through immersion.

WORD AND IMAGE

An icon is the visual image of what is invisible.
It is given to us that our understanding may be
filled with its sweetness.
—ST. JOHN OF DAMASCUS

rthodox tradition and icons are inseparable from one another. It is difficult to even imagine an Orthodox church or an Orthodox home without icons. Whether a person is entering into holy matrimony or a monastic order, setting off on a long journey, or beginning some new business enterprise—one way or another, icons will be present. Icons accompany us from the moment of our birth to the hour of our death.

The word *icon* comes from the Greek εικόν, which means image, representation, or portrait; and it refers, first and foremost, to an image of Jesus Christ. Being the true image of God, Christ is considered the only perfect icon, as he said, "He who has seen Me, has seen also the Father" (John 14:9). The apostle Paul also calls Jesus an icon of God: "He is the image (εικόν) of the invisible God" (Colossians 1:5).

Icons reveal to us the very depths of the Christian faith—that the all-powerful, mysterious, and unknowable God, whom no prophet has ever seen (Exodus 33:20), comes down from heaven and, through the mystery of the Incarnation, takes on flesh and becomes human. Saint John the Theologian tells us likewise: "And the Word was made flesh, and dwelt among us full of grace and truth, and we beheld his glory, the glory of the only begotten of the Father" (John 1:14). The Creator of heaven and earth, the God of Abraham, Isaac, and Jacob, appeared on earth as the God-man Jesus Christ.

An icon brings the good news into the world by showing the face of Jesus Christ: God became man. Moreover, through Christ, the icon also reveals to us the true image of humanity transfigured and deified; it is the image of the kingdom of heaven, the kingdom that is to come and that will restore the harmony now marred by sin.

How is it possible, though, to depict the divine harmony through earthly means? How can one convey that for which our hearts and souls pine? As everyone knows, to see certain stars we need a telescope, and to see a cell we need a microscope. In just the same way, we need a special sort of lens to see the divine realm. That special lens is the icon: an image that discloses a different world.

Saint John of Damascus, the renowned eighth-century theologian and defender of the veneration of icons, defined the purpose of icons: "An icon is the visual image of the invisible, given to us that our understanding may be filled with its sweetness."

Of course, even if we can depict Jesus' human nature, this does not mean we can successfully portray his divine essence. That aspect remains unknowable. An icon uses such symbols as the halo, rays of light, and so forth as indicators of his divinity. Since Christ's divine and human natures are neither merged nor separate, depicting Christ's human image must also put us in the presence of his divinity.

Not all icons portray Christ. There are also icons of the Mother of God, of saints and angels, and of various sacred events. Yet not every picture on a religious theme can be considered an icon. Within Eastern Orthodoxy a special language has been developed for icons, and this language is deeply rooted in a theology of visual signs, a canon that is understood as the visual expression of the dogmas of the faith.

The look of icons has gradually changed over the centuries, evolving from the general and symbolic to the more concrete and representational. During the early period Christ typically was depicted through the use of allegorical symbols such as a fish or a lamb. Those images were gradually replaced by icons portraying the Savior in his human form (icons of the so-called historical type) accompanied by signs and symbols of his divinity.

From these portraitlike images, the icon gradually evolved in a more symbolic and ritualized direction, tending all the while toward images

depicted on a flat plane. The envelope of the body, in icons, became surrounded by the uncreated light and seemed to lose all material weight, accentuating the spirituality of the image over its materiality.

Now, icons are even more a manifestation of the flesh transfigured and emanating light. Orthodox art made a conscious decision against naturalistic, three-dimensional representation in order to emphasize the primacy of spirit over matter. For the same reason, it rejects sculpture, which likewise tends to stress the material principle (Orthodox art admits at most the low projection from the surface of bas-relief). Nonetheless, the saints depicted in icons are not bodiless spirits; they are material beings whose matter has been transformed by spirit and filled with light. In the icon we find a unity of Spirit and matter, of heaven and earth, of the visible and the invisible.

An icon is not an abstract depiction of spirituality. It is a representation of the holiness shining forth from a specific historical personage. The concrete subject matter for the icon painter's brush can be found in the face of Jesus Christ, who manifested himself within human history. It is *this* light of Christ that is considered to be reflected in the face of each saint represented in an icon.

When we approach an icon, we find ourselves looking into a world where eternal light reigns, a place where, in the words of the psalms, "mercy and truth are met together; righteousness and peace have embraced each other" (Psalm 85:10). In icons the contradictions of this world are resolved: here, God is "all in all."

An icon is painted both in prayer and for prayer, for the purpose of teaching us to see the world as God and the saints see the world: as already redeemed and transfigured, made new under God—a world conquered by love.

One often hears that Orthodox Christians pray to icons, but that is not altogether accurate. Yet it is true that those of Orthodox faith pray to God while standing before an icon. But the prayer in each instance is addressed to Jesus Christ as the image (or icon) of God, as it is Christ that the icon ultimately represents.

An icon of the Mother of God portrays not simply a pious and lovely woman, but the woman through whom Christ came into our world. That is why most icons depict Mary holding Jesus in her arms.

If an icon depicts a saint, its real purpose is to bring us face to face with someone in whom Christ's goodness shines forth. Long before there were any icons, Saint Paul wrote, "My little children, of whom I travail again in birth, until Christ be formed in you" (Galatians 4:19). In icons, as in Orthodox tradition, a saint is someone who has been formed by Christ and in whom we find the light and countenance of Christ.

There are also thematic icons focusing on events that reveal Christ's glory and triumph. Such events may be derived from the New or the Old Testament, an episode in the life of a saint, or the history of the church. Regardless of the context, in every case, even if Christ's form as such is absent, his presence is implied. And in prayer with icons, each image serves to concentrate and focus our spiritual sight, directing our prayer to the center of being, toward God who appeared to us in the face of Jesus Christ.

In order to express this focus on Christ, a special pictorial language was gradually developed in iconography: it is this language that forms what is called the iconic canon. The existence of this canon should not be understood as some iron cage circumscribing the freedom of the icon painter. Rather, it represents simply a central core of meanings that ensure that the iconic image is filled with the appropriate doctrinal and theological content.

This canon first came together during the ninth century, when the Slavic peoples were converting to Orthodoxy. And history has confirmed the wisdom of the founding fathers of iconic art when they established the iconic tradition as a visual witness to faith that appeals more to the heart than to the intellect. That is why icons have been so effective at spreading the faith throughout the Slavic world, and particularly in Russia, where throughout many centuries they served as the primary instrument of theological instruction.

A painting, it is sometimes said, offers us a window onto the world. An icon does the same, except that it offers us a window into the invisible world. It portrays not what we encounter in everyday life, but instead a *transfigured* world. "Icons depict nothing whatsoever: they make manifest to us the kingdom of heaven," says the renowned contemporary icon painter Archimandrite (Vladimir Teodor) Zinon, also known as Abbot or Father Zinon.

The iconic world is seen by the soul, not by the eyes. An icon does not tell us what Christ looked like—it is not a portrait in the traditional sense,

but allows us to stand directly before the face of Christ, the God who acquired a human countenance. More than anything else, what an icon presents to us is the *personhood* of Christ. As Saint John of Damascus wrote: "I saw the human face of God, and my soul was saved" (paraphrasing Genesis 32:30).

In this same language of icons, a depiction of a saint is similarly not a portrait, but an image of the saint standing before God. The purpose of this type of icon is to invoke our prayerful appeal to the saint and also our joining with the saint in prayer to God.

The saints are almost always depicted directly facing us. Only rarely do we find an icon with a saint in profile: this pose usually is reserved either for a negative personage, for instance, Judas in the scene of Jesus' arrest in the garden, or for a secondary figure who is not a saint and not a participant in our communal prayer, for example, the women washing the infant Jesus in the icon of the Nativity.

An icon is not a fragment of heaven, but a manifestation of the fullness of being. For this reason, only rarely does a figure or a scene extend into the margins of the icon, and even then only slightly. When we place ourselves before icons, we see a world that is whole.

We are also witnessing an image of eternity, a world of completed time, which is why the world of icons looks so different from our own. They have their own space and time where the laws of this earthly plane do not apply. Illogical spatial relationships and reverse perspective serve to accentuate this difference.

For example, the iconic principle uses what is known as a reverse perspective, which differs from geometric perspective in that it gives us no vanishing point toward which all lines converge on the horizon. With icons, objects do not get smaller in proportion to their distance from our gaze. Everything pictured in the icon is so arranged that it enters into the viewer's field of vision. All lines converge—in terms of both their meaning and their geometry—in the spectator's prayerful gaze. Iconic space unfolds in all directions around the person who prays and draws that person into this space, where objects can often be seen from three or even four sides at once.

Because icons portray eternity and culminated time, events that happened at different moments and in different places are gathered together in a single icon. If we look at an icon that depicts the birth of Jesus, we find the Christ

child in his manger in a cave alongside a reclining Mother of God, angels bearing the glad tidings to shepherds, the Magi riding over the mountain tops in pursuit of the star of Bethlehem, and also the venerable Joseph together with nurse maids bathing the infant. A whole series of events connected with Christmas have been gathered in a single space that unfolds scroll-like before us.

By using the depiction of one event to reveal another, this scroll unfolds in the temporal dimension as well. The Nativity of Christ icon depicts the beginning of Jesus' path on this earth, but it also discloses the end of that path. Observe the image of the Christ child lying in the manger with the darkness of the cave looming in the background.

Look closely and you will notice that the manger resembles a coffin—and the swaddling clothes, a burial shroud. The iconographer's intent here is plain: the Savior is born and is lying in his crib, but in another cave, a tomb, that same Savior will be placed in a shroud after having accepted death. We continue to perceive the iconographer's intent when we witness the angel standing next to the cave as not only the bearer of the good news of the birth of Jesus, but also as the messenger of his Resurrection. In this way, the icon unites the beginning and the end of Jesus' earthly sojourn.

Canonical icons of saints portray no physical or spiritual defects of any kind, because the saints are considered already transfigured by the Spirit. At the same time, this movement from matter to Spirit never leads to the disappearance of the physical principle altogether—and in particular, it never leads an iconographer to the use of abstract art, or to the use of symbols and signs that make no use of an anthropomorphic form. That would contradict Christ's very nature by transforming him into a disembodied being. For the same reason, icons do not make use of animal forms in such a context. For example, using the head of a dog to symbolize the head of Saint Christopher—a symbolism used in Coptic (and certain other) art forms—was denounced at one of the ecumenical councils. Because Christ took on flesh and became man, it was decided that the human countenance is itself sacred and should not be replaced by the form of some other creature.

Far from negating the flesh, Orthodox iconography blesses and transfigures the flesh. Even as flesh is transformed and sanctified, sometimes we see images of disease or suffering. We see this only in the pictorial images

around the edges of the icon, portraying scenes from the life of one of the saints. In an icon's central panel, however, where the saint is shown in heavenly glory, we no longer find any depictions of suffering or sores, mutilation or defect, for in the kingdom of heaven we are made whole. The blind person sees, those who are crippled walk, the dead return to life.

No matter how heroic or distinguished people may have been in their earthly existence, this aspect is disregarded in icons. An icon is not a portrait of earthly existence; it is the image of one who already inhabits the kingdom of God. While iconographers do not ignore the individuality or the characteristic external traits of the saints they portray (gender, age, hairstyle, facial hair, a special headdress or other distinguishing mark), the saints nonetheless appear to us in a form that is distinct from all such characteristics, suggesting that the saint has left all earthly passions behind and peers out at us from a separate world.

When we look at icons, the face always strikes us as the central feature. Here's why: it is the face that testifies to the saint's individuality and person-hood. Iconographers even have special terms to distinguish between what is and is not "personal" in an icon. Individual elements are considered either personal (*lichnoe*) or circumstantial (*dolichno*).[1] In the category of the personal, we find not only the features of the face, but also the hands. These speak to us of what is truly connected with the person. Everything else in an icon—trees, hills, buildings, clothing, frame, and so forth—all relates to the circumstantial.

Gestures also have high significance in icons. An icon of the Savior, for example, offers a gesture of blessing. The Mother of God in an icon raises her hands heavenward. An icon of Saint Seraphim of Sarov shows him pressing his hands to his breast, and the prophet Elijah cups his hand to his ear in order to listen to God. Through gestures icons communicate the emotions that are often absent from the faces.

Eyes, which are also part of the personal aspect of icons, have special significance. In the most ancient icons the eyes are portrayed wide open. "The eyes are the window to the soul"—this well-known expression applies particularly well to an icon. In the Sermon on the Mount, Jesus told his disciples that "the light in the body is the eye: therefore when thine eye is single, thy whole body also is full of light" (Luke 11:34). Only through

a successful treatment of the eyes can an iconographer succeed in what is most important: communicating the sanctity of the person portrayed. The accentuated eyes create in us the impression that it is not we who look at the icon, but rather the icon that is looking at us.

It is light more than anything else that expresses the transcendent in icons. Icons portray light, but they do not portray shadow. There is no night in an icon; there is only an eternal day where bodies cast no shadows. A traditional icon never makes use of chiaroscuro, variations in light and shade evoked by an external source of light that makes one side of the image appear in the light, and the other in shadow. The special place held by light is seen in the fiery images of the Stylites by Theophanes (also known as Theophan the Greek) and in Andrei Rublev's radiant angels, so clearly suffused with divine energies.

Icons are painted (or *written,* rather, as most iconographers phrase it) by light upon light. Iconographers have always paid particular attention to the radiance of faces. Light is also used to draw clothing, landscapes, and architectural elements. A variety of specific techniques are used to portray what Gregory of Palamas called "the uncreated light," including *probelka* (the use of lighter shades of a given color for highlighting), *assist* (a manner of painting fine gold lines), and *dvizhki* (white lines used to heighten the face or hands). Though the techniques are various, the meaning underlying each of them is the same: they express the divine energies that suffuse the entire world.

In different places and at various times, iconographers developed a wide variety of often highly individual techniques for depicting light, and they continued to do so through the second half of the sixteenth century. Until that point, light had always been central in the icon. But when light began to fade from icons—despite the fact that the subject matter and the icono-graphic tradition remained unchanged in every other respect—the icon itself began to die out. In the seventeenth and eighteenth centuries, this uncreated light came to be replaced by naturalistic use of light and shade. The resulting art continued to be a form of religious painting, but it was no longer an icon in the canonical sense.

Central to expressing light in icons is the gold background. Indeed, in centuries past, this golden background was even called light, since saints

are considered to dwell in the light-filled glory of the heavenly kingdom. The gold background is sometimes replaced with silver or even yellow, red, green, or light blue. But whichever color was chosen, its purpose was always to symbolize eternity.

The icon presents the saint's image in light, and the face of the saint is encircled with a halo, which also symbolizes light. In this manner the icon presents the saint as a body of light on a background of light. According to the Orthodox hymn, "the righteous ones shine as lamps."

Gold represents light and at the same time it is the color of the heavenly Jerusalem that is described in the Revelation of Saint John the Theologian, as having streets paved with "pure gold and transparent glass" (Revelation 21:18-21).

Each color in icons reflects the light of heaven and is rich in symbolism:

Red is the color of earth, of blood and of sacrifice, and also the color of royalty.

Blue is the color of the heavens and of divinity; it also signifies purity, the state of being without sin and of being the chosen one.

Green is the color of the Holy Spirit, of eternal life and eternal blossoming.

White is the color of transfiguration and is also the color of the robes worn by those who do justice.

Black is the color of darkness and the infernal abyss, although hell itself is depicted in icons only in its state of destruction after having been conquered by the power of Christ's Resurrection.

Darker shades of some of the colors above (for example, dark blue) may also symbolize a divine light so brilliant in its splendor that man perceives it to be a blinding darkness.

The brightness, purity, and nobility of an icon's colors, and also the variety of an icon's surface textures, serve to reflect the incorruptible beauty of eternity itself.

Each age strives to find its own approach toward the mysteries of faith, and the same holds true for countries and even regions, each of which often develops its own schools, styles, and methods of interpreting an image—yet all the art of the Orthodox East has been founded on the basis of a common canon. This iconic canon is like a tree: it is rooted, along with Orthodox tradition, in the soil of Holy Scripture. We might consider its trunk the Orthodox Holy Tradition, and its branches the nations and localities that gave rise to the various schools and master iconographers.

The canon, rather than depriving the icon painter of freedom, more accurately holds up an ideal and a goal. The canon orients the icon toward a prototype. Properly understood, a prototype is more than just a pattern to copy: for the faithful, it represents something approximating the "true likeness" of embodied holiness. Reference to a prototype helps prevent iconographers from losing their way. We find many examples of widely divergent iconographers who followed the same canon. Theophanes and Andrei Rublev were contemporaries, and yet it would be difficult to conceive of works by two artists that are more different from each other.

Along with a strict canon of visual aspects, the iconographers of centuries past were also expected to meet stringent norms of behavior. It is no accident that in the days of Byzantium and Old Russia most iconographers were monks. After all, any given icon reflects much more than just the artistic talent of the master who produced it. It also reflects the spiritual state of the artist, the spiritual climate of his surroundings, and the general character of the age in which a given iconographer lives. An iconographer's individuality and creativity should not get in the way of the task of iconography; on the contrary, those qualities should serve it. Precisely because icons are sacred images, the artist's task is to bring the viewer into a relationship with that true likeness that is nothing less than the likeness of Jesus. Hence the importance of avoiding anything that distracts us from that relationship—external prettiness, virtuosity of technique, or decorative elegance. Free from all such distractions, the person at prayer is able to enter into a meditative dialogue with the one the icon depicts.

In the final analysis, icons serve a purpose only to the extent that they assist us in becoming icons of God, for that is the original intent of their creators. In the book of Genesis we read that God created humankind

according to God's own image and likeness. Yet as a result of the Fall we no longer—in our natural condition—perfectly reflect the face of God. Instead of being a mirror of the divine, we are more like a darkened glass through which the light of eternity passes only dimly.

The images we find in icons bear witness to the truth that humans were conceived in perfection, as an icon of God. The church fathers understood our path of spiritual development to be one of uncovering that primordial image and restoring our likeness to God. The church fathers considered the true writing of icons, "the art of arts," to be the process of doing spiritual work. It is this work that cleans and blesses and transfigures us, as Saint Paul wrote: "But we all, with open face beholding as in a glass the glory of the Lord, are changed into the same image from glory to glory, even as by the Spirit of the Lord" (2 Corinthians 3:18).

ICONS AS A WITNESS TO ETERNITY WITHIN A WORLD OF CHANGE

o strive for perfection, to love what is beautiful, to see beauty not only in the world around us but also to seek it in what lies beyond this earthly existence—all this comes naturally to us humans. Physicists claim that the form of our universe, both at the macro scale and the micro, is so beautiful and harmonious at every single point that it seems to have been made with a viewer in mind. In other words, the universe is so beautiful that it can be admired. The book of Genesis (1:31) tells us that the Creator, not unlike a painter surveying a just-completed canvas, was filled with admiration for his creation: "And God saw everything that he made, and, behold, it was very good." Wanting to share with others a delight in the world that he made, God concluded the creation by creating humans. The Bible likewise tells us that when God put Adam into the Garden of Eden he commanded Adam to care for his creation as well as to preserve and add to the beauty of the world.

Humans' idyllic life in paradise came to an abrupt end when Adam violated his unity with God and thereby fell away from the original state of harmony. Theologians explain the causes of the Fall variously, but in at least one respect they all agree—the results of the Fall were terrible. Humans found that they were living no longer in a beautiful garden, but on the harsh bare earth. Now it was necessary to labor and sweat to gain food, to build shelter from the cold and heat and from the rain and the snow. No longer, as

before, could Adam converse with God face to face. Now God was beyond his reach.

Henceforth, humankind would be pursued by need, hunger, sickness, and death. And, as the Genesis story tells it, after Cain murdered Abel, the sons of Adam came to know enmity as well. The history of humankind became a record of hatred and cruelty and war, of struggles after power and riches. It would be a history of suffering.

<center>⚜</center>

And yet, the human spirit retained a memory of that original harmony. Despite every obstacle, humans have persisted in seeking beauty within a world ruled by death and decay. Archaeological evidence gathered from the lower Paleolithic layers makes clear that the artistic impulse was already present even among the most ancient of humans. A bison on a cave wall, a female figure made of stone, even the ornament on a clay pot, all testify to the human search for beauty.

Humankind has always felt cramped and ill at ease within a merely biological existence. Humans yearn for something more. Even within the flux of time, humans sense the presence of eternity; beyond the boundaries of everyday reality, we perceive another, ideal reality.

Having been made in the image and likeness of a Creator God, people in every age never cease to be creators and artists who view the world from the standpoint of eternity. The English poet William Blake expressed this thought in *Auguries of Innocence*:

> To see a world in a grain of sand,
> And a heaven in a wild flower,
> Hold infinity in the palm of your hand,
> And eternity in an hour.

One might well conceive all of human history as the story of humankind's journey from beauty lost to beauty gradually sought and regained. Never, over the centuries, has the human need for beauty been extinguished. More often than not, however, this beauty has been associated not with what is of the earth, but with what is from the sky. Indeed, this is what formed

the religious worldview. Oswald Spengler, the well-known philosopher of history, once said that "whereas houses arise out of the earth, temples descend from the sky." Every creature builds itself a nest or digs a lair in which to live. Only humans also build temples. And only humans paint icons and compose poems. Art, somehow removed from the practical demands of everyday life, reveals that our kinship is not with the biological world only; it is also with the spiritual world.

In the book of Revelation (21:2), where Saint John the Theologian describes the dramatic end of world history, we come across a depiction of the beauty of heaven. It is described as "the holy city, the new Jerusalem, coming down from God out of heaven, prepared as a bride adorned for her husband." This image has served as an inspiration for artists throughout the ages, and they have attempted to capture it in paintings, architecture, music, and poetry.

When, in the gospel texts, Christ preaches about the kingdom of heaven, he does so by showing his listeners how to see heaven through the things of this earth. He urges his listeners in Matthew's Gospel (7:28-31) to "consider the lilies of the field . . . [and to] consider the birds of the air."

Christ made extensive use of imagery and the parable, a form still popular in the East. "To what should I compare the kingdom of heaven? It is like a pearl . . . it is like a lamp . . . a vineyard, a mustard seed, like a net, cast into the sea" (Mark 4:25-35). His parables are numerous. A parable is a striking image, an icon made of words, through which the realities of another world break through into our own.

And the apostles, during their far-flung travels, also made use of parables to create images in their listeners' minds about a kingdom whose laws are so different from those here on earth. We come across surprising images in the letters of the apostles, for example, in Peter's meditation on a woman's beauty: "Your beauty should reside not in the outward adornment—the braiding of the hair, or jewelry, or dress—but in the inmost center of your being, with its imperishable ornament, . . . and in the incorruptible beauty of a gentle, quiet spirit, which is of great price in the sight of God" (1 Peter 3:3-4). Though the first Christians did not know icons in our sense of the word, such parables and reflections as these are separated from icons as such by only a single small step.

During the first three centuries after Christ's death, early Christians suffered cruel persecution and were obliged to meet in secret to hold services. Roman emperors had the early Christians thrown to lions, burned at the stake, crucified, or exiled as galley slaves.

But the more the world turned against them, the more the early Christians turned their gaze with hope toward heaven. It might seem that during times such as these, art would be the last thought in anyone's mind. And yet, in the catacombs of Rome we come across drawings on the tombs of martyrs that bear witness to the paschal joy of Christ's followers and to their faith in the beauty and harmony of God's kingdom.

It was on these same tombstones that the early Christians celebrated the Eucharistic sacrifice. The earliest Christian drawings trace back to the second century AD. On the walls of the catacombs we come across images already familiar to us from Christ's gospels: a fish, loaves of bread, a basket filled with grapes, a shepherd with a lamb across his shoulders, and so forth. In the catacombs we also come across various scenes from the Old Testament: Moses bringing forth water from the rock; Jonah falling out of the ship into the mouth of the whale; and Jacob's dream of a stairway leading to heaven. On these same walls are also pagan symbols that have been variously reinterpreted so as to communicate the gospel effectively to people who just recently had left their pagan traditions. Images such as Orpheus playing his harp or Hercules defeating the hydra symbolize Christ and his victory over hell, his liberation of humankind from death's dominion.

To be sure, the paintings in the catacombs were not icons in the full sense of the word, but they were images created to help people pierce the veil of the everyday world to see the divine reality, performing thereby an iconic function without yet being icons.

Persecutions of Christians lasted through to the fourth century, along with images created by those same persecuted peoples pointing to what had spiritual value. One day, on the eve of a decisive battle, a Roman emperor saw a cross appear in the sky and he heard a voice saying, "By this sign thou shall vanquish!" The emperor put his faith in Christ and the sign, and his army won the battle. It was Constantine the Great who experienced a conversion that day. Having become a Christian, he issued a decree (the Edict of Milan in 313 AD) granting freedom of faith to all subjects of the Empire.

From that time forward, Christians were able to openly hold services, build churches, and paint icons. Unfortunately, no icons from the fourth century have survived, as all the churches from that period have been either destroyed or completely rebuilt. We do know, however, that art was held in extremely high regard and also that Christian theologians considered the visual arts a powerful method for converting men's hearts.

Nilus of Sinai, a student of Saint John Chrysostom (an archbishop of Constantinople and a church father), counseled artists of his day to paint in places of worship: "Let our greatest masters fill the temple from both ends with depictions of the Testaments both New and Old, so that even those who are unlettered and cannot read the Divine writings, looking at these painted images, will be reminded of the courageous deeds of the sincere servants of Christ our God, and will be inspired to try to equal that glorious and memorable valor, through which, having preferred what is unseen to what is seen, the earth was transformed into heaven."[2] It is clear from this letter that the artist's task was defined as something more than simply decorating liturgical space. The artist's task was to depict scenes reflecting the Good News of Christianity—the news of the kingdom of heaven.

It is this same task that clearly defines the meaning and purpose of icons. Indeed, it is the icon more than any other art genre, whether mosaic, fresco, sculpture, or bas-relief (or indeed any other kind of visual art), that brings us images from another world, from the world of eternal beauty and harmony.

And yet, before the icon could become an icon in the full sense of the word, it had to pass through the fires of iconoclasm. Iconoclasm arose very early in church history—as early, in fact, as images themselves appeared in its art. The second-century philosopher and theologian Tertullian saw art and representation as distinctly a pagan form and therefore worthy only of condemnation. "What does Athens have to do with Jerusalem!" he declared. He considered images of any sort to be idols. Again, in the fourth century, Eusebius of Caesarea spoke out against visual images. In a letter to Constantia, sister of the emperor Constantine I, who had written him a letter requesting an icon (or image) of Jesus Christ, he replied: "What icon of Christ do you seek? The true and unchangeable one which contains by nature the features of Christ, or, to the contrary, that image which he adapted for our sake, having taken upon himself

the form of a servant [cf. Philippians 2:7]? I cannot imagine that you are asking for an icon depicting his divine form. Christ himself, after all, taught you that no man knows the Son, but the Father who begot him [cf. Matthew 11:27]. No doubt you wish to receive an image of him in the form of a slave, in other words, in the poverty of the flesh that he took on for our sake. But about the flesh too we have been taught—that it has been overthrown by the glory of God, and that what was corruptible in it has been swallowed up by life [cf. 1 Corinthians 15: 52-54 and 2 Corinthians 5:4]."[3]

Nonetheless, many other early church fathers such as Saint Basil the Great, Saint Gregory the Theologian, and Saint Gregory of Nyssa held icons in high esteem. Take, for example, these words from Saint Gregory of Nyssa's eulogy for Saint Theodore the Martyr: "The painter, having depicted in an icon the heroic virtue . . . of the martyr . . . having painted thereby in human form the heroism of Christ, and through art bringing color to this image, lays before us as if in an explanatory book the works of this great saint. . . . For paintings also can wordlessly speak to us from walls, and thereby be of enormous value to us."[4]

But it was during the eighth century that the polemic over icons reached its height. After the Byzantine emperor Leo III the Isaurian (the Syrian) joined forces with those opposed to icons, the tide of iconoclasm swept Byzantium as a whole. The conflict, which lasted nearly one and a half centuries and led to much loss of life, came to a close only with the promulgation of the dogma on the veneration of icons during the Seventh Ecumenical Council (held at Nicea in 787) followed later by the declaration of icon veneration as the "Triumph of Orthodoxy" at the cathedral called Hagia Sophia in Constantinople (March 11, 843).

An explanatory statement (called an oros) written into the Seventh Ecumenical Council precisely formulates the Orthodox position vis-à-vis icons and their veneration. The church fathers state that:

"We preserve untouched the entirety of the Holy Tradition of the Church, whether expressed verbally or non-verbally. One of these traditions commands us to make pictorial representations, in as much as this is in accordance with the history of the preaching of the Gospels, and serves as a confirmation that Christ in reality,

and not as mere apparition, became man, which is to our benefit. On this basis we define that the holy icons, in exactly the same way as the holy and life-giving Cross, should be presented (for venera- tion), and this the same whether they are in color, mosaic, or some other material, so long as the representations are done well; and they shall be shown in the holy churches of God, on sacred vessels and liturgical vestments, on walls, furnishings, and in houses and along the roads; and these icons will be of our Lord God and Savior Jesus Christ, of our Lady the Mother of God, of the venerable angels and of all saintly people. . . . The more often these latter, with the help of icons, are contemplated, the more often will those who lift up their eyes to them learn to commemorate and to love their proto- type; and will be inspired to press their lips to their representations in veneration and honor [*dulia*] of them, but not in actual worship [latria] of them,[5] which worship, according to our faith, is reserved only for him who is the subject of our faith and is proper for the divine nature."[6]

From the time of that oros forward, the icon came to be regarded as not only a work of art, but also as a witness to Christian faith in the incarnation of God. An icon, no matter what saint, apostle, martyr, or gospel scene is depicted, is ultimately an image of Jesus Christ, an image of his life, suffering, and resurrection, and of his coming kingdom.

⚜

The earliest icons, which date back to before the iconoclastic period, were produced using a technique called encaustic (which makes use of hot pigmented wax). This technique had already been widespread throughout the ancient world. Examples of icons produced in encaustic include, among many others, those of the Savior, of the saints Sergius and Bacchus, and of the apostle Peter, which date from the sixth to eighth centuries. Encaustic gives the viewer a palpable sense of the depicted person's corporality, as was indeed the fashion in the arts of the ancient world. In this respect the early icons are similar to the Fayum mummy portraits. The latter were paintings

of deceased persons placed on sarcophagi or on mummies prior to burial. The Fayum portraits resemble icons not only in their use of encaustic, but also in many of their specific artistic devices—we see the same gold back-grounds, the same wide-open eyes and full-face poses.

But there are also important differences. The ancient funerary portraits testify to death's indomitable power. They serve solely as reminders that someone has left the world. Icons, by contrast, are ultimately images of the Resurrection and victory of Christ over death, and they present visual evidence through the depicted saint's participation in that victory and resurrection.

With time, the encaustic technique, so accurate in its depiction of the living flesh, ceded place to tempera, a paint made from natural pigments with the binding medium being egg yolk.[7] The luminosity and liquid qualities of egg tempera, especially when applied to the unyielding wooden board, create the potential for portraying the transfigured state of a saint who dwells in the kingdom of heaven.

In the post-iconoclastic period starting in the ninth century, icons came to be painted exclusively in tempera. Icons of this period no longer under-lined the corporality of their subjects. To the contrary, we witness ethereal figures with luminous faces levitating against a gold background—figures that exclude foreshortening, where the viewer witnesses a full-face portrait meant to underscore the theme of eternity and the complete dwelling of that figure in the presence of God.

Byzantium, as the eastern half of the Roman Empire, inherited the great traditions of art from Greek and Roman antiquity. But rather than accepting this tradition unchanged, it reinterpreted and reforged it in light of the theology of the church fathers. As a result, the Byzantine Empire produced superlative examples of iconic art. The greatest flowering of the Byzantine icon was reached in the thirteenth to fourteenth centuries during the Komnenos and Palaeologus dynasties.

In 1453, however, under the blows of the Ottoman Turks, the thousand-year Byzantine Empire ceased to exist as Constantinople fell. This did not, however, mean the end of icons. After Byzantium's demise, icons found a new home in the lands that had received Christian culture from Byzantium, among them the Balkan countries of Serbia, Macedonia, and Bulgaria, as

well as Greece and Russia. Within the world of Eastern Christianity, the icon served as a lingua franca of cultural exchange.

Despite the many barriers presented by language and culture, these Eastern Christian (also called Eastern Orthodox) countries were united by liturgical tradition and by an art that was based on a shared canon. Throughout the medieval period these countries witnessed a lively exchange of artists, icons, manuscripts, and sacred objects. An innovation made in one corner of the Orthodox world soon came to be known and respected through its entire extent.

Miracle-working icons, or copies of them, moved constantly about the Christian East, bearing testimony to the unshakeable laws of the heavenly kingdom through the icons' miracles of healing, protection from disease and pestilence, and defense of cities and nations. Icons came to be seen as not only reflections of the divine harmony, but also as a way of concentrating God's mercy and grace.

In the popular imagination, the icon as an object virtually crowded out in importance and reverence the person to whom the icon referred. That is why there exists in the East such a rich tradition of claims and legends about icons. We have icons that respond as though they were living beings when in the presence of sacrilege and abuse (the Iverskaya icon of the Mother of God, for example, began to show blood on her cheek; and the Vladimir Mother of God icon began to shed tears). Other icons have produced myrrh, or moved through the air, or decided, seemingly of their own will, in which place on a wall they preferred to be placed.

There are many other legends, which may or may not be apocryphal. But these traditional claims do share the same intuition: if it is true that icons are windows into the invisible world of God's kingdom, where all that happens is in accordance with laws quite different from those governing our world, then it is equally true that every icon is by definition a "miracle working" icon.

What makes icons important, from the folk point of view, is their participation in the world of the miraculous. From the point of view of the church fathers, by contrast, icons are important first and foremost because they present a theology, albeit one painted in colors. This theology has been defined according to an internal logic of visual principles that form the core

of a stable tradition (and which, indeed, is referred to as the icon painter's canon). This system of stylistic rules and symbols has proven to be stable and definitive, allowing for the re-use of the same patterns over the course of many centuries.

This stability, which is seen as a means of assuring the transmission of truth, is also what gives many viewers the impression, especially at first glance, that Eastern Orthodox icons have changed very little over time. By comparison with its Western counterpart, Orthodox sacred art appears conservative, almost frozen in its ways.

The salient point is this: Although they developed within a common Christian tradition, the East and West did so according to very different perceptions of time. During the first thousand years of Christianity, while the Church was still united in one body, these differences were less noticeable, even though from the beginning Greek and Latin cultures differed in many ways. At times these differences erupted into overt confrontations between Rome and Constantinople. Despite their common source, over time their paths diverged. The West had always been more dynamically oriented than the East, and during the Middle Ages it moved rapidly through a series of developmental stages.

Over the course of the fourth through the fourteenth centuries, the West proceeded first from Christian antiquity to the art of the barbarians; then, after going through a series of local renaissances (such as the Carolingian Renaissance, for example), Europe gave birth to the Romanesque style, which was followed by the Gothic style, after which the European Middle Ages were brought to an end by the Renaissance style. During each of these different stages, the appearance of images underwent a radical change, reflecting thereby not only what is eternal and changeless, but also what is historical, what is connected with cultural fluctuations in the purely human realm.

In contrast, the East proceeded differently. Here the image both reflects and protects eternity. Although centuries passed and the surrounding world changed, the image remained true to its foundational principles. To be sure, iconography in the East has also gone through various stages of stylistic evolution, and these stages were influenced by theological polemics, philosophical fashion, political and economic changes, and the aesthetic preferences of this or that epoch.

Nonetheless, Orthodox thought has always conceived of the icon as the image of an unchanging, eternal beauty. Within the realm of Eastern Christianity, the icon has influenced the world more than the world has influenced the icon. This view is supported, furthermore, by the numerous stories of miracle-working icons that have changed the fates of entire peoples and nations—icons that have decided the outcome of battles or saved cities from epidemics or invaders.

This large influence of icons and art on the fates of Orthodox peoples and nations is well illustrated by the Russian Primary Chronicle (the earliest of the Kievan Rus historical manuscripts), which describes how Prince Vladimir chose a faith for his people. In order to determine which faith was best, he sent his ambassadors to many nations—to the Khazars (followers of Judaism), to the Mahomedans (followers of Islam), to the West, and to Byzantium. When the ambassadors returned they each in turn described what they had seen, but the prince was impressed most of all by what he heard from the envoys who had visited Constantinople (or Tsargrad, as the Russians then called it). Having attended a liturgy in Hagia Sophia, they described their feelings as follows: "We do not know whether we were in heaven or still on earth; we know only that God dwells in that place together with men." This is what convinced Vladimir of the truth of the Greek Christian faith, and he accepted the Orthodox tradition according to the Byzantine model.

It would be fair to say, then, that it was the shock of beauty that gave rise to the faith of ancient Russia. Vladimir's ambassadors experienced this beauty in the architectural forms of Hagia Sophia, with its glittering mosaics and multicolored marble floors, its richly patterned metal work, and its columns crowned with finely carved capitals. They experienced it also in the songs of the magnificent choirs that accompanied the liturgy and in the grandeur and mystery of Byzantine icons. All this together had created the sensation of dwelling in heaven. Indeed, the Byzantine temple was conceived in the first place precisely as an icon, as an *image* of the kingdom of heaven—and of the beauty of the age to come.

After its baptism, ancient Rus began building churches of its own, and these in turn were decorated with mosaics and frescoes and icons. In the beginning, Russian iconographers apprenticed under the Greeks, but soon they outstripped their masters in skill.

The art of Old Russia was on a par with that of the other great cultures of the Middle Ages. Over the course of seven centuries—from the tenth through the sixteenth—Russian art developed in its own richly distinctive and original manner. During this period, so many masterpieces were created that even all the subsequent years of war and ruin never managed to completely destroy Russia's rich inheritance.

In Russia, icons came to be revered even more highly than they had been in Byzantium, where iconic art enjoyed in fact a more varied spectrum of genres. For the inhabitants of Old Russia, the icon was even more than a mirror of eternity; it was even more than a reflection of imperishable beauty; it was also, within a world torn by grief, a testimony to divine joy and the inexhaustibility of hope.

Within a world wracked by fratricidal wars, icons portrayed the promise of love. They were a beacon of light in a world darkened by enslavement, a world constantly beset by epidemics, famines, plague, fires, and floods. Throughout Russian history, nothing but faith has ever been stable and lasting. Nor has anything ever proven more convincing and authoritative than the icon. One cannot help being struck, while leafing through the historical manuscripts and chronicles of ancient Russia, how year after year, first one area and then another was overturned by political unrest—half of an entire city burned to the ground, then another city was visited by plague or was sacked by invaders. The Russian people suffered repeatedly from impoverishment and crop failures and natural calamities.

But when we look at the icons of this same Russia, we find beautiful faces; we see clear colors and the light-filled world of divine joy. The Russian people have always lived in search of beauty. They did not, for the most part, seek this beauty in the outer finery of garments, or in the glittering courts of princes and tsars. They sought the beauty that hides within half-darkened churches, behind monastery walls, in the quiet glow of unearthly iconic faces.

In the 1960s the Russian film director Andrei Tarkovsky directed the film *Andrei Rublev*, a work that well portrays the gloom of life in ancient Rus'under the Tatar-Mongol conquest. Russians in the fifteenth century were entirely stripped of their freedoms. Their churches were defaced. They were murdered, tortured, burned, bribed; the Russian princes, meanwhile, fought among themselves even as the Tatars did their best to set brother against brother.

The entire Russian people, it seemed, was on the verge of complete physical and moral collapse. And yet—as if Russia itself were that phoenix described in its fairytales—the nation rose again from the ashes. Despite everything, nourished by some unknown power, the people survived. So long as they held on to their faith, so long as they continued to pray and kept looking heavenward in search of beauty, they lived. Against all odds, this Russia managed to produce craftsmen capable of pouring bells, artists capable of painting frescoes and icons.

Tarkovsky shot his film in black and white. Only at the film's end, when the audience sees Andrei Rublev's timeless icons—the Holy Trinity, Our Savior of Zvenigorod, and Archangel Michael icons, among others—does color burst upon the screen like a flame through the darkness. Reflecting the eternal and incorruptible world of spiritual beauty, these icons bring with them a wondrous light. Tarkovsky found here a magnificent metaphor with which to tell us that heavenly harmony comes into being not thanks to, but rather in spite of, the laws of this world. Audiences of the Soviet era, who lived under the crushing weight of ideology for more than seventy years, were particularly sensitive to this message. But whatever the age, the sense-lessness and ugliness that so often scars this world encounters a bulwark of resistance in the icon—in the radiant face of divine wisdom.

And yet, what of contemporary Russia? Are its people seeing and fully registering the divine beauty that comes to them in the images of icons? The twentieth century, which we have just come through, has gone down in history as among the bloodiest and most atheistic of all time. Russia felt this in full measure, where the Bolshevik ideology sought to destroy traditional values as well as destroy the church, together with icons themselves. The icon's image of a heavenly realm of beauty contradicted that new reality in which image the Bolsheviks wanted to rebuild Russia. And yet, once again history has demonstrated that true beauty is both eternal and indestructible.

In today's Russia, we are witnessing a renaissance in the art of iconography, and both believers and non-believers are showing a renewed interest in icons. In truth, not only Russians but the entire world has begun paying more attention to icons. Today, icons can be seen not only in Orthodox churches, but also in Roman Catholic and Protestant churches. Icons now

hold a prominent place in museums and private collections, and also in people's homes as well as in public buildings.

Having long since crossed not only national but also confessional boundaries, icons are spreading across the entire world. And just as they did a thousand years ago, icons today continue their silent testimony to eternity.

This book serves as a witness of the crossed boundaries and the history of the icon in Russia, and also of the way that icons managed to survive the difficult ravages of twentieth-century ideologies. We will explore together the icon's path of development within contemporary culture—a culture so often referred to as post-modern, post-totalitarian, and post-Christian—and see that icons continue to be windows onto eternity, and, within a world torn by grief, the constant testimony to divine joy and the inexhaustibility of hope.

PERFECT ARTISTS AND PHILOSOPHERS OF HIGHEST WISDOM

The Iconographic Tradition, 900-1900

he Russian iconographic tradition is already more than a thousand years old. Over the centuries it has experienced several cycles of rise and fall; periods of magnificent flowering have alternated with times of precipitous decline. There have been times when iconographic art so deteriorated that it all but disappeared. And yet, despite every difficulty, the icon has in the end always found a way back to its own renewal.

It is impossible to understand the actual development of the icon today without first having some understanding of its history. After all, no matter how much the current context in Russia may have changed compared with that of the past, the fact remains that today's icon painters are still the direct heirs of the master iconographers of ancient Rus', a period that encompassed the tenth through the sixteenth centuries.[8] These early iconographers were the ones who brought fame and glory to Russian iconography. Indeed, precisely because these iconographers had such exquisite mastery of their art, they were referred to by their contemporaries as "perfect artists and philosophers of the highest wisdom."

When ancient Rus' adopted Christianity from Byzantium, it simultaneously inherited the rich cultural tradition of Eastern Christianity, with its solemn liturgy, elaborate hymnography, patristic theology (based on the teaching of the church fathers), and well-developed tradition of visual arts. Very quickly, however—within the lifetime of the first generation of Russian

Christians—Kievan Rus' began to develop its own religious culture distinct from that of Byzantium. We know from historical records that Prince Vladimir, who brought Christianity to Russia in 988 AD, erected the stone Church of the Tithes (of which only the ruins presently remain). His son Yaroslav the Wise built the Cathedral of Saint Sophia, with its thirteen cupolas, in Novgorod. Mosaics and frescoes were installed to beautify Saint Sophia Cathedral, to which were added many beautiful icons, specially prepared church ornaments, liturgical vessels, and books. All of those churches and ornaments took on a distinctively Russian flavor.

In the early years of the nation's Christian faith, Russian iconographers studied under the Greeks, learning the Byzantine traditions. At this time the Greeks were widely dispersed, living everywhere from Italy and Spain to Georgia and Cappadocia. The patericon of the Kievan Caves monastery, a collection of tales about the monks, recounts that in 1083, Mary the Mother of God inspired a number of Greek builders and artists to come to the city of Kiev, where they proceeded to build the Cathedral of the Dormition, with its beautiful mosaics, according to the design that Mary had given them.

From the same patericon we learn that the first Russian iconographer, Alipy, a monk of the Kievan Caves (Kiev-Pechersk) Monastery, trained under Greek artists. In the *Life of Alipy* it is written that "he well learned the art of the icon, and painted with surpassing skill." Saint Alipy painted new icons and refurbished older ones in addition to creating frescoes for church interiors. He always divided the payment he received for his work into three portions: one he used to buy new paints, another he gave to the poor, and the third he put aside for his own use. Once, due to an illness, he was unable to complete an icon on time, but an angel appeared and completed it for him. The artist also had the divine gift of healing. On one occasion he used his brushes to heal a man who had been stricken with leprosy. He simply applied his icon paint to the man's lesions and he was healed. The icons that Alipy of Pechersk painted have not survived till our day, although some researchers attribute two icons of the Mother of God to him—the Great Panagia from Yaroslav icon and the Kiev Caves–Svenskaya icon that depicts saints Theodosius and Antony together with the Theotokos (another name for the Mother of God). Alipy was eventually canonized by the Orthodox Church. According to traditional

claims, Alipy had a student, Brother Grigory, who also became a great iconographer.

The names of Alipy and Grigory are allied with the city of Kiev (now in Ukraine), but in fact every great city of early Rus' had its illustrious master iconographers. The names of many of these artists remain unknown to us—as do their technical secrets, passed on directly by master to apprentice without any written records. Nonetheless, through modern archaeological research it is now possible to re-create some techniques and materials used in a medieval Russian iconographer's workshop. Archaeologists excavating a site in Novgorod in the 1980s discovered the workshop of the icon painter Olisei Grechin (the Greek). Analysis of the objects found there allowed the archaeologists to recreate many of the techniques used by medieval iconographers.

We know very few names of iconographers working prior to the seventeenth century. The reason for their anonymity, however, is clear enough: according to the perspective of the time, iconographers labored for the glory of God and in the name of the church as a whole. The icon was not something to be signed, as though it belonged to an individual iconographer. What we know about individual iconographers of this period comes for the most part from various documents such as chronicles, contracts, and monastery annals. On those rare occasions that one does find an iconographer's signature, it is generally either in the margin or on the back of the icon. Sometimes signatures can be found on the church walls. In Novgorod's Saint Sophia Cathedral, for example, the names of the iconographers Stefan, Radko, Sezhir, and Gaga have been found etched into the stucco of the church's walls. But who these men were—Russian or Greek, young or old—remains a complete mystery.

The Great Medieval Cities and Their Schools

The city of Novgorod, the northern capital and second city of the Kievan Rus' state, was particularly renowned for its iconographers. The city, which survived as an independent city state even after the Mongol subjugation of Kiev, was held in such high esteem that it was given the honorific title "Lord Novgorod the Great." Through Novgorod passed the famous trade route from the Varangians (as the Scandinavian Vikings were called in the East) to

the Greeks, from the North Sea to Constantinople in the south. And it was here, as we learn from the chronicles, that Russian nationhood was born. The chronicles, it should be mentioned, were the yearly annals of a given area.[9] The so-called Primary Chronicle (composed between 1040 and 1118 by scholarly monks) records events in Kievan Rus' and is widely considered the best written and most interesting example of the genre. According to the Primary Chronicle, in 862 the citizens of Novgorod invited a retinue of Varangians—headed by Rurik, Sineus, and Truvo—to the city, requesting that they rule them and protect their city. Many historians consider this date to be the founding of the Russian state.

The first Novgorod icons are strikingly large (for example, the icons of Saint George or the Ustyug Annunciation) and are remarkable for the clarity and strength of their imagery. This clarity can be seen in the so-called Savior Not-Made-by-Hands icon and the icon of the Theotokos of the Sign. The colors used in Novgorodian icons are pure and sonorous, with reds being particularly bright. The silhouettes have a characteristic definition to them; the lines, a characteristic elasticity. The faces are open, the eyes are large and expressive. As a free city, Novgorod was a republic of aristocratic boyars and merchants, and this spirit of freedom can be felt in its icons.

Another renowned center of early iconography was in Pskov, Novgorod's younger brother city. Though for many years it languished in the older city's shadow, in fact the town of Pskov little resembles its neighbor. Pskov is the city of Princess Olga who, in 955, became the first person of noble birth to convert to Christianity. Pskovian icons have a mysterious and even gloomy air about them. They are dominated by earth tones and almost devoid of blue. The faces are dark. At the same time, these icons are suffused with an inner glow, as if a fire within them strives to break through to the surface. An inscrutable mystery lives inside these silent, almost aloof icons. Pskov, being a border town, was the frequent victim of sieges and enemy attack. Although it was repeatedly burned to the ground and looted, it just as often got back on its feet and found the strength to rebuild. Both this suffering and this spiritual tenacity has left its mark on the icons of Pskov.

An equally distinctive school of iconography can be found in the city of Vladimir, at the heart of northeastern Russia. Prince Andrei Bogoliubsky moved the Russian capital here in 1158; and when he left Kiev he took

with him the miracle-working icon, the Mother of God of Tender Mercy. In 1130, Patriarch Luka had brought this icon from Constantinople and presented it as a gift to the Kievan Prince Yurii. According to legend, the icon was painted by the apostle Luke. Scholarly evidence suggests, however, that it was produced by an imperial icon workshop in twelfth-century Constantinople. The icon stayed in Vladimir for two hundred years, which explains why it came to be known as the Mother of God of Vladimir (or in the West as Our Lady of Tenderness) icon.

In 1395 the icon was brought with great pomp and ceremony to Moscow. That same year, Tamerlane, ruler of the Mongol Golden Horde, arrived at the gates of Moscow with his army, giving every sign that he intended to lay waste the entire city. Muscovites prayed tearfully before the icon for the salvation of their city. Then something miraculous took place. This fearsome conqueror who had never experienced a single defeat in battle suddenly retreated from Moscow without a fight. Moscow was spared.

Subsequently the Vladimir icon repeatedly was connected with Russia's liberation from foreign invaders. It became the most venerated object in all of Russia and was venerated during the selection of patriarchs and the coronation of monarchs.

Unique in artistic terms as well, the Vladimir icon was drawn using the finest and most transparent layers of glazing, or light washes. This is an icon meant to be carried and viewed from both sides, as on its reverse side is an altar, where the cross and instruments of Christ's torture used during the Passion are depicted.

In Russia, icons following this pattern have come to be known as the *umilinie* (tender mercy) type. In Greek, they are referred to as *eleousa* (merciful) or *glykophilousa* (loving kindness) because they depict the warm and tender relationship between the Son of God and his mother. More broadly speaking, this type of icon depicts a love shared between God and humans in the perfection of prayer.

The Vladimir icon also expresses profound feeling. The infant Jesus shows infinite tenderness as he hugs his mother, pressing his face against her cheek, and she demonstrates the same tenderness as she presses her child to herself. Her eyes are turned to the viewer and are filled with both mercy and sorrowful resignation. To this day, the Vladimir icon is one of the

most revered in all of Russia, and copies of it can be found throughout the entire world.

During Soviet times the icon was transferred from Uspensky Cathedral to the Tretyakov Gallery, where for many years it was a museum exhibit. Since 1995, when the Church of Saint Nicholas in Tolmachi was opened as a continuation of the Tretyakov Gallery, the icon has been placed in this church. There it continues to be monitored by conservators while simultaneously being available to the faithful who wish to venerate this icon.

Finally, we turn to Moscow. Though younger than other cities of ancient Rus', its school of iconography enjoys pride of place in the Russian pantheon. The chronicles make mention of Moscow in 1147, said to be the year of the city's founding, although the city's history began in the thirteenth century when the land was given as an appendage (or fiefdom, *udel*) to the youngest son of Alexander Nevsky, Prince Daniil. The prince was fonder of prayer and going to church than he was of engaging in military exploits. He founded Moscow's first monastery and named it in honor of his patron saint, Saint Danil the Stylite. Prince Daniil himself was tonsured a monk toward the end of his life. This same Danilov Monastery that he founded was one of the first monasteries to be restored, during the 1980s, after the church had endured seventy years of Soviet oppression.

Daniil's son Ivan Kalita (*kalita* means "money bag" in Old Russian, referring to his miserliness) strengthened the principality of Moscow, forcing other princes and regions to reckon with him. And at the beginning of the fourteenth century, Metropolitan Peter transferred the seat of his bishop's office from Vladimir to Moscow in confirmation of the latter's rise in authority and significance.

Metropolitan Peter is well known as an important figure in the history of the Russian church, but he is also well known for his iconography. While still abbot of the Ratsky-Transfiguration Monastery in Volyn, he painted an icon of the Mother of God that he presented to Metropolitan Maxim upon the latter's visit to the monastery. The icon so impressed the metropolitan that he made Peter his close confidant. After Maxim's death, Peter succeeded him as metropolitan, and the holy bishop was eventually canonized. Many believe that the Petrovskaya Theotokos icon was painted with Metropolitan Peter's brush. It is said that Peter forged such a direct relationship with the

subjects of his art that he would cry as he painted the portrait of one or another saint. In the words of his biographer, Metropolitan Cyprian, writing in the late fourteenth century, this was not surprising. Peter was acting "just as do many people in ordinary life when, upon seeing, or recalling in memory, a much-beloved face, they begin to weep."

The fourteenth century marks the beginning of Old Russia's spiritual revival, a process that would eventually give the country the strength to throw off the Mongol yoke. This was also a time of the flourishing of the arts. At the end of the fourteenth century the famous master iconographer Theophanes came to Russia from Byzantium and so astonished the Russians with his brilliance that he was referred to as "the wise philosopher." Theophanes frescoed the Church of Our Savior in Novgorod (1378), and also worked in Nizhny Novgorod, Pereslavl-Zalessky, Kolomna, and Moscow. In Moscow he painted the Church of the Nativity of the Mother of God as well as the Archangel and Annunciation cathedrals in the Kremlin. We learn about the life and art of Theophanes from a letter penned by the monk Epifany the Wise, addressed to Kirill, the bishop of Tversk. In this letter, Epifanii relates that, prior to Theophanes' arrival in Russia, he had painted some forty churches in Constantinople, Kafa, and Galata. What is more, the letter continues, Theophanes paints "fluently and without looking at any model and does so while simultaneously holding forth on theological matters and answering questions put to him by the crowds of people who visit the churches where he works in the hopes of catching a sight of the unusual master."

A wandering iconographer, Theophanes moved from city to city, fulfilling commissions from various churches to paint their frescoes and icons. In 1405, we learn from the chronicles that the church of a Moscow noble family, the Annunciation Cathedral in the Kremlin, "was frescoed by Theophanes the Greek, the *starets* Prokhor of Gorodets and the monk Andrei Rublev." Here is the first recorded mention of the renowned—and no doubt the best known—Russian iconographer, Andrei Rublev. And it is no accident that his name appears alongside that of the famous Greek master. Although it is unclear whether Rublev was actually a student of Theophanes, their noted connection is nonetheless pregnant with meaning, representing a passing of the baton from Byzantium—which had only a few decades more before

its final collapse—to a traditional Russian style, which still had a glorious future before it.

In the twentieth-century film *Andrei Rublev*, director Andrei Tarkovsky provides a graphic portrayal of the interaction between Rublev and Theophanes. The Greek, with his philosophical temperament, faces worldly reality with an air of skepticism, seeing in it little more than sorrow, disease, and the calamities that result from human sin. By contrast, the Russian monk Andrei Rublev faces the world with hope and light, counting on God's mercy while striving to reveal to others that beauty which "will save the world"—an approach that links Rublev to something distinctive in Russian culture generally, as well as in the Russian tradition of icons.[10]

Unfortunately, we do not know with exact certainty which icons were written by Theophanes, for the usual reason: his works were left unsigned. Legend suggests, however, that he created the Transfiguration of Christ icon in Pereslavl-Zalessky, the Mother of God of the Don icon (with a depiction of the Dormition on the reverse side), and the deesis icons in Annunciation Cathedral, which show holy figures and saints in supplication to the glorified Christ.

Theophanes' works are distinctive and highly individual, marked by high mastery and powerful emotion. His use of a varied palette of colors harmonizes with the light-bearing nature of his images—saints and holy figures are said to be "light-bearers." The virtuosity of his drawing is complemented by the richness and vigor of his painting.

The icons are informed also by Theophanes' education and knowledge both in theology and monastic mysticism, the product of a milieu related to Gregory of Palamas, the defender and expounder of the hesychast tradition. Hesychasm (from the Greek *hesychia*, or silence) roots itself in the practice of unceasing prayer and contemplation of God's "uncreated light." This influence is evident in the work of Theophanes as we witness light streaming off clothing and shining in faces. Light leaps up like a mysterious fire from within the depths of each holy figure in the icon, spilling over into the visible world.

Hesychasm, to be sure, was also of enormous importance for medieval Russian monasticism and iconography. In Russia it was sometimes referred to as the "prayer of the mind and heart." The Russian reception of the

tradition, however, was somewhat different from that of the Greeks. Saint Gregory Palamas had taught that light is an uncreated divine energy. The Greeks felt that this energy was like a scorching fire entering into the soul of the person of faith and consuming sinfulness.

In contrast, the Russian hesychasts understood this light to be a form of grace—a quiet light within the soul that imparts love for all living things. Saint Sergius of Radonezh, who is often considered the main representative of Russian Hesychasm, taught his disciples to love every living thing and to see in all the grace and glory of God. Andrei Rublev, as a student of Saint Sergius, used his icons and paints to embody this love for God and the world. And indeed this is precisely what draws us to Rublev's icons: they are suffused with a profound prayerfulness and a quiet joy. Rublev's works, like those of Theophanes, are light-bearing. But whereas the latter paints a light that rages and flares, the former produces a soft light that floods space with an even glow, penetrating everything. Andrei Rublev's icons such as the Holy Trinity, the Zvenigorod Savior, the Apostle Paul, and the Archangel Michael, among others, are all revelations of this heavenly beauty. They are depictions of a lost heavenly harmony reflecting both a deep understanding of the mystery of the divine Incarnation and the distinctive Russian tradition of hesychasm.

A definition of iconography as "contemplation in colors" provided by the twentieth-century philosopher Evgeny Trubetskoi applies with particular aptness to Rublev. Over the centuries, Andrei Rublev's authority has never waned or been superseded, and in the twentieth century his name became the banner of those working to revive the iconographic tradition.

Rublev was canonized during the Russian Orthodox Church's council of 1988 honoring the 1,000-year anniversary of Russia's conversion to Christianity and celebrating the great iconographic tradition that rose up as a result. Throughout the world, the very name Rublev is now taken as a symbol of Russian iconography.

It was during the early fifteenth century that Rublev picked up the torch from Theophanes and so brilliantly defined one aspect of the Moscow school. Later that same century another genius of Russian and Muscovite iconography came to the fore: Dionisius. Unlike Rublev, Dionisius was not a monk but a layman, whose sons Vladimir and Feodosy worked

alongside him. Dionisius' contemporaries also made use of the phrase "wise philosopher" in reference to this great iconographer, observing how he united his artistic gift with a special vision of the world in all its freshly created and uncorrupted divine beauty. With good reason he is considered the finest colorist in all of medieval Russian art, as well as the most musical of the old masters. Using the subtlest gradations of color, he softly forms the silhouette of his figures and rhythmically organizes the composition of the whole. His art is inimitable. The elongated proportions of his figures are another easily recognizable feature of his iconography. He is called the last of the great masters of medieval Russia. His ability to reflect the aesthetic of heaven explains why Dionysius, like Rublev, continues to strongly influence modern iconography.

The Onset of Decline

In the following century, Russian iconography continued in the path of the great masters of tradition, even as today's viewers notice that the faces become less expressive, the coloring duller. Icons in the sixteenth century retain all the requisite elements, but in lesser measure: less light, less theological depth, less prayerfulness. The icons seemingly reflect a premonition of the coming crisis.

In 1551, the so-called Stoglavy (Hundred Chapters) Council of the Russian Church was convened to settle a range of important questions concerning church life and administration—as well as matters of iconography. The council declared its fealty to the dogmatic foundations of iconography while focusing attention on certain images contradicting Orthodox teachings. This concerned, in the first instance, any icons attempting to depict all the persons of the Holy Trinity. The controversy centered around God the Father, who, according to the second of the Ten Commandments, is by his very nature unrepresentable. As a result, the council banned a number of icons including the Fatherhood icon and the New Testament Trinity icon, both of which depicted God the Father as an incarnate human being.

Nonetheless, despite the bans of this church council, such imagery continued to appear—and continues to this day. A striking confirmation of

this fact can be found in the preeminent church building of contemporary Russia—the Church of Christ the Savior in Moscow. Under the central cupola, we find God the Father depicted in the form of an old man flying through the sky alongside his youthful son, Christ. The Holy Spirit, in the form of a dove, soars above them. This sort of imagery was forbidden by the Stoglavy Council, and yet, as was ironically pointed out by the nineteenth-century Russian writer Mikhail Saltykov-Shchedrin, "the severity of Russian law is always counter-balanced by the non-obligatory nature of its fulfillment."

The Stoglavy Council also considered the ethical norms expected of iconographers. They concluded that the moral character of an iconographer dedicating his life to painting holy images was as important as technical competence and theological understanding. The council set forth the following guidelines: "An iconographer shall be reverential, humble, not given to vain talk or clownery; not quarrelsome or of an envious nature; shall not be a drunkard, or a thief, or a murderer; most important of all, he must guard to the utmost the purity of his own soul and body, and whosoever is unable to endure in this state till the end, let him marry according to the law. The artist should regularly seek the advice of a spiritual father, listening to his counsel in all things and living accordingly, fasting, praying and leading a life of restraint and humility, devoid of shame and disgrace. . . . If any master painter, or one of his students, should begin to live in a manner contrary to the rules: in a state of drunkenness, uncleanness, and disobedience of every sort, then the Church hierarchs are to place such persons under discipline, must forbid them from painting, and not allow them to [even] touch their paints."[11] In medieval Russia icon painting was looked upon as an ecclesial vocation on a par with the priesthood. For this reason its practitioners were expected to behave accordingly.

These questions of ethics continue to be timely in our own day. Modern iconographers, the heirs of Rublev and Dionisius, have the same set of talents as their predecessors, but it is harder to live the life of an iconographer in today's world. The contrast between the world in which the painter lives and the world that he or she is painting has become sharper.

There is an intimate connection between the iconographer's way of life, the form taken by his thoughts and faith, and the form of the finished icon. The moral purity of the painter is no less important to the final result than the iconographer's technical mastery of the art. "Why do we have no geniuses in our day on the level of a Rublev?" wrote Archimandrite Zinon, Russia's leading iconographer. "Because the nature of the person defines the nature of the icon."

By the end of the sixteenth century, we witness some changes in the lives of iconographers—and in the status of icons. The century closes with the first patrons of the arts becoming active in Russia: the Stroganovs. Industrialists from the salt-mining town of Solvychegodsk, they also worked as merchants on a large scale and participated in the taming of Siberia. They constructed schools, and they set up iconography studios. It was under their patronage that the Stroganov school of iconography was born. Its adherents paid particular attention to technical perfection and mastery of the subtleties of artistic style. Icons of the Stroganov school are noteworthy for the purity and detail—and also the ornateness—of their decoration, their choice of luminous colors, the skill with which small figures are painted, and the golden tonal highlighting of clothing and structures. Public interest and taste for this style, where an icon is often valued more as a fine ornament than as a symbolic likeness oriented to prayer, continued right through to the twentieth century. The earlier emphasis on the spiritual nature of icons and iconographers gradually faded—along with memory of the Stoglavy Council's teaching that artists should paint icons "as they were painted by the ancient and holy iconographers."

In the seventeenth century—a time of consolidation of an autocratic centralized state—adherents of the Stroganov school became the founding members of the Armory Palace school of Tsarist iconography. They received a salary for their work and were considered professional artists. As a result of the influence in the Armory Palace, the orientation of Russian iconography began to shift more and more in the direction of aestheticism at the expense of the icon's moral dimension. In this age, the icon became a painting to admire rather than a window to the spiritual realm and an object of veneration.

In 1613 Mikhail Romanov ascended to the throne, thereby initiating a new dynasty that would rule Russia for more than three hundred years, until

1917. After finally coming through the "Time of Troubles," a fifteen-year period of chaos that featured the tumultuous reigns of Boris Godunov and the "False Dmitry," Russia experienced a flowering of the arts that gave rise to a variety of styles, new subject matter for artists, and new genres. It was from the West that these influences had arrived, and they included not just baroque architecture, portrait painting, and other secular arts, but also such prosaic matters as the eating of salad and asparagus, the use of snuff, and the cultivation of roses.[12]

From this period quite a few names of iconographers are known to us, with the tradition of anonymous painting of icons receding into the past. Now the names of salaried iconographers fulfilling commissions for the Tsar were recorded in documents and many of their icons and frescoes simply signed.

By the beginning of the seventeenth century, artists only rarely oriented their work to imitation of the old masters of icon paining. They now more commonly took Western European art as their model. As a result, the early Russian tradition and iconic canon oriented to "the ancient and holy iconographers" gradually fell into oblivion.[13] In previous centuries there had also been occasional lively contacts between Russia and Western culture, but the impact of these interactions had not merged and melded to the disregard of the spiritual nature of the icon and the Orthodox tradition. The best Armory Palace iconographers, such as Simon Ushakov, tried to unite the old and new traditions, but this could not save the icon from such a fundamental change in orientation. The icon continued to evolve in the direction of a fine art painting.

In the eighteenth century Russia turned decisively to the West—or, as many historians would insist, was so turned by Peter the Great. Embracing first the baroque, then the neoclassical style, ecclesial art again changed in dramatic fashion. New gilded and luxuriously carved iconostases (the wooden screens on which icons are placed) were created. Sculptures, along with paintings rendered in the naturalistic style, became common features of church interiors. Oil paintings (often surrounded by imitation cartouche frames) took the place of frescoes. Three-dimensionality of space suddenly appeared in Russian ecclesial art, along with the modeling of figures with light and shadow, and lavish decoration—all of which contrasts markedly

with the spirit of asceticism and symbolism of the ancient icon. In the older tradition, light had been used to symbolize a person's transfiguration by the uncreated light and was illustrated by a glow from within. Now light came from an external source, and its purpose was to convey naturalistic realism. The new style was embraced—rather, was imposed—by the royalty, first by Peter the Great and then by the empresses Elizaveta Petrovna and Catherine II.

It may strike some readers as odd that matters such as artistic style could be imposed from above. The following entirely typical incident illustrates how such control was accomplished. In 1767, Empress Catherine II visited Vladimir, the capital of ancient Rus'. While attending the divine liturgy in the Cathedral of the Dormition, it occurred to her that the decorations were terribly threadbare, the iconostasis too dark and gloomy. The empress commanded that monies be made available for the construction of a new iconostasis. Soon a gilded and richly carved baroque-style iconostasis was brought into the cathedral, and the self-taught artist Mikhail Strokin painted icons for it in the then-fashionable painterly, fine-art style.[14]

Meanwhile, the cathedral's ancient icons created in 1408 by Andrei Rublev and Daniil Cherny were sold to a country church in a village called Vasilevsk (in Shuisk District, Vladimir Province). It was subsequently decided that the cathedral's ancient frescoes, also painted by Rublev, should likewise be renewed, and so they were painted over in oil according to the fashions of the time. The iconostasis created by Rublev and Cherny might have sunk into permanent oblivion, had it not been discovered by restorers in the nineteenth century. Ultimately, in the twentieth century, the church's icons were divided between two museums, the Tretyakov Gallery in Moscow and the Russian Museum in St. Petersburg.

By the nineteenth century the baroque style had been definitively replaced by neoclassicism, a European style further removed from Russian national traditions. The porticos and colonnades of churches were decorated with bas-relief sculpture. Church interiors were outfitted with iconostases reminiscent of triumphal arches while pompous religious artwork took the place of icons. The baroque and classicist trends were felt most strongly in St. Petersburg, a city built without reference to the traditions of ancient Rus' and oriented deliberately to Western European culture.

Nonetheless, even in such cities as Moscow, with many centuries of Russian history behind them, the sudden shift in cultural standards brought about a significant loss of roots. Two centuries of change transformed the look of the Russian heartland, as new fashions came to such places by varied means. The heartland areas did not want to lag behind the big cities; and in any case, the cultural policies of the central government were in this respect both definite and harsh.

Playing a leading role in the policies, the Academy of Arts cultivated Enlightenment ideas and looked to French classicism. The Russian art world began taking cues from the famous artists of the West—in relation to whom Russian artists always felt in a sort of permanent apprenticeship.

The academic style became the reference point even for ecclesial art. The Holy Synod, responsible for the decoration of newly constructed and refurbished churches, made the Academy of Arts its chief censor over the production of ecclesial art. Examples of this collaboration between the Synod and the Academy of Arts can be found in the artwork of Saint Isaac's Cathedral in St. Petersburg (1818–1858) and in the Church of Christ the Savior in Moscow (1839–1883), which in turn set the tone for new churches across the entire Russian empire. And although the academy made use of the best artists to carry out these projects, the new churches bore more resemblance to palaces or museums than to Orthodox places of worship.

Mikhail Pogodin, the nineteenth-century historian and writer, commented on the situation with bitterness. "How," he asked, "can our modern artists, with their gaze constantly turned toward Pantheons and Madonnas, understand the nature of a Russian icon, or understand what Russian art is?"

As Russian icons began to look more like Western paintings, canonical iconography apparently was a thing of the past. Icons were spoken of with scorn, and their production considered a village handicraft distant from the artistry of the academy.

Iconographers holding to the canon were dismissively referred to as "icon-daubers." Nonetheless, icon studios continued to exist, albeit in provincial regions away from the capital cities, their work considered inexpensive art for unsophisticated folk.

Over time, however, some iconography studios, such as those at Palekh, Mstera, and Kholui, became known for their icons throughout Russia. By

the end of the nineteenth century their products were in demand and were highly valued, even commercially. In fact, by this point, the atmosphere of Russian society was changing; due in part to a small number of enthusiasts, scholars, conservators, and collectors, society was again becoming interested in Russia's national traditions and other relics of the past. And the onset of the twentieth century would bring this about in an even fuller way: through the rediscovery of the icon.

The Discovery of the Icon and the New Iconoclasts

The twentieth century started out full of optimism and vigorous activity, promising to reach unimagined heights of achievement and progress. Culture would blossom, science would triumph, and industry would continuously expand. Many people hoped this was the beginning of an intellectual and spiritual renaissance, and the crash of these hopes came with unexpected speed.

For Russia, the twentieth century was particularly cruel. In 1917, the Bolsheviks came to power. The founding principle of their ideology was destruction, even as the ideology purported reconstruction, as seen in the words of the song they declared their national anthem: "We will destroy this world of violence down to its foundations, and then anew, our new world shall we build." In this way enthusiasts of the revolution announced their intention to build a new world based on justice.

As it turned out, however, the "radiant future" painted by Soviet propaganda as a new heaven on earth required the sacrifice of millions of people. Those who did not want to build their "paradise" were labeled enemies of the people and condemned to either death or exile.

The Orthodox Church was cruelly repressed inasmuch as its very existence stood as a reproach to the Bolsheviks' utopian ideology. Once again, as in the days of early Christianity, thousands of Christians were persecuted for their faith. They were deprived of all rights; they were exiled to Siberia or

to the far north; they were tortured. They were left to rot in prisons or sent into hard labor. Many were shot. For seven decades the country festered in darkness.

At the same time, not only Russia experienced a catastrophe during the twentieth century. Many countries were overtaken by forces of the Left—if not in the political sense, then at least in the moral sense. European culture broke away from its Christian roots and began cultivating new ideals. While previous generations had built their culture on the basis of Christian faith, the "new man" would be free from the old religious prejudices and bourgeois ideals. It was during this time that Friedrich Nietzsche declared the death of God, Karl Marx declared the end of the old world, and Jean-Paul Sartre declared the absurdity of existence. The very foundations of the world had apparently disappeared.

Meanwhile, noble-sounding ideas about the construction of a new world led to quite a different result: the creation of the modern totalitarian state in both the western and eastern halves of Europe. In one set of countries, Communists waved the banner of the dictatorship of the proletariat and class struggle while systematically eliminating those classes of people that had outlived their historic purpose. In another set of countries, fascists placed the ideals of nation and blood purity on a pedestal, and then worked to eliminate entire peoples that it considered inherently defective. Despite the differences in their ideological presuppositions, these regimes had keen similarities. The second millennium of the Christian era concluded with the Gulag and Auschwitz.

⚜

Throughout the ages it is art that has served as a mirror reflecting the spiritual condition of humankind and the world in which we live. The artist, perhaps even without being aware of it, witnesses to the time in which she or he lives, adjusting like a fine instrument to the movements taking place in the deepest reaches of the human heart.

In pre-revolutionary Russia a host of poets and artists expressed, consciously or unconsciously, their sense of the state of the world on the eve of the coming catastrophe. Some sang its praises. "Let the storm break in all its

fury!" wrote Maxim Gorky in his prose poem "Song of the Stormy Petrel." Others, such as the symbolist-poet Alexander Blok, reacted with dread: "The twentieth century comes—still more bottomless life's gloom, and more somber; still more enormous, and blacker, the shadow of Lucifer's wing." But it was Kazimir Malevich, with his famous painting *Black Square*, who most acutely captured the tenor of the age. Behind the intentional simplicity of the design hides a profound philosophical insight: *Black Square* is an anti-icon: a depiction of the end of the world and a metaphysical vacuum. It is a prophecy of the coming spiritual disaster.

The idea for his *Black Square* came to Malevich in 1915 as he was working on illustrations for the drama by Mikhail Matyushin, *Victory over the Sun*. Against the background of a white canvas the artist saw a black abyss opening in the very center of the world and swallowing it up. Malevich called his paintings road signs, and in this context his *Black Square* can be read as a sign signaling "Stop, go no further, beyond this point lies nothing but a chasm, the abyss, and utter darkness." After he painted *Black Square* the artist declared, "With this, the history of art has come to an end!" And yet, looking into that black abyss it seems all *human* history has come to an end.

The Discovery at the Dawn of Revolution

There were other prophecies, other signs of the times. In the early years of the twentieth century, as war and revolution drew near and many in Russia were already losing their faith in life's meaning, a great discovery took place whose significance would become fully apparent only a century later: the *re*discovery of the icon. With the help of new technology, conservators learned how to remove from the icons layers of darkened oil varnish and over-drawings—along with the traces of earlier, awkward attempts at restoration. This restoration process allowed original layers of color used in the ancient works of art to shine forth. ·

Icons that formerly had the appearance of blackened blocks of wood were revealed to the world in all their original beauty, brightness, and delicacy of line. It was now clear that early icons were not primitive works of art, as many Russians had thought, nor were they gloomy. Like a firebird released from its darkened cage into the light of freedom, these freshly

uncovered icons revealed their brilliant, joyful colors. This revelation caused
an enormous stir in late tsarist Russia. Artists, theologians, philosophers,
and ordinary thoughtful people began excitedly discussing this new
phenomenon of the icon. It appeared that the past as a whole would have
to be reassessed.

This discovery marked a spiritual turning point in Russian contemporary
history, and an important one. It cannot have been accidental that it took
place on the very eve of the Russian Revolution.

As the Russian Revolution began, the icon served both as a spiritual
warning against this coming catastrophe and as an indication of the path
beyond it, precisely because iconic images address and allow us to see real-
ity as a series of oppositions. On one hand, a vision of heaven and the light
of the Transfiguration; on the other, the ugliness of the world. Within the
darkness of a war that sets brother against brother we are given a vision
of transcendent harmony. The beauty of the heavenly Jerusalem is seen in
contrast with a world of social chaos devoid of any human face.

Pioneering this new understanding of icons was the philosopher and
theologian Prince Evgenii Trubetskoi. In an essay called "Contemplations in
Colors," he wrote about the icon's philosophical significance:

> If it is true that both nature as a whole, and human history as
> a whole, lead *in the end* to nothing but the final victory of the evil
> principle, then where do we find that meaning of life for the sake
> of which we live our lives, and which, indeed, makes life worth
> living? I will refrain from answering this question myself. I prefer to
> point to the answer given by our distant ancestors. They were not
> philosophers but mystics and clairvoyants, and they expressed their
> thoughts not in words but in colors. And yet their paintings directly
> answer our question. . . . In their time too, the Kingdom of the Beast
> existed, and it forced the nations to face the age-old temptation: "All
> this shall be thine if thou wilt bow down before me." All religious
> art of medieval Russia was conceived and born from within the
> struggle over this temptation. And in answer to it, the medieval
> iconographers took what filled their hearts and souls and, through
> the use of paint and imagery, gave it physical form—and they did

so with astonishing clarity and force. They disclosed to the world a different truth about life, a different meaning of the world.[15]

What do we mean, though, by the "discovery of the icon"? Had not the icon for many centuries already formed an integral part of Orthodox tradition? Was it not already an object of intense devotion within Orthodox churches? Icons, to be sure, were still being displayed in churches (although it is true that paintings rendered in what is called the "academic style" were crowding them out).

In the early twentieth century, the educated Russian began to lose interest in icons and lose appreciation for their meaning. The Russian intelligentsia during this period moved in one of two camps, either becoming more rationalistic or becoming increasingly enamored with Eastern and Western mysticism. At the same time, all this was far removed from the mood of the ordinary people. The popular cult of the icon—especially the cult of miracle-working ones—remained strong among ordinary folks. One might add that the veneration of icons, and the veneration of holy objects generally (relics, holy places, and the like), had always played and continued to play a special part in the daily habits of many ordinary people. This type of piety connected their daily routine in the world with what lies "beyond the world"—with what Eastern Orthodox theology refers to as the kingdom of heaven.

Ordinary Russians sought from icons answers not only to the eternal questions, but also to their present-day problems. And in many cases miracles ascribed to icons served to make sense of events happening in the early twentieth century. In the spring of 1917, for example, Russia witnessed the miraculous appearance of the "Reigning" icon of the Mother of God, an appearance that was widely connected with the revolutionary changes then taking place.

The story of this icon began on March 2 (or March 15, according to the old calendar), when the Russian Emperor Nicholas II abdicated the throne, thereby creating utter chaos in the country. It was this chaos, in the end, that allowed the Bolsheviks to triumph.

The very day of the emperor's abdication, a peasant girl named Evdokia Adrianova, who lived in the village of Pererva outside Moscow, was given a vision in a dream. She saw Mary, the Mother of God, who told her to go to

the village of Kolomenskoe and find there an old icon, which, Mary told the girl, "will change color from black to red." The peasant girl was uneducated but pious and didn't dare disobey.

When she arrived in the village of Kolomenskoe she described her vision to a priest in the Church of the Lord's Ascension. The priest took her at her word and helped her search for the icon. He went through the church and all the adjoining buildings until finally, in a storage room filled with odds and ends, he found a large, old icon left there because of its dilapidated condition. The icon was so blackened that one could barely make out the contours of a throne on which the Mother of God was seated with the Holy Infant in her lap.

When they took the icon out into the light, however, before their very eyes the blackness began to fade, and the image became more and more clear. The Mother of God's clothes gradually turned a color as red as blood; the crowns on both Mary's and Christ's heads became visible, and in Mary's hands appeared a scepter and orb—signs of monarchical authority. As the Mother of God had predicted, the icon did "change color from black to red."

Since this took place on the same day as the emperor's abdication of the throne, the appearance of this icon was immediately thought to be connected with that event. What is more, the priest was given to understand that the crown that had fallen from the head of the tsar had been taken up by the Theotokos, the Mother of God: henceforth she would be the reigning tsarina of the Russian state. Thus, the icon was named the "Reigning" icon and became widely revered among the Russian people.

Subsequent research into this icon revealed that its history was tightly bound with that of Russia and was full of twists and turns. It had originally belonged to the Ascension Convent in Moscow, located not far from the Kremlin in the Chertolye neighborhood, and it had been much revered there.

In 1812, when Napoleon's army occupied Moscow, it had been placed for safekeeping in the church in the village of Kolomenskoe. For some reason, after the end of the war the icon failed to return to its convent home, and not long afterward the convent itself was destroyed. In the 1830s the decision was made to erect the enormous Christ the Savior Church in this same area of the city, and the Holy Synod decided that the convent would have to be demolished.

The convent's inhabitants were sent out of the city to Krasnoe Selo. The nuns resisted this move with all their strength; the mother superior even chained herself to the monastery wall, but the police helped displace the rebellious nuns from the capital city. In parting, the mother superior cursed the site, saying, "May this place be made barren!" The curse was fulfilled: the church, built on the ruins of the convent, stood less than a hundred years before the Bolsheviks came in and leveled it. Only in the 1990s was the Church of Christ the Savior finally rebuilt.

Meanwhile the icon stayed in Kolomenskoe, where it gradually slipped into oblivion until, thanks to the simple peasant girl Evdokia Adrianova and the earth-shaking events of 1917, it was again brought to light, and it remains one of the most revered icons both inside Russia and in Russian émigré circles. Copies of the "Reigning" icon of the Mother of God can now be found all over the world.

The story of this icon reveals a deep and surprising link between seemingly disparate events that took place in Russia over the nineteenth and twentieth centuries. These links are revelatory in regard to the meaning of both church and state: an empire rises and then falls; the church itself is utterly abased, but it then experiences rebirth and renewal. This link was also seen in Nicholas II's abdication of the throne during the same year that a gathering of great importance happened within the Church: the All-Russian Council of the Orthodox Church. Here, after a lapse of more than 200 years (since the time of Peter the Great), the office of the patriarch was restored and His Eminence (later Saint) Tikhon (Belavin) was named Patriarch of All Russia.[16] Even as Russia ceased being an empire, the spiritual life of the Russian Church was restored.

In a similar way, this discovery of the "Reigning" icon of the Mother of God meant so much more than merely finding a lost and forgotten icon. The rediscovered icon became a spiritual phenomenon, changing the face of religious life in twentieth-century Russia. What had been found was the icon itself.

To be sure, at that time icons still occupied a place of honor in the popular rituals of everyday Orthodoxy, but they were no longer considered great works of art or even a part of high culture. Their true theological content went ignored and unknown. When ordinary folks revered icons they were

often unaware of the meaning behind a given image. At times this failure to see was literal, as certain icons continued to be revered even though the images that they depicted were no longer even visible.

The obscuring of the image stemmed from traditional icon-writing techniques, which dictate that icons be painted on wooden boards using mineral pigments covered with a protective layer of oil varnish called *olifa*. After eighty years of absorbing dust, dirt, and soot this oil varnish darkens; and after 200 years, the icon becomes a blackened wooden board whose imagery is almost completely obscure.

Old icons were often "renewed"—in the sense that a new image was painted right on top of the darkened older one—while particularly honored icons were placed under elaborate metal settings (the *oklad*) that covered the image still further.

The result was that an old icon became something shrouded in darkness and mystery; and although a given icon may have been surrounded by legends and holy traditions, the meaning of its imagery was often unclear. Many ancient icons were revered mostly as a matter of tradition. People would kneel before these darkened, mysterious boards and say their prayers, little concerning themselves with the theology behind them, even though this theology forms the foundation of iconic art.

In one of his stories, the Russian writer Nikolai Leskov ironically comments on this situation: it so turns out that under the darkened varnish of a greatly honored icon there lies hidden an indecent image—and not, as had been thought, a depiction of the Savior. This was not, of course, a description of an actual event but it does reflect the situation in Russia of what is called the Synodal period, a time when traditions were increasingly preserved in a purely nominal spirit, and when forms were adhered to even when their inner content had been lost.

In Russia during this time, the situation extended even to Holy Scripture. The well-known Russian preacher Vladimir Martsinkovsky, who at the beginning of the twentieth century traveled all over Russia delivering lectures on Christianity, describes in his memoirs an incident that happened in the midst of the Russian Revolution, around the year 1918. Martsinkovsky was traveling by train, and his compartment was filled with revolutionary soldiers and sailors. He tried to start a conversation

about the gospels with those on the train, but it turned out that none of the others in his car had the slightest clue about the contents of the New Testament.

"Aren't you baptized? Haven't you ever been inside a church?" he asked them in surprise.

"What? You think we've read the New Testament?" replied one of the sailors. "We just used to kiss the cover. But what's underneath the cover we have no idea."

According to Orthodox practice there is a tradition of kissing the New Testament as a sign of respect, and inside the church it is usually kept in a container covered with intricate settings. Both icons and books have since ancient times been kept in covers with adornments as if they were reliquaries containing sacred objects. Having successfully protected the sacred, the Church had unwittingly also distanced it from the faithful. As a result the content of the gospels (along with the content of the icons, which had since ancient times been described as "gospels in pictorial form"), remained unknown to the majority of the population. Even the reading of the gospel from the pulpit during church services did little to clarify its meaning, because the archaic Church Slavonic language had, by the end of the nineteenth century, become less known to the people.

By the time of the revolution, even people who were baptized Christians and had yesterday gone to church accepted Bolshevik propaganda and began to take part in demolishing churches and monasteries, profaning holy objects, and burning icons.

Most of the churches destroyed in Russia were ruined not by foreign invaders, but by Russians themselves and natives of their own land—a land which, not long before, had considered itself an Orthodox Christian empire and the Third Rome. The new wave of iconoclasm was Russian, born from within.

Nonetheless, alongside all the destructive processes taking place in twentieth-century Russia there were also creative processes that put people in contact once again with the true values. The rediscovery of the icon belongs to this category.

The rediscovery of the icon relates, in fact, to a whole series of scientific and scholarly discoveries. Some were in the restoration arts, archaeology and

history, others in the area of iconography and theology. The improvements in restoration came about as information accumulated from archaeological discoveries, the publication of historical documents, and investigations into avenues such as philology and the history of the icon—these studies culminated in making it easier for art historians and other scholars to understand how the art of the icon had developed, how its style and plastic form had evolved, and how the icon's idea and tradition had changed over time. Along with the unfolding knowledge in various fields, the first two decades of the twentieth century witnessed the discovery of dozens of important icons from the Russia of the medieval period. Today, the history of Old Russian pictorial art simply cannot be understood without them.

Among the discoveries was Andrei Rublev's Holy Trinity (sometimes called the Old Testament Trinity) icon. It is difficult to fathom that the now-famous Trinity icon became truly visible again only in the twentieth century. For the previous five centuries it lay under a layer of soot and lampblack and was further obscured by a gold covering (*oklad*).

In 1904, a conservator named Vasily Gurianov performed a test restoration of a small portion of the icon and became convinced that under the layers of darkened varnish and soot, through which there were the barely discernable outlines of three figures, there lay hidden a timeless, priceless painting.

Only much later would many books and articles be written about the splendor of Rublev's color scheme, with its piercing blues and gentle greens, its saturated purples and its surpassingly delicate transitions from ochre to gold; only later would books be written about the deep dogmatic and theological significance of Rublev's images, their reverse perspective, and so forth.

Back at the outset of the twentieth century, just this one small fragment was discovered, but this already sufficed to give Russia a feel for the style of Andrei Rublev, an artist who over the course of centuries had been considered the very pinnacle of iconic art.

Soon crowds began making pilgrimages to the icon, which was located within the iconostasis of the Holy Trinity Cathedral, the main church of the Trinity-Saint Sergius Lavra.[17] Frightened by the crowds, the monks decided to postpone the icon's restoration and re-cover the icon with its metal setting. The icon remained untouched until 1918 when a restoration

commission formed, paradoxically, by the new Soviet government again took up the task of research and restoration. That such work would have been undertaken by the new Soviet government is not shocking. Soviet power and ideology were not fully consolidated until the late 1920s. But in the early years there were still some prominent intellectuals within the Soviet government, such as the minister of education Anatol Lunacharsky, who appreciated high culture and certain forms of religious inspiration. In any case, after the work of restoration was completed, the icon was not returned to the Trinity Cathedral but was instead sent to the State Tretyakov Gallery. Its place in the cathedral iconostasis was taken by a copy painted by the restorer I. Baranov, which remains there to this day.

During this same period other icons were being discovered that likewise became known as masterpieces of Old Russian culture. One of the more curious examples is the discovery of a grouping known as the Zvenigorod row. In 1918, the restoration commission was doing research in the ancient city of Zvenigorod. According to the chronicles, Andrei Rublev worked here at the beginning of the fifteenth century at the invitation of Prince Yury Dmitrievich. But a search of the Cathedral of the Nativity in the Savvino-Storozhevsky monastery (built in 1405) and the Church of the Dormition (1399) came up empty. No works by Rublev were found.

Almost as an afterthought, the team decided to take a look in the woodshed in the yard behind the church. One of the restorers, with his experienced eye, noticed amidst the clutter of rubbish and firewood some broken pieces of wooden icons. Although the fragments had nothing visible on them besides dirt and soot, the thickness of the wood and the dowel marks suggested that these pieces of wood were from icons, and their large size and the peculiar way the wood had been worked pointed to their extreme age.

The fragments were taken to the restoration workroom, where layers of soil and darkened varnish were removed, and the fragments assembled. Here they found a magnificent work of art, which experts dated as from the beginning of the fifteenth century—the time of Andrei Rublev. The style strongly suggested the hand of the master, and yet, without documentary evidence, it is impossible to prove this with complete confidence. Yet, whoever the author of these remarkable icons, it remains obvious that several previously unknown old masterpieces had been brought into the world.

The icons were named as the Zvenigorod row and are now housed in the Tretyakov Gallery. There are three within the row: the Savior, the Archangel Michael, and Saint Paul. The images are half-figures, written on large panels (160 by 108 centimeters [63 by 42.5 inches]). Originally they would have been part of the deesis (the central row of an iconostasis). To this day it remains a mystery, however, to which church they belonged, as they do not fit into the architecture of any of the ancient churches of Zvenigorod.

Restorers of icons can tell you a number of such stories, although of course by no means every restorer manages to discover a Rublev. All the same, the first decades of the twentieth century were rich in discoveries. Between 1910 and 1920 other medieval Russian art masterpieces were discovered, including what is known as the Vladimir Mother of God icon, which has become a sacred national treasure of Russia. Study of the under-layers during restoration revealed that the Vladimir icon as it exists today preserves from the original twelfth-century version only the faces of Mary and Christ—every other part of the icon was painted over in the fifteenth, seventeenth, and nineteenth centuries. History certainly left its mark.

In 1907, taking advantage of the new restorations and discoveries, the first exhibit of ancient icons was opened in Moscow. The exhibit gave rise to both lively responses and heated arguments. In 1913, another exhibit was held at Gostinny Dvor on Varvarka Street. This one was grander in scale and was timed to coincide with the 300-year anniversary of the house of the Romanovs.

The exhibit included 147 works from sixteenth- through seventeenth-century Russia, and not only icons and paintings, but also embroidered icons, applied art, and sacred vessels used during Orthodox liturgy. What previously had been known only to collectors and a few scholars now became the property of the broad public.

One of these exhibits was seen by the renowned French painter Henri Matisse, who visited Russia in the early twentieth century. What he saw there astonished him. The medieval Russian masters had already found what the modern European avant-garde had been seeking. Matisse was delighted by the brightness and clarity of colors in Russian icons, the expressive, supple lines of their silhouettes, and their rhythmically organized compositions and laconic imagery. He found much in common between these icons from Old Russia and the new European art. Far from being out of date, as many in the nineteenth

century had thought, the icon was revealed instead as entirely contemporary and capable of solving new aesthetic, spatial, and conceptual problems.

Not only Matisse, but also many Russian artists found inspiration in the icon at the beginning of the twentieth century, including such luminaries as Kazimir Malevich, Natalia Goncharova, Kuzma Petrov-Vodkin, Nicholas Roerich, Viktor Vasnetsov, Mikhail Nesterov, Mikhail Vrubel, and others. The works of these artists make evident that the discovery of the icon left its mark on world art. Some of these artists were so influenced by icons that they began working with devotional art, painting church frescoes.

Alongside the discovery of the icon in the realm of restoration and aesthetics, a parallel discovery was taking place in the realm of the icon's theology and the meaning of its images. A number of prominent Russian philosophers and scholars, including Evganii Trubetskoi and Father Pavel Florensky, wrote works disclosing the icon's meaning and symbolism, its liturgical significance, and its ties to Church dogmatics and theology.

Even though icons had continued to exist on the level of craft during the period of the Russian baroque and neoclassicism, the profound, succinct language of icons had essentially been forgotten. This lost language stood in need of reconstruction, just as the images themselves needed reconstruction, given that the icons so often had been preserved in only a fragmentary state.

After years of attentive study, scholars came to realize that the iconic language is far from primitive, despite the fact that, in Old Russia, icons had been called "the Bible of the illiterate." Its idiom was clearly directed not only at elderly women and unlettered peasants, but also at people of profound learning and spirituality. To fully read an icon one often needs an understanding of history, the liturgy, and theology.

The discovery of the icon served as a revelation not only to the secular world, but also to the Church itself, inasmuch as the ancient icon brought back to the Church the creative spirit of the church fathers and served to counteract the spirit of perfunctory ritualism and hypocritical dogmatism characteristic of the Synodal period.

The church fathers understood the icon as a branch of theology directly linked with dogmatics and liturgy and saw in it an expression of the ascetic and mystical life of the Church.

When these links were broken, the icon became a sort of pious craft and was perceived as an object of worship, and the specifics of its style changed to suit currently reigning social tastes. And so, in the eighteenth and nineteenth centuries, we find the language of signs and symbols used by the early iconographers replaced by a painterly style, an expression of the new church atmosphere of outward piety operating within a secularized consciousness. Icons ceased being that "visible image of the invisible" as Saint John of Damascus once described them, and it became fashionable to associate icons painted in the Old Russian style with the Old Believers sect that had become entrenched in its traditionalism and had strayed from the truth. The Old Believer movement was considered a form of narrow sectarianism and the refuge of backward, uneducated people. The academic style, by contrast, was welcomed within what were considered enlightened Orthodox circles, though it was equally embraced by patriotic church leaders eager to bolster public morality.

Earlier Steps

The discovery of the icon fundamentally changed the prevailing understanding of early iconography, as well as Byzantine and medieval Russian culture generally, even as it opened up new spiritual paths within Orthodox tradition. This discovery also came into the world at a time, near the end of the second millennium of Christian history, when the world seemed to be on the verge of losing contact with the traditional values. Yet, this is not what has happened.

The rediscovery of icons came about gradually. Restoration work at medieval Russian monasteries had already begun in the nineteenth century. In Kiev, eleventh-century frescoes of Saint Sophia's Cathedral were newly freed from layers of grime. In the Church of Saint George in Staraya Ladoga, remnants of frescoes from the twelfth century were discovered, as were wall paintings by Andrei Rublev in the Cathedral of the Dormition in the city of Vladimir. In major centers of Old Russia—towns such as Novgorod, Pskov, Yaroslavl, and others—almost every year new traces of monumental paintings and early icons were found.

Shedding light on the very beginnings of Orthodox iconography, Bishop Porfiry Uspensky, the eminent scholar known for his research of the

Christian East, brought back to Russia from Saint Catherine's Monastery at Mount Sinai a collection of encaustic icons from the sixth to seventh centuries. Bishop Porfiry entrusted his collection to the archaeological and ecclesiological museum of the Kiev Theological Academy. Museums began springing up in seminaries and theological schools in order to study church-related art and archaeology, and significant space in them was dedicated to ancient icons. And by the end of the nineteenth century, secular museums were exhibiting ancient church objects, including icons, and becoming an important source of support for continuing scientific study of iconography.

Soon contemporary artists were also becoming fascinated with Russian antiquity; and many began attempting to revive the art of the church by combining the medieval and modern styles. The famous Russian artist Viktor Vasnetsov (1848–1926) was at the forefront of this movement. As a descendent in a line of Orthodox priests (including his father), Vasnetsov was familiar with wall paintings in churches, and although he started out his artistic career within the *Peredvizhniki* (realist "Itinerant") school, he was inspired by the idea of creating a "new iconography." During his Peredvizhniki period his art dwelt on social themes such as the lives of the poor. He then moved on to Russian epics and fairytales (his famous paintings *Alyonushka* and *Three Bogatyrs* adorn the walls of the Tretyakov Gallery), and then, during his final artistic period, he dedicated himself entirely to church art.

His movement toward church art was facilitated by his friendship with the archaeologist Andrian Prakhov, who also dreamed of a revival of ecclesial art based on Russian national traditions. In 1887 Prakhov invited Vasnetsov to Kiev so that he could fresco the walls of the Vladimir Cathedral. This enormous church, dedicated to Prince Saint Vladimir, the "baptizer" of Russia, had been built in the neo-Byzantine style. Construction had begun in 1862, when the Russian state was celebrating the 1,000-year anniversary of its founding, and it had been decided that the painting of the interior walls should coincide with the 900-year anniversary of the baptism of Russia in 1888.

Prakhov and Vasnetsov mapped out the program of wall paintings, assigning a special place to the theme of holiness. A joyful host of Russian and ecumenical saints stand facing Christ in the church's interior, looking

like a choir. Themes from the New Testament alternate with events from the history of the church, with the whole ensemble creating the impression of a great cosmos—one where decorative elements, such as Byzantine ornamentation and a gold-colored background, play primary roles.

The famous Russian artist Mikhail Nesterov, who also participated in the painting of the cathedral, wrote about the project with great enthusiasm: "A dream lives in this place! It is the dream of a 'Russian Renaissance,' the revival of the long-forgotten but superlative art of such iconographers as Dionysius and Andrei Rublev."[18]

And yet, because such a task was very difficult to fulfill, this dream would remain only that—a dream. No matter how hard he strived to bring it in line with the aesthetics of the icon, Vasnetsov's artistic technique was nonetheless rooted in art nouveau and therefore managed to approach the iconic level only slightly more successfully than had the earlier academic style.

The Vladimir Cathedral was not fated to become the first seed of a pan-Russian flowering of iconic art, despite the fact that certain images from the ensemble became famous and were copied in churches all over Russia.

Vasnetsov's image of the Mother of God, painted in the apse of the church, acquired a particularly devoted following. This work combines elements of early Russian icons (the background of gold, the widely opened eyes of Jesus and the Mother of God, the expressive gesture of the Christ child) with elements of the Western European academic tradition. More than the iconic, what shows is the obvious influence on the artist of Raphael's *Sistine Madonna*. The composition of the main figures—the Mother walking on top of clouds and pressing her son to her bosom—is repeated almost verbatim. This image, like all the others in the Vladimir Cathedral, expresses a certain sensuality and dramatic theatricality. Such qualities are incompatible with the emotionally restrained spirit and strictly observed forms of Orthodox liturgical prayer. While Vasnetsov dreamed of a renaissance of Old Russian iconography, in actuality he only retreated from it further and further.

More time was needed before the new knowledge of the early icon could become a foundation on which to create something modern, something that could serve as a continuation of the great iconic tradition. Vasnetsov came to understand this only toward the end of his life when in 1925,

surrounded by friends, he suddenly began speaking in tones of resigned awe about the frescoes in Ferapontov, Nereditsa, and other important sites of medieval Russian art. Someone in the group asked him, "But what about your icons? Or your frescoes? They are masterpieces, after all! They show such a profound understanding of the spirit of religion!" But Vasnetsov objected.

> "No, not at all! One could still say that before the discovery of medieval Russian icons. I myself was convinced, mad with pride as I was, that I and I alone had understood the essence of the art of Old Russia—along with Nesterov, that is, though his work was in a somewhat different vein. But when they began restoring the paintings of the medieval period, and the old frescoes in monasteries . . . as well as art of even more ancient origin; well, it disclosed a whole new and wonderful world, one grounded in an extremely profound inspiration and understanding of the law of nature, and with a simply amazing understanding of the relationship between colors and the technique of painting. These ancient paintings, bound by tradition and the strictures of specific forms, succeeded in creating paintings (*zhivopis*)[19] in the truest sense of the word—as a play of colors. These old boys were not mere draftsmen, like we are today. They were creators, true artists. . . . We should be proud of our medieval Russian icons and paintings. . . . I was convinced that I had penetrated to the essence of the Russian icon . . . and that I had reached the same technical level . . . as had been attained in those long-gone days. It turned out, however, that I was deluded. . . . My works are just a faint reflection, and a watered-down one at that, of the sumptuously rich world of the Old Russian icon."[20]

And with those words, Vasnetsov, one of the giants of early twentieth-century Russian art, admitted that the ancient icon had defeated him.

At the outset of the twentieth century, when one after another stunning masterpieces of medieval Russian art were being discovered, it appeared that Russia might be on the verge of entering a new day when iconic art would flourish again as it had before. Just as Vasnetsov believed, emerging

artists themselves were convinced that every new work they produced was bringing them closer and closer to the creation of a new style of church art synthesizing elements from the old and the new. It was a time of bold experimentation and spiritual daring.

Working alongside Vasnetsov in Kiev was the artist Mikhail Nesterov (1852–1942). He worked with great subtlety and originality and had a deep understanding of the Russian national character. Although his work on the Vladimir Cathedral was his first experience with church art, he did not let it go to waste. In his subsequent efforts, for example, at the Church at Abastuman or at the Convent of Martha and Maria, Nesterov sought to surpass Vasnetsov's achievements. His most interesting and significant work can be found in his frescoes and icons for the Pokrovsky Cathedral of the Saints Martha and Maria Convent in Moscow (1910–1912).

This convent was founded by the Grand Duchess Elizabeth Fyodorovna, who, after the death of her husband, Grand Duke Sergei Aleksandrovich, at the hands of a terrorist, entered monastic orders and devoted her life to works of charity. She organized a sisterhood in Moscow and named their convent in honor of the New Testament sisters Martha and Mary. Ordinarily the two sisters are set in opposition: Martha, as we learn from the gospel text, labored much but lost sight of what is spiritually important, while Mary was contemplative and sat at Christ's feet, thereby choosing what is most important.

But Elizabeth Fyodorovna decided to combine both vocations: of work and contemplation. The sisters in her convent took on a wide range of charitable activities even as they practiced a strict life of prayer. The convent grounds found room for a hospital, an outpatient clinic, a pharmacy, and a shelter. The sisters cared for the sick and the infirm from all over Moscow and during the First World War worked in hospitals as well. Unlike traditional Russian monasteries for women, the Martha and Maria convent allowed their nuns to travel beyond the monastery walls.

There were also unique features to the architecture and interior décor of the order's church, which had been named in honor of the Pokrov (protecting veil) of the Most Holy Mother of God. According to Elizabeth Fyodorovna's concept, its design should correspond to the convent's special character, which combined features of ancient monastic orders with the demands of

the modern world. The church was designed by Alexei Shchusev, who at the time was considered one of the foremost architects in Russia (later, during the Soviet period, he went on to design Lenin's tomb).

The small but harmoniously dimensioned church was built after the architectural style of the Novgorod-Pskov school and truly unites features of both new and old church traditions. It has a single dome, the walls are decorated with fragments of chiseled stone, and an image of Christ in an icon case embellishes the façade. The grand duchess entrusted the church's interior to Nesterov, and here too we find the same synthesis of old and new. There are both icons and paintings. The walls are painted in a decorative pictorial art style, the cupola and apse in the iconographic style. The iconostasis has been executed in keeping with traditional iconographic canons.

The church's interior decoration ended up with more eclecticism than its exterior. Even though the artist was inspired by the medieval icon, he remained in thrall to the aesthetic of art nouveau, which considers form more important than content. But such a stance comports poorly with the requirements of ecclesial art. Still, one cannot accuse Nesterov of lacking daring and sweep in decorative decisions, and, taken individually, some of his images are not only meaningful, but profoundly so. Of particular interest in the church is the icon of saints Martha and Maria, whose portraits share a resemblance with Elizabeth Fyodorovna, the convent's founder.

The works of Vasnetsov, Nesterov, and other artists represent an important stage in the development of church tradition. During the period from roughly 1910 until the revolution the ecclesial arts were all on the upswing, making this period a uniquely creative one. Private patrons of the arts eager to encourage artistic creativity became sponsors and builders of churches. Maria Tenesheva's estate at Talashkino (near Smolensk) and Savva Mamontsev's Abramtsevo estate are just two examples of this trend. Because projects such as these were, for the most part, not built within the structures and domain of the Holy Synod of the Russian Orthodox Church, they afforded the artists an unheard-of freedom. It was a time of experimentation and discovery, and there was a mood of high expectation in the air. Artists with an interest in the sacred expected that the new style that would represent a worthy continuation of the medieval iconographic tradition might appear at any moment.

Then, quite unexpectedly in fact, this movement that had been gathering steam was artificially cut short. After the revolutionary takeover in 1917 the ecclesial arts not only stopped their onward advance, but in many respects they began retreating. Such freedom and such breadth of artistic conception would not be experienced again: neither by the many iconography-influenced artists nor by the icon painters who strove to preserve the tradition despite the pressures of the Soviet regime. And such freedom would not be available, even, to those striving to renew that tradition after the sudden reappearance of political and religious freedom in the late twentieth century.

The Discovery Rejected

The rediscovery of the icon was soon followed by an openly iconoclastic era. More than ever, the fates of icons and the fates of individual persons were interwoven. A particularly stark example of this can be found in the fate of the Grand Duchess Elizabeth Fyodorovna, who, in addition to being the founder of the Convent of Saints Martha and Maria, also produced magnificent embroidery.

The life story of Elizabeth in many ways resembles that of the princess in fairytales. She was born in Darmstadt, Germany, a member of the House of Hesse and the niece of England's Queen Victoria. From her early childhood Elizabeth was noted for her kindness and sensitivity to others as well as her spiritual orientation. She held her own patron saint—Saint Elizabeth, Princess of Hungary, noted for her charitable work and assistance to the poor—in high regard and dreamed of imitating her, a dream destined to come true.

Elizabeth Fyodorovna was endowed by nature with an almost unearthly beauty, and yet she lived a chaste life and secretly wished to join a religious order. In the end this wish also came true. But first she was given in marriage. She received an offer of marriage from Grand Duke Sergei Alexandrovich Romanov, an offer she humbly accepted. The choice was not not hers, but made for her by her parents. Her older sister Alexandra had acted differently. She had chosen independently, of her own will and love, to marry Nicholas Romanov, who would later become tsar of Russia. Elizabeth nonetheless came to sincerely love her husband and strove to be a good wife.

When Sergei Alexandrovich became governor general of Moscow she was obliged, as wife of the city's chief executive, to attend many receptions and balls, although she enjoyed neither, and found greater pleasure in seclusion, quietly reading books or attending church services. But she accompanied her husband everywhere.

When Sergei Alexandrovich, who also headed the Imperial Russian Palestine Society, traveled at one point to the Holy Land, his wife accompanied him. While there, she attended the blessing of a Russian church named after Mary Magdalene located on the Mount of Olives. As she gazed at the beauty of the surrounding scenery, Elizabeth remarked, "How I would like to be buried here!" Many years later God granted her this wish after the tragedy that occurred on the outskirts of Alapaevsk, where she was shot for being a member of the Romanov royal family. Later, the retreating forces of General Vrangel discovered her remains, and those of one of her lay sisters, Barbara, who had been shot alongside her. Their remains were transported over the entire length of Siberia, then to China and Harbin; finally from Harbin, the bodies of the two martyrs were transported to Jerusalem and buried on the Mount of Olives in the Church of Mary Magdalene. They remain there to this day.

Elizabeth Fyodorovna was well known as a benefactress—she had sold all her jewels and finery in order to create her center for charitable works. It is far less well known that she was also a gifted artist. To this day in certain Moscow churches one can find shrouds that she produced by hand. Regrettably, the majority of the artistic objects she produced have already vanished. Nonetheless, Elizabeth Fyodorovna did succeed in leaving a major mark on twentieth-century icons, if only because it is her image that many of these icons depict. During the Russian Orthodox Church's Council of 1988, Elizabeth Fyodorovna was canonized a saint of the Orthodox Church and her face has been appearing on icons ever since. During her life she was already much loved by the people and after her death she was widely revered as an exemplar of Christian love and holiness.

At the dawn of Christian history Tertullian famously announced that "the blood of the martyrs is the seed of the church." The twentieth century has shed the blood of countless people and has destroyed countless icons and churches, and yet this bloody process of sowing continues to bring

forth new seedlings. Christianity has survived and new saints continue to be honored and revered, as do new icons.

The iconoclastic tendencies of the Soviet regime were directed not only at the physical destruction of icons, but also at the deconstruction of their image's profound message concerning human destiny. The icon, as a witness to divine beauty and wisdom, not only had no place in the new social order, but many believed it should not even exist.

The Bolsheviks, having set their sights on the construction of an earthly heaven that excludes God, planted throughout the land images of their own creation: their own sanctuaries, holy relics, ceremonies, and even their own calendar. Their arsenal of propaganda in support of their ideology borrowed from Orthodoxy: portraits of Communist leaders replaced icons of the Savior and the saints; the "red corner" in clubs or government buildings was an imitation of the Orthodox icon corner found in peasant dwellings or public places of worship; parades were designed in imitation of religious processions. Soviet authorities even attempted to replace the rite of baptism with a "ritual of the red star" (*zvezdiny*) for newborn infants (which fortunately never was embraced). And finally, a mausoleum was built on Red Square as the final resting place for the great leader of the proletariat. This ziggurat-like structure was to become in essence the primary holy place of the new Soviet religion.

In this contrived parallel world, authorities attempted to wipe out the memory of the historical past as well as the religious past of a rich, thousand-year history of Christian culture. During this time many churches were either destroyed or defaced, sometimes being reused as clubs, garages, barns, or granaries. Ancient icons were either burned or sent to the state warehouse and subsequently sold overseas. The icons that were allowed to exist were housed in museum exhibits where icons and other objects associated with religion (books, crosses, holy vessels, prayer beads, chains, and so on) were exhibited to demonstrate how workers had been exploited and how the uneducated masses had been fooled and manipulated by religion.

In scientific circles, scholars continued to study icons, and restoration work continued. But Soviet authorities inserted their control here as well, promoting the icon as nothing more than a cultural artifact of the long dead past, part of the archaeological record of medieval ignorance. There was a tacit

ban on certain ideas and phrases. Soviet scholarly works always referred to icons as being of Byzantine or Old Russian (as well as Balkan, Georgian, and so forth) origin, always omitting the phrase "Orthodox icons." Discussion of the theological meaning of icons was likewise forbidden—only analysis of an icon's form and historical roots was permitted. Even the phrase "contemporary icon" was taboo, unless a scholar was using it in reference to works by an avant-garde painter such as Malevich. Soviet ideologists were convinced that there was no place in a socialist society for ecclesial art, just as there was no place for the Church that had given rise to it. Indeed, it was expected that the latter, no longer supported by the forces of history, would soon vanish without a trace.

During the age of total ideological control, most creators of religious art met with a tragic fate. For some the price they paid was exile and forced emigration. Others abandoned icon painting and took up another craft. Not infrequently, they died of starvation. Still others were left to rot in the Soviet gulag. It is not for nothing that the icon has always been called a "window into another world." The closure of that window made it all the harder to catch a glimpse of the light from this other world—the light from the kingdom of heaven that inspires people to stand in the light and resist the darkness.

THE RUSSIAN EMIGRATION
AND ITS QUEST FOR THE ICONIC

he 1917 revolution marked a bloody watershed in Russian history. The Bolsheviks turned the country's history in a new direction and began building a new culture, while at the same time treating the country's old culture, and the bearers of that culture, in a ruthless fashion. Those who had no desire to participate in the construction of the new society were declared "enemies of the people," and at first were sent west, though later they were sent east and north to be "reeducated" in prison camps.

The last steamship sailed for the West in 1922. That ship has come to be known as the "philosophers' steamer," and for good reason, as it carried a number of Russia's most famous thinkers,[21] including Nicholas Berdyaev, Sergei Bulgakov, Semyon Frank, and similar "superfluous men," all of whom are now are numbered among Russia's finest intellectuals and are a source of national pride.[22] They were deprived of their native land, but not of their personal culture, because they were not only the bearers of culture but also creators of culture.

Even far from Russia's shores, they and thousands of such people continued to consider themselves Russians and held to the faith that their country would someday shake off the Communist night and become hospitable once again to normal life.

This tragic exodus held great significance for Russia itself. Banished from its native land, Russian culture not only did not die—it planted seeds in

foreign soil and brought forth new life. The most shining example of this can be found in the Parisian theological school that introduced the world to the enormously rich Orthodox theological tradition. These Russian immigrants who had been considered pariahs and rejected by their Soviet homeland made major contributions to Western theology, and they had an important influence on the development of twentieth-century Western theological thought. At the close of the century the legacy of the Russian emigration returned to Russia, where it helped resurrect the many traditions lost during the long years of Soviet rule. An analogy for such a feat might be the biblical story of Joseph and his many-colored coat. After having been sold to the Egyptians by his brothers, he returns in the end with honor and riches to his father's house, and to the brothers who had betrayed him, having brought great glory to Israel.

The names of the artists, writers, and poets of the Russian emigration are also now known throughout the world. They include Fyodor Shaliapin, Sergei Rachmaninov, Marc Chagall, and Ivan Bunin. Today their work is accepted as part of world culture. The iconographers in the Russian emigration are less known, but the fate of each of them is a testimony to the victory of the human spirit over the tragic twists of history.

The great iconographic tradition of Russia is like a river. And just as, in the case of some of Russia's actual rivers, the Bolsheviks wanted to reverse their natural flow, so too did they want to reverse the flow of this tradition. And once again they failed, because the river of iconography refused to be tamed. Instead, it divided itself into a multitude of smaller streams that continued a life-giving course while flowing sometimes into unexpected places.

In Soviet Russia the stream of tradition seeped deep underground and only much later came forth again to offer itself to a parched land. The greater part of Russian church life, especially during the years before World War II, transpired in conditions of the Underground. Throughout these same years, in the freer conditions outside of Russia, cultural creativity flowed in a continuation and development of tradition—including the iconographic tradition.

From our present vantage point we can see that the emigration was not just a tragedy for Russian culture but also its salvation; it helped preserve a great many of Russia's intellectual and spiritual treasures. Among these treasures the icon occupies a particularly important place.

Wherever Russians settled, churches followed, and then icons and frescoes and various church ornaments. Over time the emigration gave rise to a new tradition of church art. The small stream of iconography that emerged in Russian émigré circles in the 1920s and 1930s swelled by the end of the twentieth century into a whole new river of Russian iconography.

One of the first to begin reviving iconography in the difficult conditions of émigré life was Dmitry Semyonovich Stelletsky (1875–1947). He had gained renown as an artist while still living in Russia, where he had been a member of the Union of Russian Artists and the "World of Art" collectives. He did wood carving at the artist colonies set up on the Talashkino and Abramtseva estates. His sculptures were shown in international exhibits. He also sketched designs for stage scenery and costumes for productions at the Marinksky and Alexandrinsky theaters, and illustrated the epic poem *The Saga of the Host of Igor*. All his works demonstrate his orientation toward an authentic Old Russian style, with its decorative color scheme, expressive silhouettes, elongated figures, and flatness of the spatial plane.

Stelletsky was also a knowledgeable collector of Russian antiquities. He traveled regularly to the north of Russia where he studied ancient icons and frescoes. His dream was to create a new artistic movement founded on the traditions of medieval Russia, similar to what had already been accomplished by such illustrious Russian composers as Rimsky-Korsakov, Mussorgsky, and Borodin in the world of music. In 1910 the artist turned to painting frescoes in churches. Together with V.A. Komarovsky he painted two churches: Saint Sergius Radonezh at Kulikovo Field and Saints Constantine and Helena near Khvalinsky. The first of these churches still stands. The other, unfortunately, does not, and no icons remain from either.

Stelletsky left Russia prior to the First World War and in the wake of the revolution decided not to return. He settled in France where he devoted himself to church art. His icons can be found at the Church of Our Lady of the Sign in Paris, and in the Church of Saint Raphael and the Church of the Resurrection, both in Grenoble, among others. His icon entitled The Assembly of New Russian Martyrs Killed by the Godless Ones became the prototype for many subsequent works on this theme, which, sadly, gained ever-increasing relevance throughout the twentieth century.

Stelletsky did his most famous work at the Church of Saint Sergius in Paris, where he painted the iconostasis and the frescoes from 1925 to 1927. The Church of Saint Sergius was the spiritual center of the Russian emigration in Paris. It was here that Father Sergei Bulgakov served, along with other leading lights of Orthodoxy; and it was here that Mother Maria Skobtsova and Sister Joanna (Julia Reitlinger) were tonsured as monastics. Many philosophers, theologians, historians, and writers numbered among its parishioners, and many of these (including Nicholas Berdyaev and George Fedotov) were also teachers at the Saint Sergius Orthodox Theological Institute founded by Father Bulgakov. According to the accounts of contemporaries, the atmosphere was intellectually and spiritually profound as well as creative.

The story of the painting of Saint Sergius Church in Paris illustrates those early years of the emigration. Funds were needed before the church's icons and frescoes could be painted. But most Russians of what was called "the first wave" of immigrants to the West lived from hand to mouth, and the funds simply couldn't be raised—until, in almost miraculous fashion, the funds were provided. Mikhail Osorgin, the church's choirmaster, tells the story: "The main impediment to completion was the lack of money for painting the walls and the iconostasis, and this very circumstance, strange as it may seem, contributed to our success in getting Stelletsky. By chance I happened to learn that the Grand Duchess Maria Pavlovna owned a valuable emerald she had received from her aunt, the Grand Duchess Elizabeth Fyodorovna, who had asked her to use this stone for the beautification of one or another church. When I began suggesting that the grand duchess use this precious emerald for the beautification of our church, she answered that she was prepared to do so but only on condition that the work be done by Stelletsky and by no one else—if he agreed in principle to do the work she was prepared to chair the artistic committee to raise the remaining funds. Within two years she had managed to raise 400 thousand francs."

The Russian émigrés had been given a former Lutheran church building that needed many changes before it could be suitable for Orthodox liturgical services. Stelletsky's frescoes and icons transformed the place, turning it into a little island of Russia in the very heart of Paris. The Old Russian style from the seventeenth century, with its richly varied ornamentation, served as the

artist's main inspiration, helping him to produce a church that was at once elegant and flamboyant.

"I was struck by the beauty, the grandeur, and the profundity of the entire church," wrote N.A. Kulman from the Theological Institute in Paris. "Here the culture of Old Russian art and church life stares out at you from every corner. My memory was suddenly flooded with images of forgotten paintings from far-off Russia, from ancient sanctuaries in Novgorod, Yaroslavl, Moscow, and the Russian North. It was hard to believe that I am still here in Paris."[23] Likewise, L.A. Zander spoke of it as "the only church in the West that has successfully transplanted from far-off Russia the traditions of Ancient Rus'. The spirit of iconographic restraint and chasteness that one finds here is at once so pure and so rare, that we have every right to consider the Church of Saint Sergius one of the monumental achievements of our long Russian sojourn in distant lands."[24]

Not only in this instance, the contribution of Dmitry Stelletsky to the development of the Russian iconographic tradition is significant. His major works completed in the pre-war years are testaments to the first-wave Russian émigrés. Having been deprived of their native land, they continued to dream of returning to it and lived their lives in service to it.

Throughout the many years when, in the Soviet Union, internal conditions made icon painting simply impossible—churches were being shut down and demolished, and icons were being destroyed—iconographers in the diaspora continued not simply to survive but to develop the tradition still further despite the difficulties they faced, and the credit for this goes in large part to Stelletsky. Sergei Makovsky, a prominent émigré Russian art critic, wrote that Dmitry Stelletsky's "frescoes and icon painting in the Church of Saint Sergius in Paris are likely to become the single most significant creative work that Russia will inherit from the émigré world. . . . He managed, as it were, to sprinkle our ecclesial art with the magical 'water of life.'"[25] This achievement, Makovsky felt, was made all the more significant by the degraded status—but not disappearance—of iconography within the Soviet Union.

Makovsky also noted, however, that for a true renaissance of iconography to occur, "one artist or even several artists . . . is not enough—what we need is the inspiration of an entire age or epoch." In fact these new sources of inspiration were gradually gathering, little by little, led by different

masters of the art, and the majority of them were receiving their training as iconographers while living abroad under very new conditions. In this new atmosphere, women iconographers had begun working right alongside men.

The concept of a woman iconographer is a new one for Russian Orthodox culture, not having occurred before the twentieth century.[26] In Byzantium and in Old Russia icons were painted only by men, whereas women, by and large, were in charge of needlework. Whether they were nuns or laypeople, princesses or commoners, the task of women in the arts of the Church was to sew vestments, embroider shrouds and veils and similar items, and to make the fabrics from which clerical vestments were sewn. And because the creation of images was considered a form of theology, the designs and patterns for this work were likewise created by men. A woman's task was confined to execution.

Yet, in the exacting technique of embroidered icons, women were the acknowledged masters. The twentieth century did away with such traditionalism and stereotypes, bringing revolution to every aspect of life. During this revolutionary century women were often obliged to master professions that formerly had been practiced only by men. And women would master the techniques of iconography as well.

But if the delicate brushwork needed to make the miniature icons that were so popular in the early decades of the twentieth century was clearly commensurable in scale with women's needlework, this was not the case when it came to the monumental scale of church frescoes. For people of a traditional religious mind-set, such work was seen as entirely unsuited to the frailty of a woman's figure. All the same, there were women who showed clear gifts for working at precisely the monumental scale and who were easily able to take responsibility for the painting and beautification of an entire church. One such woman was Julia Nikolaevna Reitlinger, known as Sister Joanna, a bright star in the Russian diaspora whose fate exemplifies in miniature the paths trodden by Russia's Orthodox intelligentsia during the twentieth century.

Julia N. Reitlinger was born in St. Petersburg into an aristocratic family. Her father, the Baron Nikolai Reitlinger, held a high position in the court of the emperor. He was the descendent of an old German house of nobility and the son of a general. Her mother was from the Russian gentry family of

Gonetsky. Julia received an excellent education. When she showed a talent for drawing, she was placed in the school of the Society for the Advancement of Artists. In 1918 she first made the acquaintance of Father Sergei Bulgakov, who became her spiritual director. She followed him in 1924 to France. In Paris, she helped Bulgakov set up the Saint Sergius Orthodox Theology Institute and participated in the Russian Christian Student Movement. She entered the Orthodox-Anglican Community of Saints Sergius and Alban while continuing her icon painting and work on the adornment of churches. The tiny attic of the Church of Saint Sergius served as her atelier.

In 1934, Julia was tonsured a monastic, taking the name Joanna (in honor of John the Baptist). Although according to Orthodox tradition she should have been addressed from this point onward as Mother (*Matushka*) Joanna, everyone instead addressed her as Sister: with her short stature and slight build she appeared far younger than she was. Her slightness notwithstanding, she was endowed with an iron will and a burning desire to paint the interiors of churches.

Sister Joanna's interest in iconography began while she still lived in Russia, but she began working in ecclesial art only after emigrating, despite the many difficulties—now of an economic, not political, nature. She met the Russian icon painter Mikhail Katkov, who worked in what was called the traditional, or Old Believer, style of the region of Psov. Under his tutelage she mastered craft aspects.

In Paris she continued training under Old Believers, although in fact she found their approach unacceptable, even dead, based as it was on the exact copying of patterns. For a time she took lessons with Stelletsky, but she found his style too mannered and decorative. She herself sought something of greater simplicity and depth and for several years she visited the atelier of the well-known French painter Maurice Denis, who tried to create a new form of religious art. Yet his painterly approach didn't satisfy her either.

Sister Joanna was drawn to the canonical style of the ancient icon. And in the end she incorporated elements from all of her teachers into her own style. Having mastered the iconographic technique, she retained her painterly freedom; while observing the canon, she continued striving to create something new. Her approach combines traditional theology with artistic innovation and she called her approach "creative iconography."

In 1928 an exhibit was held in Munich of ancient Russian icons from the Soviet Union. It became a huge cultural sensation in Europe. Hearing of this, Sister Joanna traveled to Germany and spent several days at the exhibit copying icons. And it was this close contact with the Old Russian masterpieces that formed an important school for her.

Over the course of only a few years Sister Joanna became a master iconographer with a strongly developed personal style and a gift for monumentalism. She frescoed dozens of churches in France, England, and Czechoslovakia. Her frescoes in the Church of Saint John the Warrior, located in Meudon not far from Paris, are the most famous examples of her work (where she was assisted by Gregory Kroug, who later also became a famous iconographer).

Unfortunately, this church is no longer standing. After the war the priest who served there, Father Andrei Sergienko, returned to Russia; the parcel on which the church stood was sold, and the church was disassembled. By an odd twist of fate, however, Sister Joanna's icons did not perish along with the church. The parish in Meudon had been too poor to allow for frescoes painted on stucco, and so they were painted instead on large panels fastened to the walls. These panels were removed before the church was demolished and were preserved for many years by Nikita Struve, editor of the Parisian journal *News Bulletin of the Russian Christian Movement* (*Vestnik RXD*). A few years ago he bequeathed sections of the Meudon frescoes to the Center for Russia Abroad in Moscow, where they are on exhibit.

Sister Joanna's art created a special atmosphere, turning otherwise architecturally modest churches into spaces filled with light and spiritual joy. In her frescoes traditional iconography is combined with modern artistic approaches. Russian saints stand next to Western ones, and the worlds of Orthodoxy and Roman Catholicism—for so many centuries at odds with one other—come together fully in the world of art. Inasmuch as their main theme is the hymn of thanksgiving to the Creator, these icons may be called Eucharistic.

In similar fashion her icons of saints practically shine with paschal joy. Many of Sister Joanna's icons are kept and protected in churches and private homes throughout Europe. Father Bulgakov referred to her icons as "little candles," bringing warmth and light into people's homes from the world beyond.

Fr. Sergei Bulgakov's relationship with his spiritual daughter was a close and creative one. She had a serious interest in theology and they frequently engaged in long discussions on the most varied of themes, including icons. These discussions gave rise to Bulgakov's book, *The Icon and Its Veneration* (*Ikona i ikonopochitanie*), which remains one of the fundamental treatises on the theology of the icon.

For many émigrés, return to Russia was their fondest dream, but few ever returned. When on the eve of his death in 1944, Father Bulgakov said to Sister Joanna, "Return to your Motherland, Joanna, and joyfully take up your Cross. Listen carefully, Joanna: carry it with joy!" she began the process of returning, but it was only in 1955 that she finally received permission from the USSR to enter the country. Like many others, she was confident that the Soviet Union, after so long a time and emerging victorious from such a frightful war, must have changed in dramatic fashion. Surely new freedoms will have taken root. But freedom was still a long way off.

Upon her return, Sister Joanna was sent to live in the city of Tashkent in central Asia. Repatriates were prevented from living in either of Russia's capital cities (St. Petersburg and Moscow) or in cities close to those centers. Sister Joanna was now fifty-six years old and in poor health, but if she wanted to retire with a pension she would have to work. She spent several years in a factory painting scarves by hand. The hot climate, the contact with chemicals at work, and her impoverished living conditions all took a heavy toll on her already fragile health.

When she left France she had assumed that in the Soviet Union she would not be doing any more icon painting. She knew she was entering a land where atheism was the reigning ideology and where icons were banned. Nonetheless, after a long pause, she was urged to return to iconography by Elena Braslavskaya, a student of Brother Gregory Kroug with whom Sister Joanna had been friends in her Paris days.

Elena Yakovlevna Braslavskaya-Vedernikova had returned to her native land several years earlier. Her husband, Anatoly Vasilyevich Vedernikov, worked as a personal assistant to His Holiness Alexei I (Simansky), the Patriarch of the Russian Church. It was Elena and her husband who played a defining role in Sister Joanna's subsequent life and return to ecclesial art,

for whenever she came to visit Moscow from Tashkent she would stay in their apartment and, once again, paint icons.

And it was through the Vedernikov family that, in 1973, she made the acquaintance of Father Alexander Men, an Orthodox priest and a spiritual father to many as they lived under the pressures of the Soviet regime. The Vedernikovs were close friends with Father Men: Anatoly Vasilyevich regularly requested articles from the learned priest for the *Journal of the Moscow Patriarchate*, while Elena Yakovlevna gave the priest lessons in painting icons.

Soon Father Men became Sister Joanna's spiritual father. Even though he was half her age, she saw in him a continuation of the priestly tradition of pre-Soviet times, and she gave him the vestments that had belonged to Father Bulgakov in Paris, vestments she had brought with her and treasured as sacred relics. Indeed for both of them this gift was deeply symbolic: it restored a spiritual unity that had been painfully sundered, bringing into direct contact the two halves of Orthodox Russia—both the one being tested in the West and the one that was still somehow managing to survive under the Soviet regime.

In the Vedernikov apartment, with the renewal of her work in iconography among her friends and her spiritual mentor, Sister Joanna's iconography entered a new phase. Her works during this period of her life express a child-like naiveté and a surprising simplicity, even as they retain their theological depth and artistic expressiveness. Every sort of stylization, mannerism, or pretentiousness becomes alien to her. In a letter written during this period she sets forth her understanding of icons: "In our own day we have come to understand what they didn't understand back in the eighteenth and nineteenth centuries when they were painting over masterpieces from the fifteenth and other early centuries. Even so, everything that is very early and from the pre-Mongolian invasion period is more realistic than the works of Rublev, and for this reason, I believe, is closer to us—closer to our spiritual sensibility."[27]

After her retirement Sister Joanna moved to Moscow. Afflicted with progressive blindness added to the hearing disability she had suffered from early childhood, she bore these new challenges bravely and referred to her diseases as her "monastic robes." While her eyesight remained, she continued

painting icons and her very last icon, painted when she was nearly blind and of which she was particularly fond, was titled Christ Walks on the Water. It was titled as such, no doubt, because it expressed her attitude to life: walking on unstable surfaces where a single false step puts you in danger of drowning but continuing to be buoyed by faith.

Sister Joanna passed away in 1988, at the age of 90—the year Russia celebrated its thousand-year anniversary of the baptism of ancient Rus. A new age had now begun. The iron curtain dividing the sundered halves of Russian culture had fallen.

As is true of the work of many other Russian cultural figures forced to leave their native land, the works of Sister Joanna (Reitlinger) are gradually finding their way back to Russia. In 2000 in Moscow, the Andrei Rublev Museum of Old Russian Art organized the first exhibit ever held in Russia of her works. Most of the works exhibited had been painted after Sister Joanna's return to Russia, although the exhibit also included several icons painted while she was in emigration. The exhibit marked the discovery of the icon that had been born in exile.

While living in Paris Sister Joanna became friends with another nun whose name has become familiar to many around the world—Mother Maria Skobtsova. Her life's path was more tragic than that of Sister Joanna, but it also was intimately connected with artistic creativity, including the painting of icons. Indeed, Mother Maria's life cannot be understood except in the light of her creative work.

Mother Maria, born Elizaveta Yurievna Skobtsova (1891–1945), was firmly connected with Russian Silver Age culture. In the early years of the twentieth century, she participated in philosophy circles (*kruzhki*) and poetry groups in St. Petersburg. She was a friend of such luminaries as Alexander Blok and Anna Akhmatova, and she herself was a renowned poet, holding a prominent place in the list of leading cultural figures of the period.

Mother Maria was an excellent draftsman even in childhood, as can be seen from her drawings now kept at the Russian Museum. While she still lived in Russia, however, the life of an artist did not come to pass, and when fate tossed her into the maelstrom of émigré life in Paris, her approach to creativity was turned in a whole new direction. Despite the difficulties of daily life in Paris, Skobtsova continued to write poetry, plays, and theological

essays. She delivered lectures and was actively involved in a wide variety of groups devoted to cultural and spiritual matters.

Mother Maria was convinced that creativity, like prayer, counteracts the chaos that stands ever ready to engulf the human soul, and her new Parisian life was filled with artistic creativity. After organizing a new Orthodox parish in the heart of Paris, on Rue de Lourmel, she sewed vestments and shrouds, painted frescoes, made stained glass windows (after first learning the techniques used by the medieval masters), and painted icons.

Sofia Borisovna Pelenko, her mother, wrote about this burgeoning creative life. "It appears," she wrote, "that this building had formerly been a stable. There were feeding racks for the horses. When all this stuff had been removed Mother Maria realized that some paving stones out in the yard could be used to build the dais." Sofia Pelenko uses the rest of her long diary entry to detail an extensive collaboration between Maria Skobtsova and Sister Joanna (Julia Reitlinger) as they transform this stable into an Orthodox church. Sister Joanna drops off several icons of her own creation to be used for the iconostasis and the "royal doors." Mother Maria contributes an embroidered icon of the Last Supper, processional banners, covers for the icon table, vestments, and all sorts of smaller things, all of her own creation. One such vestment, "beautifully embroidered with depictions of all the feasts connected with the Mother of God . . . was a true work of art."[28]

The spirit of émigré life was not so distant from that of the early Christians, and there was not much difference between the architecture of the catacombs and the architecture of the garages, barns, and stables that the émigrés used for their churches. The Russians in Paris referred to these buildings as "barracks-churches." And yet, with the splendor of the liturgy and the icons, these barracks were transformed into "heaven on earth," even as the icons, holy vessels, and vestments were made from whatever materials could be found. Mother Maria valued this poverty. She felt that privation was a small price to pay for the unheard-of freedom that, finally, the Church was now experiencing. "Time has become the angel of the Apocalypse," she wrote. "It trumpets and calls out to every human soul. The accidental and the contingent get flushed away and the eternal root of life is laid bare. Each of us stands face-to-face with our doom. This doom reveals every vanity, and

also the fragility of our dreams and strivings. Everything is burned up. What remains is God alone, the human soul, and love."[29]

Not much of Mother Maria's creative output has survived; what remains, for the most part, is her needlework. One of these is a sewn icon of an angel (it is currently kept in the Parisian church of Holy Protection and Saint Seraphim of Sarov on Rue Lecourbe, to which it was transferred when the church on Rue de Lourmel was demolished). The Angel of the Book of Revelation is depicted holding an incense censer as if he were a deacon participating in a liturgical celebration in heaven. This image calls to mind Mikhail Vrubel's famous painting *Angel with Censer*, which is no coincidence, as Mother Maria was a product of the Russian modernist style just as was her contemporary Vrubel.

Another of her sewn icons is the Last Supper (now in a private collection in England), also executed in a modernist spirit. The central figures in this work are particularly moving, as we see Christ blessing the chalice and Saint John leaning his head against Christ's chest, with the deeper meaning of the Eucharist explored alongside the mystery of love conquering death.

Mother Maria's needlework pieces are faithful to the iconographic canons and traditions of Old Russian embroidery, but they are nonetheless filled with a wonderful spirit of creative freedom. According to those who witnessed her at the work of embroidery, Mother Maria sewed while hardly looking down and without prior preparatory drawings. Any technical limitations were outweighed by the artist's spontaneity and creative imagination.

Within the small body that remains of Mother Maria's works (now assembled at the Monastery of the Theotokos in Marcenat, France) we find her icon of Basil the Blessed, Mother Maria's beloved saint. Saint Basil lived during the reign of Ivan the Terrible and opposed the tyrannical tsar's abuse of power, openly rebuking the murderous tyrant when everyone else was silent. Maria's contemporaries found in this image a projection of present-day Soviet realities under Stalin's reign—as the Soviet propaganda machine worked to rehabilitate the image of Ivan the Terrible, portraying him as a great statesman. For many émigrés, however, the image of Basil, a holy fool rejected by the world even as he himself rejected the world of violence, represented human dignity incarnate. Mother Maria depicted Saint Basil almost naked and defenseless against the forces of this world, but strong in

spirit. As is traditional in icons, the saint is surrounded by small depictions of scenes from his life. But rather than placing them in neat, geometrical rows, as in a classical icon, they flow freely one into one another. The boundary between center and border has fallen, as if to suggest that all the borders that could protect this child of God have collapsed.

Mother Maria began her final embroidered icon in the Nazi death camp at Ravensbruck, where she was sent in 1944.[30] She was not allowed to complete it. As recalled by a fellow prisoner, Mother Maria said that if she finished her embroidery, she would make it out of the camp alive, but if not, then she would die there. The work was left uncompleted. On March 30, 1945, on Good Friday, Mother Maria was sent into a gas chamber. She had taken the place of a young woman, who survived. The day after Mother Maria's death, Ravensbruck was liberated by Soviet forces.

Mother Maria's prison embroidery was dedicated to the sufferings of Christ on the cross. What makes the imagery unusual is that it depicts Mary embracing the cross on which the one crucified is not Christ as a grown man, but the Christ child. We know of the image only from the descriptions of fellow prisoners, since the embroidered icon itself did not survive the war. The same motif, deeply symbolic, both in terms of the life of Mother Maria and the life of the Russian emigration as a whole, was taken up by several others, including Sister Joanna in a fresco, Sofia Raevskaya-Otsup in an icon, and finally by Elena Arzhakovskaya in an embroidered work.

In 2004, the Patriarchate of Constantinople canonized Mother Maria along with her son, Yuri Skobtsova, Father Dmitry Klepinin, and Ilya Fondaminsky, all of whom died at Buchenwald.

The fate of Christians during the twentieth century has been a remarkable one. Regardless of where they lived, whether in Russia or elsewhere, the durability of their faith has been tested. Mother Maria, after immigrating to France, accepted a martyr's death in Ravensbruck. The theologian and scientist Father Pavel Florensky, who rejected the path of emigration so as to share with his native land the path it had chosen, met with his own Golgotha in the Solovki prison camp. There are many similar examples, all bearing witness to the words of Mother Maria: "Christianity is either a fire—or it doesn't exist!"

Dmitry Stelletsky, Sister Joanna (Reitlinger), and Mother Maria (Skobtsova) were all artists of the pre-war generation of the Russian émigré world. Their names do not exhaust the list of Russian iconographers working outside Russia—and yet it was these three who built the foundation for subsequent developments in the émigré community's iconographic tradition. After the war, the circle of icon painters expanded significantly, and the most well-known iconographer of the postwar period is the monk Gregory Kroug.

George Ivanovich Kroug (1908–1969), whose monastic name was Gregory, was born in St. Petersburg into a Swedish Lutheran family. In 1921 he moved with his family to Estonia, where he completed the local *Gimnazium* (secondary school). He studied at art schools in Revel (Talinn) and Dorpat (Tartu)—and all expected of him a brilliant future as an artist.

At the age of nineteen he was baptized in the Orthodox Church, and this decision decided his fate. He moved to France in 1931 and continued his education there at the Parisian Académie des Beaux-Arts, where his teachers included the well-known Russian artists K. Somov, N. Miliotti, N. Goncharova, and M. Larionov. While in Paris he mixed in elite artistic circles, but gradually he became immersed in study of the icon and withdrew from purely secular art. He began studying with the Old Believers and assisted Sister Joanna in her painting of frescoes for the Church of Saint John the Warrior in Meudon. This marked the time when iconography became the focus of his artistic life.

Kroug did not adapt well to life as an émigré and with the onset of the war and the German occupation of Paris he fell into depression. He was placed in a psychiatric hospital, where he stayed until Father Sergei Shevich, his friend and spiritual father, rescued him and placed him in a monastery where he gradually regained his spiritual and physical strength. In 1948 Kroug was tonsured a monk, taking the name Gregory in memory of the iconographer Gregory Pechersky. He settled in the Hermitage of the Holy Spirit in the village of Le Mesnil Saint-Denis. He stayed there for twenty years, until his death in 1969.

Kroug was highly productive, and a large number of his works have survived. His most well-known work is the fresco in the Church of the Three Hierarchs in Paris (painted with L.A. Ouspensky); others include the

iconostasis for the churches of the Holy Spirit in Clamart and of the Holy Trinity in Vanves, a church in Noisy le Grand (where Mother Maria created her home for the elderly), the Monastery of Saint John the Forerunner in Maldon (Essex, England), and in churches in The Hague (Holland).

Kroug did his best work at the Hermitage of the Holy Spirit in Le Mesnil Saint-Denis. The church is not large and was fashioned from roughly cut stones. It has low vaults and in its simplicity is reminiscent of early Christian catacombs. The sanctuary is separated from the nave of the church by a rough screen, and the altar itself is covered in frescoes that fairly shine with light from another world. They seem almost to pierce through the denseness of matter to give us a glimpse into the realm of the spirit. Through these windows we see Christ, the Mother of God, and the saints shining in the rays of the uncreated light. At the center of the top row of the iconostasis is Christ Pantocrator ("ruler of all"), and to either side, as if ascending upward toward him, we find Mary the Mother of God, John the Baptist, archangels, and the apostles Peter and Paul. The four evangelists are depicted on the royal doors. Above the arc of the altar is a small composition, the Apostles Receiving the Eucharist. The iconostasis screens only half the opening to the altar and gives way to a view of an altarpiece depicting the Descent of the Holy Spirit onto the Apostles. The overriding theme of the church's frescoes is the transformation of humanity and the world through the actions of the Holy Spirit. Everything here is suffused with light—pictorially represented by a fine pattern of bright lines on the surfaces of clothing and other objects. This device brings to the fore an inner pulsation that fills an otherwise apparently static composition with movement, which is continued and intensified by the rhythms of the bodily silhouettes, halos, folds, and pleats. The painted surface is remarkably dynamic. Color has been applied lightly and flowingly. Gregory Kroug followed the accepted canons even as he made use of artistic devices that are close to avant-garde. He portrays traditional subjects but uses materials in a new and original way. We find nothing like this in the iconographic work of any other émigré artist.

Kroug's work always bears the imprint of experimentation. The boldness of his work is all the more surprising if one bears in mind the difficult environment in which he was painting, and his surrounding milieu, which was more inclined to conservatism than innovation. Inspired by the idea of

reviving the ancient iconographic art, his aim was never to simply copy the images of the old icons. This avoidance of imitation distinguishes him from other émigré iconographers. His experience of tradition and the canon was very much a living thing—something that touched his very core. That is why his images are so original, contemporary, and inimitable.

Gregory Kroug often experimented with his palette and, ignoring the usual techniques, made use of whatever materials happened to be at hand. Forever dissatisfied with his results, he rewrote his icons multiple times, painting right on top of the old lacquered surface. Acquaintances of Kroug say that he was tormented by his inability to fully convey the images over-flowing in his heart and soul.

Unfortunately, as a consequence of his experiments with technique, many of his works have reached us in a poorly preserved state. The colors have faded or darkened, the paint layer is cracking, and the foundation is crumbling. In the conditions of émigré life it was difficult to properly adhere to all the sequences and procedures recommended by the old iconographic recipes. And yet, even under different conditions it is doubtful that Kroug would have given greater importance to matters of technique. Brother Gregory wanted to paint his images of a heavenly world that lives without reference to earthly restrictions.

The images created by Gregory Kroug are bright, individual, and memorable. Behind the somewhat detached expressions on their faces we find traces of sorrow, nostalgia, even a certain dreaminess. In this respect, of course, they reflect the artist's own emotional relationship with the life of an émigré living in a foreign land. Having lost his own country, Gregory Kroug sought to show that man's soul is rooted not in this earth, but in the kingdom of heaven, our true native land.

Kroug felt particularly drawn to the great saintly hermits. He found their heroic feats of prayer and asceticism entirely understandable. Among the most original of his icons is his depiction of Saint Seraphim of Sarov, located in the church in Montgeron. The saint is depicted on his knees dressed in white sackcloth against a light background that symbolizes both his luminous milieu and the luminescence of his prayer.

Kroug was gifted both as an artist and as a theologian. He thought deeply about the meaning of every detail in his works, and each of his icons is an

original interpretation of Holy Scripture. He kept a record of his meditations in a notebook that was found in his monastery cell after he passed away. Its publication under the title *Thoughts on the Icon* caused a sensation; many of his reflections came as revelations even to experts in the theology of the icon. On the meaning of the icon called The Transfiguration of Our Lord, he wrote: "The top of Mount Tabor where the Savior brought his chosen disciples is overflowing with the Divine light and the ineffable glory of the Divinity. The icon dedicated to this feast is likewise filled with this over-flowing light. The entire surface of the icon becomes capable, as it were, of absorbing light; the very foundation of the icon speaks of light and is defined by it. . . . The Transfiguration of the Lord on Mount Tabor cannot be interpreted by us as a miracle that can be separated from the other events described in the New Testament: it is, instead, at once the path, the image and the zenith of the universal Transfiguration."

Kroug's works were enthusiastically received in the West, where he was called "a second Andrei Rublev" and "the last of the true iconographers." Gregory Kroug numbers among those artists who have created the future tradition of the icon; he had no doubt that the icon's future holds in store for us just as much greatness as does its past. In his notes he tells us "the veneration of icons by the Church is like a lantern whose light will never go out. It was not a human hand that first lit that lantern, and the light from it has never been extinguished. It will continue to burn, as it has in the past; but its flame is not motionless. . . . And even when all that is hostile to the icon strives to extinguish its light, covering it in a shroud of darkness, the lantern does not run dry and cannot run dry. And if, through loss of piety and devotion, the ability to paint icons should ever fade, even then the light will live on, ever ready to reappear in all its power to renew us through the victory of Christ's Transfiguration."[31]

The Russians who found themselves living in the West understood the need for a renewed understanding of not only the iconographic tradition, but of Orthodox Christianity as a whole. The Western world—whether Roman Catholic, Protestant, or atheist—represented a challenge to the firmness of their faith and their dedication to their traditional spiritual and cultural values. This challenge was answered in works written by the most distinguished of Russian émigré theologians: Father Sergei Bulgakov,

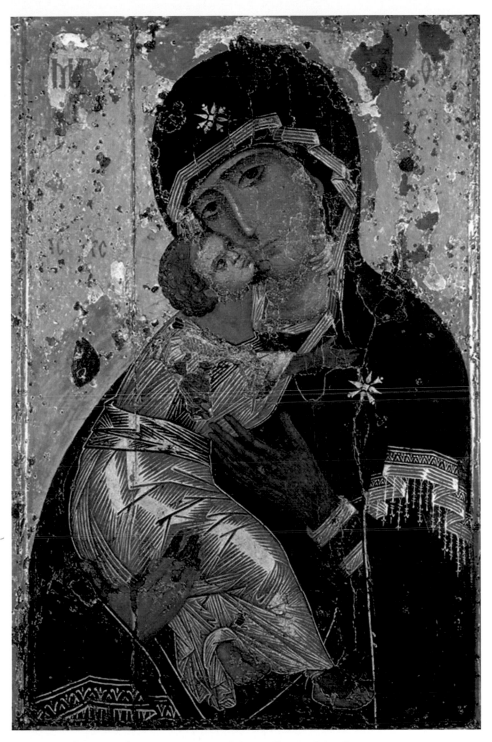

1. Attributed to St. Luke the Evangelist, *Vladimir Mother of God*, 12th c., Tretyakov Gallery, Moscow.

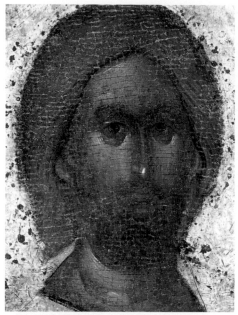

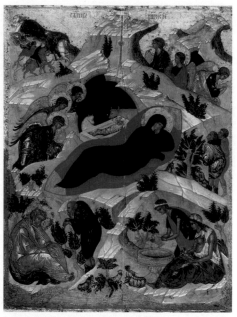

2. Theophanes (Theophan) the Greek, *The Saviour Among the Heavenly Powers* (detail), late 14th c., Church of the Annunciation, The Kremlin, Moscow.

3. Andrei Rublev, *Nativity of the Lord*, 15th c., Cathedral of the Annunciation, Moscow.

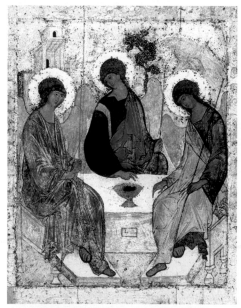

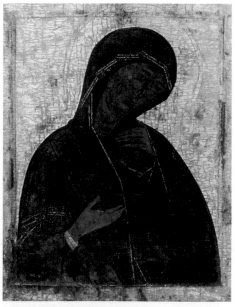

4. Andrei Rublev, *The Holy Trinity*, early 15th c., Tretyakov Gallery, Moscow.

5. *Deesis Mother of God*, circa 1550, Museum of Russian Icons, Clinton, Massachusetts.

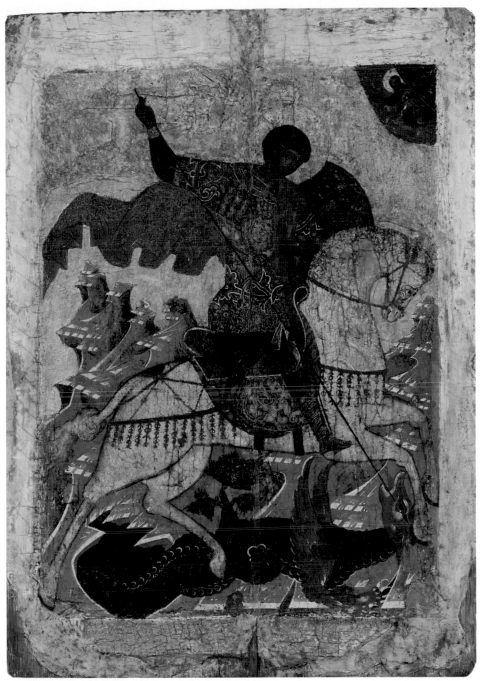

6. *St. George*, circa 1500, Museum of Russian Icons, Clinton, Massachusetts.

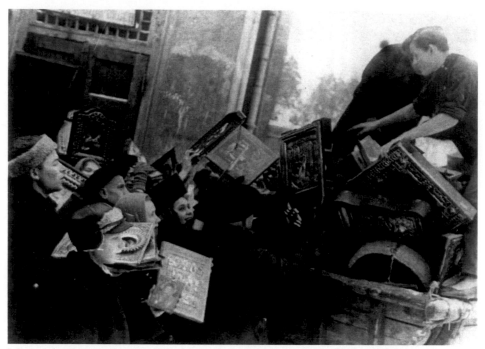

7. A group of atheists in the Bogorodsk district loading a farm cart with scores of icons which were later burned. Associated Press photo, March 5, 1950.

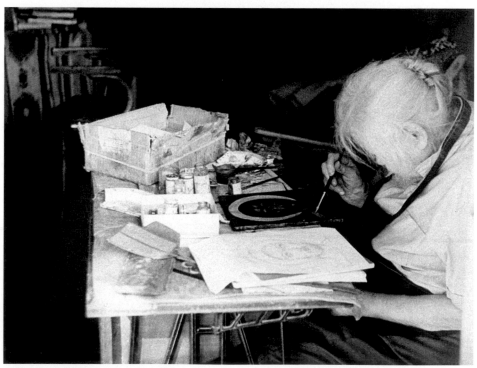

8. Sister Joanna Reitlinger at work, circa 1980.

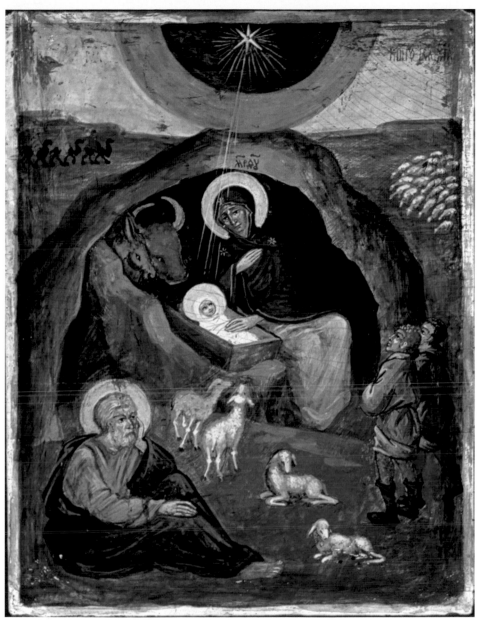

9. Sister Joanna Reitlinger, *Nativity*, mid-20th century, Monastery of the Protection of the Mother of God, Bussy.

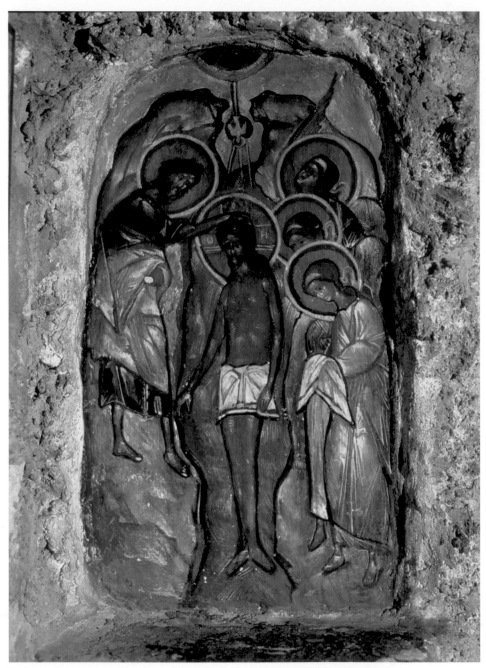

10. Gregory Kroug, *Theothany* (fresco), mid-20th century, Hermitage of the Holy Spirit, Le Mesnil Saint-Denis.

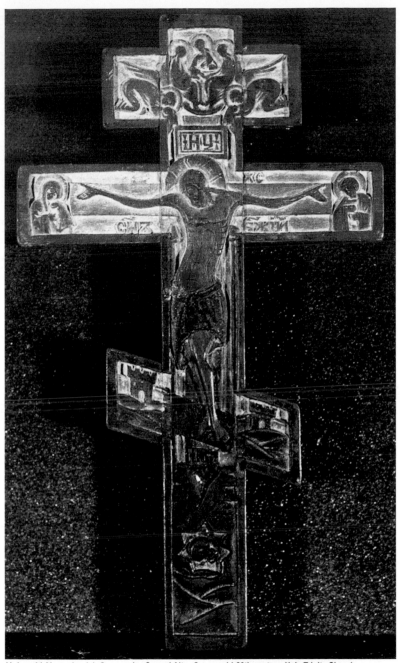

11. Leonid Alexandrovich Ouspensky, Carved Altar Cross, mid-20th century, Holy Trinity Church, Vanves (Paris).

12. Pavel Korin, *The Departure of Old Russia (Requiem),* sketch from a series of prepatory works created between 1935–1959, The Korin Museum, Moscow.

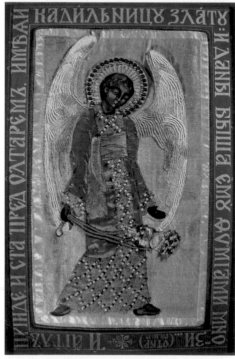

14. Mother Juliana (Maria Nikolaevna Sokolova) in the church archeological cabinet in Trinity-Saint Sergius Lavra, 1970s.

13. Mother Maria Skobtsova, *The Angel of the Book of Revelation* (embroidered icon) completed during World War II, Parish of St. Seraphim of Sarov, Paris.

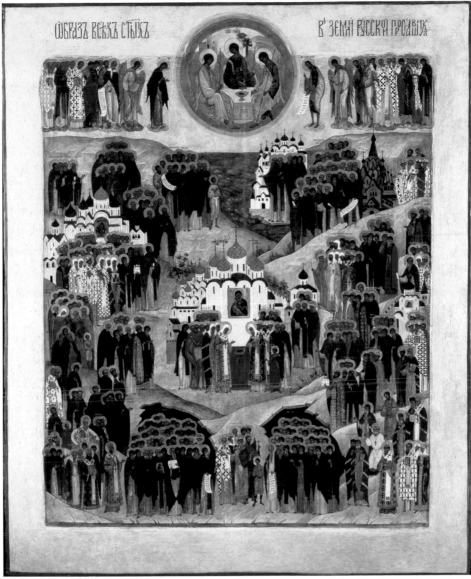

15. Mother Juliana (Maria Nikolaevna Sokolova), *The Assembly of Russian Saints Glorified on Russian Soil*, 1934. Private Collection of Afanasy (Sakharov), Bishop of Kovrovsky, Trinity-Saint Sergius Lavra, Sergiyev Posad.

16. Archimandrite (Vladimir Teodor) Zinon, Iconostasis. The Church of St. Sergius of Radonezh, 2004-2005, Semkhoz.

17. Archimandrite (Vladimir Teodor) Zinon, *St. Isaac the Syrian*, from an Iconostasis of fresco-icons, 1996, The Church of Stephan the First Martyr, Mirozhsky Monastery, Pskov.

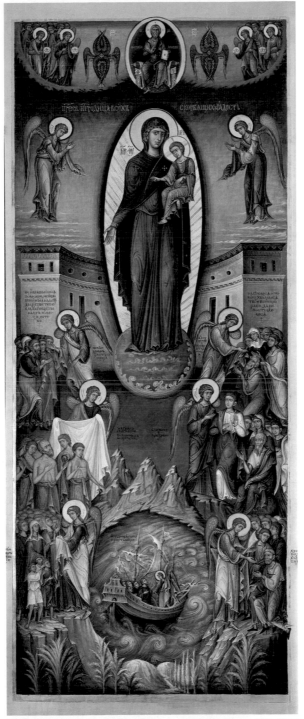

18. Alexander Lavdansky, *Mother of God Joy of All Who Sorrow*, 2007, Private
Collection.

19. Andrei Davydov, *St. Ignatius the God-Bearer,* 2004, Holy Nicholas Church, Suzdal.

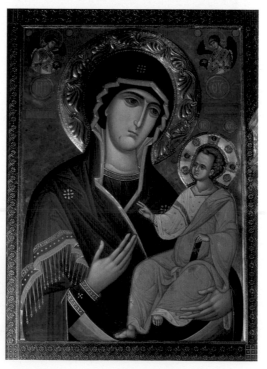

20. A. Alexei Vronsky, *The Iverskaya Theotokos,* 2003, Church of the Trinity, Khokhly, Moscow.

21. Alexander Sokolov, *The Resurrection of Christ,* 1997. From the iconostasis in the Church of the Icon of the Mother of God the Life-giving Spring, Tsaritsyno District, Moscow.

22. Olga Klodt, *The Holy Bishop Nicholas, the Miracle-Worker of Myra,* 2008, The Church of the Holy Trinity in Electrougli, Moscow Region.

23. Andrei Bubnov-Petrosian, *Christ Enthroned,* 2005. Church of the Nativity, Rybushka, Saratov Region.

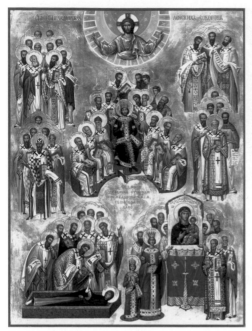

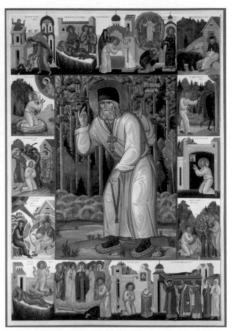

24. The studio at Novo-Tikhvinsky Monastery, *The Fathers of the Seven Ecumenical Councils*, 2005, Yekaterinburg.

25. Pavel Busalaev, *St. Seraphim of Sarov*, 2003, for the city of Sarov.

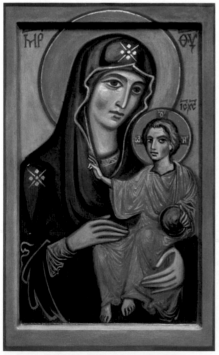

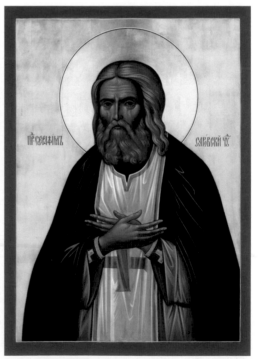

26. Ilya Kruchinin, *The Mother of God (Theotokos)*, 2008, Town of Mytishchi, Russia.

27. Father Andrei Erastov, *St. Seraphim of Sarov*, 1989, Holy Trinity Monastery, Jordanville, New York.

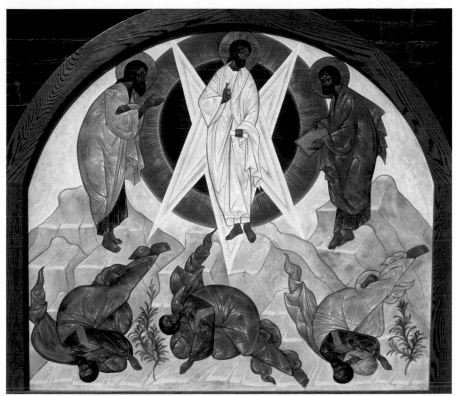

28. Fr. Andrew Tregubov, *Transfiguration* (wall panel), 2001, St. George Albanian Orthodox Church, Trumbull, Connecticut.

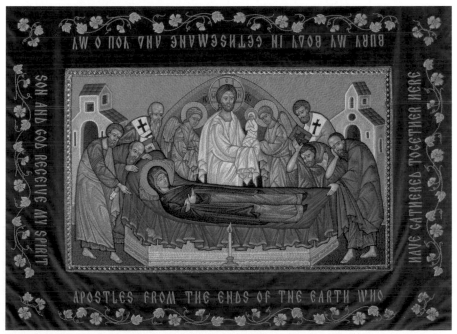

29. Mat. Galina Tregubov, *Shroud of the Dormition of the Theotokos*, 2004, Holy Dormition Orthodox Church, Cumberland, Rhode Island.

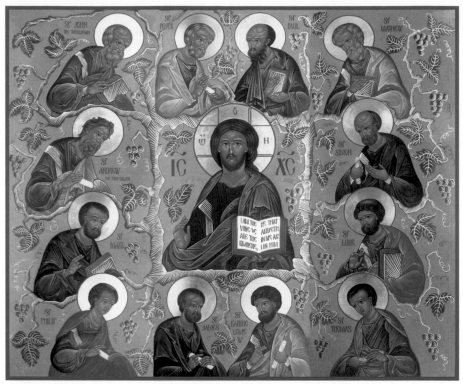

30. Ksenia Pokrovsky, *True Vine*, 2005, St. Andrew Antiochian Orthodox Church, Lexington, Kentucky.

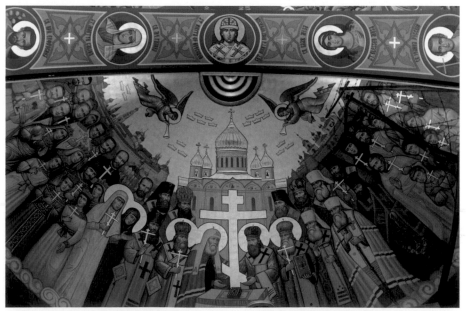

31. Alexander Chashkin, *New Martyrs of Russia* (wall painting), circa 1993, St. Nicholas Cathedral, Washington, DC. Wall painting includes members of the royal family (far left of cross), Patriarch Tikhon (near left of cross), and Grand Duchess Elizabeth Fydorovna (middle left of cross, in white).

Father George Florovsky, Father Vasily Zenkovsky, Semyon Frank, Nicholas Lossky, and, after the war, by Father Alexander Schmemann, Father John Meyendorff, Paul Evdokimov, Vladimir Lossky, Metropolitan Anthony (Bloom) of Sourozh, and others.

An illustrious school of iconographic studies also formed in the West, one that has left a major mark in the field. The works of Nikodim P. Kondakov, A.N. Grabar, P.P. Muratov, S.K. Makovsky, and N.L. Okunev have all made major contributions to scholarly understanding of icons and had an influence on the development of icons throughout the twentieth century.

Among those luminaries in iconographic studies was Leonid Alexandrovich Ouspensky (1902–1987), a friend and also a student of Kroug's. He became one of the most prominent scholars in the field of iconography and his *Theology of the Icon*, first published in Paris in 1960, was subsequently issued and reissued in Russia. Translated into ten languages, the text remains to this day the fundamental work in the theology of the icon.

It is symptomatic that such a fundamental study was undertaken outside of Russia. Inside Russia publication of such a book would have been impossible for ideological reasons. What is more, in the West, theological reflection was allowed to develop freely and in a manner more sensitive to the spiritual demands of the day. Thanks to Ouspensky, icon painting has been firmly established among iconographers as a branch of theology, and the canon as the foundation of iconography.

In *Theology of the Icon*, writes Ouspensky,

the Church sees . . . not simply one of the aspects of Orthodox teaching, but the expression of Orthodoxy in its totality, the expression of Orthodoxy as such. . . . Therefore, one can neither understand nor explain sacred art outside of the Church and its life. . . . The icon, as a sacred object, is one of the manifestations of the Holy Tradition of the Church, similar to the written and oral traditions. . . . [From this] it is clear that the meaning and content of the icon can only be a subject of theology, similar to the study of the Holy Scripture. . . . The Orthodox Church has always fought to defend its sacred art against secularization. Through the voice of its councils, its hierarchy, and

its faithful, it fought to retain the purity of the sacred image against the penetration of foreign elements characteristic of secular art. The Church has always fought not for the artistic quality of its art, but for its authenticity; not for its beauty, but for its truth.[32]

Leonid Ouspensky was himself a talented icon painter. His first experience painting the interior of a church was as an assistant to Gregory Kroug at the Church of the Three Hierarchs in Paris. Kroug's stylistic influence on his icons is apparent, even if they are very far from possessing the subtlety and virtuosity of those written by Kroug. On the other hand, Ouspensky's talent is more varied. He was a marvelous woodcarver, creating wooden crosses, icons, icon-cases, and iconostases; he also built molds for casting in copper and worked with other media. At the Russian cemetery of Sainte-Geneviève-des-Bois, many of the memorial crosses were made by Ouspensky.

Ouspensky was a talented teacher who was always surrounded by his students. Soon after World War II he began giving iconography lessons at the Saint Denys Theological Institute in Paris.[33] He continued teaching until the very last years of his life. His students included Orthodox Christians as well as adherents of other faiths, and a good number of them continue working till this day in a variety of countries—in France, Russia, Finland, Belgium, Egypt, America; on Mount Athos; and even in India.

During the 1980s he made several trips to Russia where he delivered lectures on icons, and his articles were printed in the *Journal of the Moscow Patriarchate*, the official publication of the Russian Orthodox Church. Ouspensky numbered among those who strived to demolish the barriers erected by Soviet ideology that separated Russians in Russia from those living in emigration. And for his efforts on behalf of the Russian Church, His Holiness Patriarch Pimen awarded Leonid Ouspensky the medallion of the Order of Saint Vladimir.

Each of the émigré masters of iconography described above developed his or her own individual style. Meanwhile, dozens of other, less illustrious iconographers did their work in a more stylized vein. Although it is difficult to lump them all into a single group, it is now commonly accepted to speak of a "Paris school" to describe the entire Russian iconographic tradition as it existed in Europe.

The Old Believers played a major role in the formation of this tradition. They were often the teachers of émigré artists, and they themselves painted many icons. The Old Believer style had already been valued by knowledgeable Russians prior to the revolution. They were known as strict followers of the iconographic canon who preserved the traditional techniques of painting, who abhorred innovation, and who used the works of the medieval masters as their models. Their iconography cultivates a peculiar style characterized by a fanciful and often exaggerated decorativeness that appealed to the contemporary art nouveau sensibility. In the pre-war period this style was prevalent, and Old Believers received many orders from both Orthodox parishes and private persons.

The most prominent representative of the Old Believer school was Pimen Maksimovich Sofronov (1898–1973), who studied under the famous Old Believer master G.E. Florov. Pimen Sofranov worked in Riga between 1928 and 1931 and taught iconography for a study circle called the Devotees of Old Russia. In 1931, already an acknowledged master, he moved to Paris where he began accepting students. In 1932 he taught courses in iconography under the auspices of the N.P. Kondakov Seminary in Prague and later headed an icon painting school in the Rakovitsky Monastery (1937–1939). Throughout the years 1939–1947 he lived and worked in Rome, where he created the iconostasis for the papal Oriental Institute (Russicum). After the war he relocated to the United States, where he continued working through the early 1970s, thereby facilitating the spread of the Russian icon tradition into the New World.

Pimen Sofronov's fate was happier than that of many Russian iconographers outside of Russia. No doubt this was providential: Sofronov trained a great many students, and these students helped spread the art of the icon throughout the world. He himself served as a bridge between the pre-war tradition and the world of the 1970s, between the Old World and the New.

Another among the Old Believers was Vladimir Pavlovich Ryabushinsky (1873–1955). The descendent of a famous Old Believer clan, he had already made a name for himself in Russia as a patron of the arts. In 1927 he founded the Icon Society in Paris with the goal of disseminating information about icons, helping iconographers find orders for their work, and helping parishes finance the adornment and frescoing of their churches. Ryabushinsky was

appointed president of the society (a position he held until 1951), with S.K. Makovsky as his deputy and P.P. Muratov as his secretary, both of whom were art historians of the highest order who also furthered the study and popularization of Russian icons.

Many of the leading lights in Russian culture, such as the artist Ivan Bilibin, the writer Boris Zaitsev, the architects A.A. Benoit, N.I. Istselenov, N.V. Glob, among others, belonged to the society. The Grand Duchess Ksenia Alexandrovna, Metropolitan Evlogy (Georgievsky), the academicians Mille and Breillet, and professors A.N. Grabar and N.L. Okunev were honorary members. Nearly every iconographer working in Paris at the time was a member, including Dmitry Stelletsky, Princess E.S. Lvova, Pimen Sofronov, V.V. Sergeev, P.A. Fedorov, G.B. Morozov, Sister Joanna (Reitlinger), Gregory Kroug, Leonid Ouspensky, and T.V. Elchaninova.

The Icon Society engaged in a great deal of educational work. They published books, scheduled lectures, and arranged art exhibits where traditional icons were exhibited along with paintings by contemporary masters. The society also provided material assistance for the construction of new churches, not just in France, but also in other countries where there were Russian Orthodox parishes. They also helped new iconographers get started by finding them commissions and apprenticeships with established artists.

One of the firstfruits of the society's efforts was the beautification of the Church of Saint Sergius in Paris, whose frescoes and icons were painted by Dmitry Stelletsky. Of almost equal artistic and social significance was another church built through the society's support, the Church of the Dormition located in the cemetery of Sainte-Geneviève-des-Bois. Designed by the architect Albert Benoit, its frescoes were also painted by Albert and Margarita Benoit. Parisians call Sainte-Genevieve-des-Bois the Russian cemetery not only because it has a Russian church, but also because so many famous Russians are buried there, including Ivan Bunin, Feodor Shalyapin, Father Sergei Bulgakov, Nicholas Berdyaev, Vladimir Lossky, and many others.

The dean of the society's atelier for many years was Peter Alexandrovich Fedorov (1878–1942), one of the leading iconographers of the Russian emigration and a unique and fascinating individual in his own right. He was born in Kronstadt, served in the military, fought in the Russo-Japanese War (1905)—for which he was decorated with the Order of Saint George—and

rose by the end of his service to the rank of vice-admiral. After emigrating he turned to iconography. His contemporaries considered him very nearly the most accomplished artist of his generation. His book *The Technique of Icon Painting*, published by the Icon Society in 1947, was popular.

Fedorov delivered lectures frequently, participated in exhibits, and was the head of an icon painting circle affiliated with the Russian Christian Student Movement. Many of his icons can still be viewed today in the iconostasis of the Dormition Church in Sainte-Geneviève-des-Bois, in the memorial church in Mourmelon-le-Grand (Albert Benoit, architect), and in the lower row of the iconostasis of the Church of Saint Seraphim of Sarov in Paris (N.V. Glob, architect), among other places. His icons are distinguished by their adherence to the iconographic canon even as they make use of certain art nouveau elements. Their warm, brightly decorative style and love of ornament coexists with a certain aloofness.

The society's band of iconographers received orders not only from Orthodox Christians, but also from Roman Catholic and even Protestant communities. Particularly close partnerships were formed with the Monastery of the Elevation of the Cross in Chevetogne, Belgium, and with the Jesuit Centre Saint George in Meudon, France. The beautification of both of these churches was carried out under the leadership of G.V. Morozov.

It was through the efforts of the Icon Society that many Westerners first became familiar with the Russian icon. Initially this interest was a matter for elite circles, but gradually it became much more of a popular phenomenon. Icons became fashionable. Suddenly antique shops were flooded with Old Russian icons (and also with fakes made to look old). Collectors placed orders with Russian iconographers, the great museums were eager to acquire icons, and the price at auctions of ecclesial objets d'art rose steeply. A Russian icon in one's home became a mark of respectability. Nonetheless, in parallel with all this popular interest, there also grew a deeper, more spiritual interest whose fruits became evident only toward the century's end, when the West began producing iconographers of its own.

The significance of the Russian diaspora has been enormous for Russia also. For seventy years Russians were divided by an iron curtain, and yet both Russias—the one that was imprisoned as well as the one that was exiled—were still participants in a single culture. The two sides lived as

if connected by an underground system of communicating vessels. On the one side, in the Soviet Union, the state worked decade after decade to systematically destroy the country's spiritual heritage. Meanwhile, on the other side of the iron curtain, this very same tradition was being gathered up and preserved so that one day it could return to a free Russia and inspire new generations to take up the tradition again. What is more, thanks to the iconographers of the Russian emigration, the icon broke free from narrow confessional boundaries. Icons are now considered part of the heritage of Christianity as a whole.

CHAPTER 5

Beauty Against Totalitarianism

Icons and Iconoclasm in the Soviet Union, 1920–1979

he year 1917 marked the opening of a new age in Russia, one with its own distinct values, standards, and heroes. The entire country was caught up in a paroxysm of revolutionary renewal, intent on building a new culture. Far from being oriented toward tradition and the inheritance of the past, now society ran headlong toward a future deemed "shining"—this new future that would stand in sharp contrast to the darkness of the past. The futuristic impulse was propelled forward by mass enthusiasm, and anyone who fell out of step, or glanced backward, or even stumbled during the headlong rush forward was branded an enemy of the people and dealt with ruthlessly. The spirit of struggle, no doubt, was the overarching leitmotif of this new Soviet culture.

In the early years the struggle against the Orthodox Church and its traditions was waged with particular cruelty. The Bolsheviks had declared their goal to be the construction of a shining future—and this future would have no room in it for God. The Bolsheviks were waging more than an ideological struggle with the Church: they sought to eliminate it physically by liquidating its clergy, monks, and laity.

Churches and monasteries were being destroyed and, still more terrible, being intentionally desecrated. Houses of worship and sacred places were turned into cattle yards, car repair shops, warehouses, movie houses, swimming pools, and prisons. And icons, ecclesial literature, chalices, and

vestments were either thrown onto bonfires or sold abroad for hard currency to help finance the Soviet authorities' quest to rebuild society. But while that shining future was still beckoning from the future, here in the present, war, famine, and destruction were the day-to-day reality.

To justify such a situation it was necessary to create a new religion, one with its own saints and martyrs—and also with enemies who could be blamed for all the deprivations and disasters. That religion was Communism, and it proclaimed the proletariat as the new messiah. Its main competitor for the hearts and minds of the people was the Christian Church, and for that reason it had to be destroyed. In 1922, the campaign to confiscate church property was meant to weaken the position of the Church still further. Priests were accused of refusing to give up the church's gold out of indifference to those who were hungry. Yet confiscated gold and other property was used not for meeting the needs of the hungry, but to equip the Red Army, fill party coffers, and line the pockets of the revolutionary elite.

Meanwhile, the Soviet authorities needed artists, and many were eager to serve. In the first years of the revolution many artists on the Left—futurists, cubists, abstractionists, Cezanne-enthusiasts—welcomed the revolution and rushed to join those constructing a new world. The signs and murals they enthusiastically painted in cities and villages were meant to hurry the arrival of the brilliant future.

But a clash between totalitarianism and the free spirit of art was inevitable, as seen by the story of Marc Chagall, who in 1918 was appointed commissar of the city of Vitebsk. By the time the first anniversary of the October Revolution came around, he had managed to plaster a good bit of the town with public art using his customary imagery. Wall posters, even the signs held aloft during political demonstrations, were decorated with winged cows, snow white angels, birds of paradise, and embracing lovers, all floating in the air. Chagall welcomed the revolution as a victory over everything dense, heavy, and imprisoning, including the very forces of gravity. He expressed his joy at this world of new possibilities by giving his subjects wings and using a palette of bright colors. The Bolsheviks, however, found that such art was not at all to their taste. As Chagall wrote years later in his autobiography *My Life*, "The bosses didn't understand why the cows were green, and why the horse was flying, and what all this had to do with Marx."

Chagall was removed and replaced as commissioner by Kazimir Malevich, who painted the town with squares and lines, but again "the bosses" weren't happy. Bolsheviks did not like avant-garde art as such; they found abstract art incomprehensible. Symbols and metaphors made them suspicious. And the artists themselves filled Bolsheviks with feelings of class hatred. In fact the Soviet leaders' tastes were both primitive and bourgeois. What they wanted from their artists were straightforward illustrations to accompany their agit-prop. They wanted ceremonial portraits of leaders and heroes; or, at the limit of their imaginative possibilities, pastoral landscapes of the motherland—but only if they depicted lush fields of grain ready for the harvest.

Very soon the artists, regardless of their stylistic allegiances, found themselves in a position of outright conflict with the authorities. Conflict between such unequal sides could bring only one outcome: total victory for the party line. By the end of the 1920s, out of the whole wide diversity of artistic groups that had sprung up during the fertile second decade of the twentieth century, only one ideologically approved group remained: the Association of Artists of Revolutionary Russia (AARR), which had evolved out of the earlier *peredvizhnik* tradition. This same group eventually served as the basis for the Union of Artists of the USSR, the Communist Party–controlled body that managed all the arts during the Soviet period.

Henceforth all art would have to obey the law of the dictatorship of the proletariat and strictly follow the party line. There would be only one permissible style of Soviet art—socialist realism. All other styles were considered counter-revolutionary and were punished with the full severity of Soviet law.

Iconographers of Russia's Requiem

While secular artists had been given an entire decade to make up their minds both politically and artistically, iconographers were not afforded the luxury of time. The Soviet system declared war on them immediately. Many were forced to renounce their calling altogether. Mikhail Nesterov (1862–1942), for example, whose fondest dream prior to the revolution had been to create a new style of art for the Church, after the revolution had to confine

himself to portrait painting. Nonetheless, he refused to violate his sense of artistic truth. In no hurry to avail the Soviet authorities of his talent, he steered clear of such politically correct subjects as Communist Party bosses and other "heroes and heroines" duly designated by the authorities.

Deprived of the opportunity to paint portraits of saints, he began painting the faces of people of cultural and intellectual achievement, people filled with an inspiration that he saw as also rooted in the spiritual realm, the realm of the Holy Spirit. During the 1930s, Nesterov painted portraits of the physiologist Ivan Pavlov; the surgeon Sergei Yudin; the brothers Korin, who were both painters; and the sculptor Vera Mukhin, among others. Although deprived of his dream to paint icons, he still managed through these "secular" works to give viewers a glimpse of divine light.

Among his students were Pavel Korin (1892–1967), who helped him paint the Saints Martha and Maria Convent. Korin was born in the village of Palekh (itself an ancient center of iconography) to a family of iconographers. Together with his brother he studied iconography in the village's ateliers. But his artistic temperament was not satisfied with the handicraft approach to art that was the fashion in Palekh at this time. He left for Moscow, where he continued his studies, and it was here that he made the acquaintance of Mikhail Nesterov, already a famous artist. His work alongside the master while painting the Holy Protection Cathedral at the Martha and Maria Convent served as an entire education in itself. And even as Korin dreamed of working for the Church, the revolution turned his plans upside down.

In fact, the first and only independent iconographic work done by Pavel Korin was his painting of the lower crypt of the Holy Protection Cathedral, which took place in 1915. Here he sought to surpass his teacher by devising a new iconographic language. But he too foundered, unable, like Nesterov, to overcome his roots in the modernist aesthetic. He styled his paintings after the icons of Novgorod, with bright colors, elongated bodies, and a smooth application of paint. Furthermore, his lettering is in the Old Russian alphabet and the ornament is suitably decorative. And yet he never reached that same harmony and quiet present in the icons and frescoes of medieval Russia. Even so, his approach to ecclesial art with such an innovative spirit deserves credit.

Korin experienced the events of 1917 as a personal tragedy. He attempted to prevent the destruction of churches and rescued icons by pulling them from the flames of burning churches. He studied and restored damaged icons and assembled an impressive collection of medieval Russian art, now kept in the P.D. Korin Museum, a wing of the Tretyakov Gallery of Art.

Too much of an artist, however, to be satisfied by the role of collector and restorer, Korin yearned for a chance to paint something new. In the 1930s Pavel Korin was given the opportunity to decorate the Moscow Metro rapid transit stations. Here he resurrected the ancient art of the mosaic for his work. And the sketches for the metro borrow extensively from the entire arsenal of medieval Russian art, with some images even taken from iconography (for example, the Icon of the Savior Not-Made-by-Hands, also known as the Icon of the Holy Face, on the banner of Alexander Nevsky).

Yet preceding that work was an earlier inspiration for Korin for a painting that would serve as a sort of iconic record of the persecuted Church. It was 1925. Moscow had just witnessed the burial of Patriarch Tikhon, who had been chosen as patriarch at the momentous All-Russia Council of the Russian Orthodox Church held in 1917, and who had served as the spiritual leader of Russia throughout all the horrors of the early revolutionary years. The patriarch implored the Russian people to not turn on their brothers during the civil war. He comforted the aggrieved, assisted the needy, prayed for the fallen, and gave hope to the survivors—and encouraged others to do the same. Patriarch Tikhon was a good pastor to the entire nation, and the people of Russia responded by returning his goodness with their sincere love. For this reason the Bolsheviks hated him, putting him under house arrest. When an attempt to assassinate him failed, they persecuted him to the point of causing his death by heart attack. Patriarch Tikhon died while under house arrest in the Donskoy Monastery.

Hearing of his death, all of Christian Russia came to bid him farewell. And here Korin witnessed a sight as unique as it was powerful. All the roads to Moscow, and all the streets leading to Donskoy Monastery, suddenly filled with a seemingly endless stream of humanity. Monks, priests, peasants, city-dwellers, the poor, the crippled—night and day they silently walked toward the monastery to pay their respects. They flowed like a river after a storm. Members of the intelligentsia also came—writers, composers, artists,

scientists—everyone capable of recognizing the significance of what had just happened came to pay their respects to the last twentieth-century Church hierarch who had the strength to spiritually resist the militantly antagonistic Soviet state. The Russia that Korin was now witnessing, in the aftermath of the revolution and the ever-widening purges, had seemingly vanished into the past and would never return.

In response, Korin envisioned a grandiose canvas that he intended to call "Requiem." But his friend, the writer Maxim Gorky, suggested a different name, "The Departure of Old Russia," which became the title of this ultimately unfinished work. For forty years Korin labored on the painting, never completing it. Many preparatory sketches, however, were completed, and they provide a gallery of portraits, many of them great works of art that easily stand on their own. They portray not only Church leaders but also those pillars of Russian culture who—seemingly—were departing Russian history forever.

Among the sketches, one that provides a sense of the intended whole depicts the interior of Dormition Cathedral in the Moscow Kremlin. Against the background of the iconostasis and frescoes stand monks of various ranks, priests, bishops, and patriarchs. The artist's composition provides a balanced distribution of a large number of people, including portraits of the artist's heroes. The separate preparatory portraits indicate Korin's careful research and study of each personality among the main protagonists, even though some had posed for no more than two hours. Staring at these faces, the viewer cannot but feel the tragic intensity of this historic period, its apocalyptic mood.

Among those portrayed are Proto-deacon Ivan Kholmogorov; the Abbess Famar (Mardzhanova), an aristocrat both by blood and by spiritual temperament; the starets Aleksei Zosimovskii; the mystic and seer Metropolitan Trifon (Turkestanov); the philosopher and theologian Sergius (Stragorodsky) who was later to become patriarch; the young and devoted hieromonk Pimen who would also later become patriarch of the Russian Church. Among the many faces represented, each is distinctive, brilliant— and most met with a difficult or tragic fate.

In these works Korin showed himself both a great portraitist and a worthy student of Nesterov—as well as an heir to the iconic tradition. His

portraits extend beyond realism, the faces gaze at us as if already dwelling in eternity.

Korin's goal was to give each face an iconic dignity, even as the individuals presented here were by no means all saints, nor did he present them in idealized form. In their faces he wished to capture the inner spirit of the age and a generalized portrait of the Church as it experienced a descent into a reality that only the darkest prophecies had ever imagined. Even though incomplete, the sketches are fragments of a unified whole and form quintessential icons of their age.

One of the heroes of Korin's uncompleted painting was Bishop Trifon Dmitrovsky. In the painting he stands in the foreground wearing red vestments, looking bent but not spiritually broken. Bishop Trifon authored a liturgical hymn, an *akathist*, titled "Glory Be to God for All Things." During the years of Stalin's purges, the appearance of this poetic work bore witness to the internal strength of a Russian Church that was about to offer the world many new martyrs and confessors.

There were times, during the years of the Soviet regime, that the faithful were unable to attend holy liturgy. With local churches closed, and priests arrested or killed, and other local priests turned informants, parishioners were soon obliged to gather in their own homes, as the early Christians once had done, to pray. And one of the most beloved forms of home prayer was the akathist, a genre of Church hymnography in which the prayer is given a poetic form consisting of twelve parts, each of which is accompanied by a refrain of "Rejoice" or "Glory Be to You."

Throughout its long history the Orthodox Church has created many beautiful akathists that are outstanding examples of hymnography and sources of comfort for the faithful during difficult times. The twentieth century demonstrated that even during a period of harsh persecution the Church was capable not only of preserving its heritage, but of continuing and extending it.

Discovered hidden among the articles of Father Grigory Petrov, a priest who had been arrested and subsequently perished in Stalin's gulag during the 1940s, was the text of the akathist "Glory Be to God for All Things." For many years he was mistakenly taken as the author of the hymn, but its author was in fact Metropolitan Trifon Dmitrovsky (Turkestanov), who wrote it in the 1920s or the early 1930s.

Prior to his ordination to the priesthood, Bishop Trifon had been Prince Boris Petrovich Turkestanov, an aristocrat whose father was from the prominent Georgian family of the Turkestanov (Turkeshvili) line and whose mother was from the Naryshkin family (of Russian boyars). He was a striking individual. Gifted in many areas, well educated, he was the spiritual leader of Russia's intelligentsia. He provided pastoral care to many persons of high rank, including the Grand Duchess Elizabeth Fyodorovna, but was equally loved by ordinary folks. He acquired the nickname "Bishop Early Bird" because he served an early morning liturgy, providing working people the chance to go to Mass before work.

It was through his influence that Korin was able to create the gallery of images in his "Departure of Old Russia" cycle. As soon as he understood the significance of Korin's concept, Trifon not only posed for the artist himself, but he also gave his blessing to many others—priests, abbots, monks—to go to the artist's studio on Arbat Street. In an era permeated by fear and mistrust, such a thing was unthinkable. But Bishop Trifon was among the few who proved capable of standing strong during that a time that gave every appearance of being the end of the world, comforting many who suffered personal tragedy.

Characteristically, it was during this tragic period during the great purges that he composed a work of light and optimism, filled with gratitude to the Creator for the gift of life. Perhaps coming from a desire to support and encourage his spiritual children, he wrote the akathist hymn whose main message rang out: "The storms of this world do not frighten those in whose heart shines the light of Your fire. Where there is Christ, there is warmth and peace."

A portion of Bishop Trifon's now-famous akathist hymn "Praise Be to God for Everything" follows:

Glory to Thee, Who transfigures lives through works of mercy;
Glory to Thee, Whose every precept is inscribed with unutterable sweetness;
Glory to Thee, Who abides wherever there is kindness and charity;
Glory to Thee, Who brings us failure and sorrow, that we may gain
 sympathy for those who suffer;
Glory to Thee, Who makes of goodness its own reward;

Glory to Thee, Who welcomes every noble gesture;
Glory to Thee, Who has elevated love beyond all else in heaven or on earth.
Glory to Thee, O God, unto all ages.

To this day this akathist is read in Russian homes and churches. During such a dark time, the appearance of this prayer strikes some as an improbable miracle, but it is no less a miracle that the art of iconography managed to survive at a time when the persecution of the Church was gathering force with every passing year.

⚜

In the Soviet government's war against the Christian religion we are also witnessing the birth of a new religion, and soon Soviet leaders began to claim their own "holy sites" as centers of "worship" for official doctrine. Such sites were often raised on the ruins of demolished churches. And one such site of the new religion was planned for the spot where the Church of Christ the Savior had stood in Moscow.

The Church of Christ the Savior had been conceived as a memorial to soldiers fallen during the Napoleonic War of 1812. At the war's close Emperor Alexander I announced a design competition for the memorial church at the same time as he initiated a national campaign to raise the needed funds. The architect Alexander Vitberg submitted the winning drawing. His design called for a grandiose structure with three separate levels. The lower level would contain the burial vault for the fallen heroes; the second level structure would be for memorials and public gatherings; and finally on the third level would be the church proper for serving the divine liturgy. His design further specified that the building would be decorated with a great many columns. An enormous dome crowning the whole would symbolize the harmonious structure of the cosmos.

The site selected for the project was the Sparrow Hill section of Moscow, a spot affording impressive views of the entire city. (Today it is the site of the Moscow State University.) The author Anton Chekhov would later write, "He who would understand Russia must view Moscow from this site."

The foundation for the structure had already been built when all construction work suddenly ground to a halt. Emperor Alexander I had died and his brother, Nicholas I, immediately took his place on the throne. Nicholas did not share his brother's liberal views. Vitberg was accused of embezzling and wasting funds and was exiled to the provinces.

A new competition was announced and this time the winner was Konstantine Ton, a court architect entirely to the emperor's taste. The worldview of Tsar Nicholas I, as famously expressed by Sergei Uvarov, his minister of culture, could be summarized in just three words: orthodoxy, autocracy, and nationality (*Narodnost*). The church was built in a Byzantine-Russian style with elements of classicism. The church's cubic form is crowned with the traditional array of five cupolas while the façade is decorated with sculptural relief.

Given a new location on the banks of the Moscow River, the church stood not far from the Kremlin. Centuries earlier this district had been called Chertolye (in Old Russian *cherta* meant border, and this area originally marked the border of the city).

As noted in chapter 2, this was also the site of an ancient convent, which in the middle of the nineteenth century had been demolished to make room for the enormous new Church of Christ the Savior. The reader will recall that the convent's Mother Superior had pronounced an ominous curse on the site ("May this place be made barren!") as she was dragged away by tsarist soldiers, a curse that was fulfilled in 1931 by the Soviet government. The site indeed remained "barren" for seventy years.

It was on exactly this site that the Bolsheviks intended to erect a worthy monument of their own. On June 18, 1931, the newspaper *Izvestiia* published a notice announcing the construction of the Palace of Soviets on the site of Christ the Savior. The architect Boris Iofan headed the design team. His plan called for the new structure to be topped with a statue of Lenin 50 meters (164 feet) high. Later, in the final draft of the construction drawings, the statue was planned for 100 meters (328 feet). Even without the statue, the building itself came to the considerable height of 340 meters (1,115 feet).

Soviet newspapers announced that the palace would be "the largest architectural structure ever built in the entire course of human history and

stand as a living testimony to the victories of socialism that were gained during the battles of the Great October Revolution, a victory that will lead mankind to the shining future of communism."[34] The Palace of Soviets was to be the tallest building in the world, and the statue of Lenin, the world's tallest statue, rising to twice the height of the Statue of Liberty (46 meters, or 151 feet).

V. Mikoshey, the Russian cinematographer, documented the demolition of the Church of Christ the Savior. The film is truly tragic to watch: the broken crown of the dome, shorn of its gold veneer, and with its cross bent to one side, tumbles downward like the head of a giant until the enormous bell strikes against the ground, and even though the film is silent, the viewer has the impression of hearing its final peal. Enormous stone blocks, each of them numbered, lie scattered on the ground next to sculptures with cables stretched across their necks. There are fractured marble tablets bearing the names of heroes of the Napoleonic War of 1812. In the film, we sense we are witnessing a disaster of cosmic proportions, the death of an entire world. But even in its broken and defiled state, the church remains beautiful and majestic.

Construction of the Palace of Soviets began in 1937, the very year that Stalin's great purges reached their chilling zenith. All the same, fate pulled the rug out from under this grandiose building, preventing it from ever dominating this holy spot. By 1939, the structural steel and masonry had been completed for the foundation of the main tower, the main entrance, and the northern exposure. In 1941, however, the Second World War began and all the nation's resources were redirected in support of the nation's military needs. The whole structure, which had only just barely risen above street level, had to be disassembled.

When the Donbas coal region in the Ukraine was occupied, the steel beams in the Palace of Soviets were removed to build bridges and railroad tracks so that the central parts of the country could be supplied with coal. After the war, the concept of building the Palace of Soviets was rekindled, but the design competition held in 1957–1959 failed to produce viable results. By 1960 all design work came to an end. That same year the former site of Christ the Savior Church was remodeled and renamed the Moscow Swimming Pool.

Just thirty years later, in the early 1990s, after the fall of the iron curtain, the decision to rebuild the Church of Christ the Savior was made. Reconstruction of the church in a form close to the original took only five years (1995–2000).

Today a controversy has arisen over the aesthetic value of the Church of Christ the Savior and whether it was wise to rebuild it in its present form. After all, the present structure resembles the original only in broad outline. Zurab Tsereteli's copper sculptures on the church's façade, which have replaced works in white stone by Loganovsky and other nineteenth-century sculptors, have attracted sharp criticism. But even greater controversy has surrounded the interior frescoes, which were executed in an academic style that most iconographers today consider unacceptable in ecclesial art.

What is more, whereas the earlier works decorating the church's interior were painted by the greatest masters of Russia's Academy of Arts—Briullov, Bruni, Repin, Makovsky, and Surikov, among others—the new frescoes were painted by artists of lesser stature who copied the old motifs, even as a number of them are entirely noncanonical (for example, the image of God the Father in the cupola, which, according to the traditional canon, is never to be rendered).

The state of ecclesial art in the nineteenth century, prior to the discovery of the icon, was far from ideal; thought was not given to the iconographic canon. Today, at a time when the Church is striving to revive not simply the past, but the best of past tradition, recreation of this sort of art appears unnatural.

In 1931, when the church was dynamited, its frescoes were destroyed, and most assumed that the iconostasis perished as well. During the pre-restoration research, however, several interesting facts were unearthed. Several fragments of the original iconostasis were discovered in the Vernadsky Geological Museum: these included black marble columns that had separated the icons, as well as columns with capitals made of light blue-gray marble that demarcated the area for the *kliros* (used by the choir). Here were original fragments of the structure. Yet the icons themselves had been sent out of Russia for destinations unknown, until further research revealed they had been taken to the United States. According to one version, they were presented by Stalin as a gift to Eleanor Roosevelt. She, in turn, sold them at

auction where they were purchased by the Vatican, which supposedly still holds them in its vaults. This story is just one among many and has never been confirmed.

When the Church of Christ the Savior was rebuilt in the 1990s, the iconostasis was recreated based on sketches and a few remaining photographs. The original had taken the form of a *ciborium* (a free-standing chapel) topped with a roof made of gilded bronze. The form of this ciborium can be traced to medieval canopies used to cover the altar and traditionally made of wood. In this instance, however, it had been made of marble inlaid with colored marble and gold flecks.

In describing this work of reconstruction we have gotten ahead of our story of the Soviet period. Let us return, then, to Soviet Russia of the 1920s and 1930s. Despite the growing persecutions against the Church, and the destruction of churches like Christ the Savior, there were still those who stubbornly engaged in ecclesial art. That such persons were few makes it all the more meaningful to know their names and stories. The first is Vladimir Komarovsky, an iconographer and scholar who began painting icons before the revolution. After the revolution, he stalwartly refused to make peace with the new atheist regime.

Born into an aristocratic family in St. Petersburg, Vladimir A. Komarovsky (1883–1937) studied at the Academy of Arts and then continued his education in France and Italy. He married Varvara Fyodorovna Samarina, a descendent of the famous Slavophile F.V. Samarin. In the early part of his career he concentrated on decorative arts such as woodcarving and embroidery and participated in the "New Society" art exhibits. His fascination with icons began after seeing an icon exhibit organized in 1910 by his friend P.I. Neradovsky, who worked at the Russian Museum.

This fascination matured into a profound and deep-rooted interest that continued throughout his life. Initially Komarovsky became involved in icon restoration work at the Russian Museum, but once he had mastered the technique, he began painting icons of his own. From 1911 to 1913 he painted icons and frescoes for churches together with Dmitry Stelletsky, whom he had already befriended through the New Society. Together they created a three-level iconostasis for the Church of Constantine and Helen near Kvalynsk, on the Volga River. The church, which was constructed in

the neo-Russian style, was destroyed during the Soviet years, its icons disappearing without a trace.

Komarovsky and Stelletsky painted icons also for the Church of Saint Sergius of Radonezh on Kulikovo Field. Built in the neo-Russian style, this beautiful church still stands to this day with only one icon remaining from the original iconostasis—Saint George the Victorious (painted by Stelletsky). All the others have been lost. While Komarovsky was involved in several other projects prior to the revolution, no ecclesial art remains of these.

After the revolution, Komarovsky taught drawing in a school and painted portraits on commission. I.A. Olsfuev invited him to join the Committee for the Protection of Monuments, organized a few years after the revolution. Employment there gave Komarovsky the chance to be in close contact with masterpieces of ancient iconography. And among his projects, Komarovsky was asked to produce copies of the icons in the Trinity-Saint Sergius Lavra (Monastery).

Komarovsky's aristocratic class background, together with the nature of his work, struck the Bolsheviks as suspicious. On several occasions they arrested him but each time released him due to lack of evidence. Possibly protected by the fact that he was working for the Committee for the Protection of Monuments, which, in the persons of academician I.E. Grabar and the Minister of Culture A.V. Lunacharsky, enjoyed patronage at the highest levels of Soviet power. Each time he was released from prison Komarovsky would immediately take up his brushes and return to the work of painting icons. In 1928, after returning once again from exile, he accepted a commission from the Church of Saint Sophia to paint the church's interior. This church was just a stone's throw from the Moscow Kremlin, seat of the Soviet government. Komarovsky had no shortage of courage.

From his work of this period his icon of the Vladimir Theotokos survives, which was painted in the 1930s for the cemetery church in Peredelkino. The church was disassembled during the war and this icon was acquired by a local resident. Now it is preserved by the Danilov Monastery in Moscow.

During his last year Komarovsky lived in the town of Vereya outside of Moscow. He was receiving fewer and fewer commissions, as the state's pressure on the Church and the faithful grew fiercer. In 1937, Komarovsky

was once again arrested and imprisoned "without the right to engage in correspondence." This phrasing was well known to signify a death sentence. Nonetheless, it was several years later that his family learned that Vasily Alekseevich Komarovsky had been shot before a firing squad in Butovo. He was buried in a mass grave at the same site.

In 1930, Komarovsky had written a letter to Father Mechev, a priest at the Church of Saint Nicholas in Kelnniki, a church with an active parish life and close community in Moscow. This letter serves as a remarkable record of the period in which it was written, proving that at a time when the very thought of iconography was potentially hazardous, there were nonetheless some who were already thinking about the icon's future, who were meditating on the content and meaning of the icon, and who had faith that the tradition would one day be restored.

"A different time is coming," wrote Komarovsky, "and people are feeling the need for, and in fact are already striving for direct contact with the True Likeness and Prototype. The medieval icon appears before us as a comprehensible form of beauty, fully conveying the spirit of the Church. We dream of creating an art that returns us to the true prototype; it is an art we have been deprived of."[35]

As a creative man, Komarovsky realized that simply copying the old models could not bring about the restoration of the icon. He wrote,

> An icon painted in full accordance with the accepted iconographic techniques, even if executed in good taste, will still create an impression that is opposite to the one intended unless the iconographer understands the rules and techniques of iconography in a creative spirit. If this creative element is missing, the icon will scatter and disturb the soul rather than gathering and focusing it. However much an icon may resemble a medieval icon painted in the high style, it will still be false, and the more the icon's individual elements are imitative of the ancient model, the falser it will be. All this is dishonest. It is the result of a superficial approach to the old icons and bespeaks a failure to ascend to the Prototype. . . . One has to have a creative gift if one wants the medieval icon to serve as a doorway to the Prototype. Native talent and good taste are entirely insufficient.

So what is to be done? Maybe it is best not to paint icons at all? No, I think that too would be a mistake. The craft side of iconography is also important and useful, so long as no one fools himself into thinking that this suffices to make true icons. Making good copies of ancient icons is already a great achievement, because in them we find a level of taste and artistic genius that far transcends what today's craftsmen are capable of. It takes a genuine artist to make a good copy that does not feel counterfeit. But in order to prepare the way for creative iconography, we need something entirely different—we need to become aware of the laws of plastic art—since the art of iconography, in essence, belongs to that category. It is practically impossible to teach someone the forms of this art: one can only become aware of them on one's own, but at least it is possible to know them. We are in an impossible position, it seems! Of course, what we are aiming at is in any case little short of a miracle. Whatever effort we make in the right direction is always both valuable and necessary. But ersatz iconography that gives only the illusion of high style good taste is hypocritical and harmful. Let the icon be mediocre, but honest! At the same time, of course, we cannot cease striving for perfection of form, just as we cannot cease striving for contact with the True Likeness."[36]

As an experienced master of the iconographic art, Komarovsky immediately took special notice of the work of Maria Sokolova, one of several iconographers affiliated with the parish of Saint Nicholas in Klenniki. Maria was a young woman who had just recently begun to paint icons. "You've got a whole collection of ancient icons on Maroseika Street, and you've also attracted some experienced iconographers," wrote Komarovsky in a note to Father Sergei Mechev. "You've managed to instill in your parishioners a keen interest in the task of 'praising God through faces.' The best results so far have been achieved by M.N.S. [Maria Nikolaevna Sokolova]. Not only has she beautifully mastered the technical side of iconography, she is also trying to do something more than make copies. She has already entered the realm of free composition. This in itself is quite an achievement, and, of course it is also the expression of a living need."

Komarovsky's insight was borne out in her work and life, as Maria Sokolova became one of the true master iconographers. She was fated to serve as a bridge between the prerevolutionary tradition of ecclesial art and the new generation of iconographers beginning their work and studies at the end of the twentieth century. In the years before World War II she was perhaps the only person remaining in the country still painting icons; and in the postwar years, it was the small circle of artists that formed around her that began the slow process of reviving the great art of iconography in Russia.

The Artist of Iconography's Rebirth

Maria Nikolaevna Sokolova (1899–1981) was born in Moscow to a family with deep roots in the Church. Her father, Nikolai Aleksandrovich Sokolov, was dean of Ascension Church in Goncharnaya Sloboda (Potter's Quarter, a district in Moscow) on Taganka Street. He himself came from a long line of priests, as did Maria's mother, Lidiya Petrovna. And Anna Nikolaevna, her maternal grandmother, was also connected to the Church: having lost both her parents early, she had been raised by Metropolitan Filaret (Drozdov). Maria Sokolova continued that meaningful connection to the Church, studying in Women's Gymnasium No. 5, a school administered by the devout Empress Maria Fyodorovna and considered one of the finest in Moscow.

With artistic talent evident from a very young age, Maria drew well already at three. It was her father, an amateur artist, who gave Maria Sokolova her first painting and drawing lessons. In his spare time Father Nikolai enjoyed painting oil landscapes and making copies of works by Vasnetsov. Maria Sokolova completed her studies at the gymnasium on the eve of the 1917 revolution, after which she was offered a position teaching drawing in a school. When the young teacher was told to deliver a lecture preaching atheism to her young charges—a perfectly normal event in a Soviet school—Maria refused. She was immediately fired.

She began to seek new work when, unexpectedly, she got the chance to continue her artistic education. She was accepted as an apprentice in the private studio of F.I. Rerberg and A.P. Khotulev. Upon completing the apprenticeship she received a graphic design diploma. Diploma in hand,

she was able to secure a job with a publishing house, a position which, by the standards of the time, paid well.

Earlier, when Maria Sokolova was only twelve years old, her much-beloved father passed away. It was a tragic loss for her, but she found a spiritual father in the person of Father Aleksy Mechev. They forged a deep relation grounded in complete mutual trust. Father Aleksy Mechev (1859–1923), friend and confidant to Komarovsky, was a famous Moscow elder to whom people streamed from all over Russia for spiritual advice. The Church of Saint Nicholas in Klenniki, where Father Aleksy served, became Maria Sokolova's second home.

When in 1923 Father Aleksy's earthly path came to an end, his son Father Sergei, who had inherited his father's gift for spiritual ministry, took over as dean of the church. Father Sergei (1892–1941) collected icons and was something of an expert on ancient icons. He also knew many iconographers and icon restorers. Despite all the hardships of those years, he managed to recruit a number of the best artists and specialists of his time to restore the lower church. He gave his blessing to Maria to begin studying icon painting and introduced her to the famous iconographer and conservator Vasily Kirikov. Years later, Kirikov praised Maria as his most talented and faithful student, holding her work in high esteem. Maria absorbed Kirikov's teachings and went on to become a tutor for many beginning iconographers.

The 1920s and 1930s were a time of mass arrests and executions (the Red Terror). With churches being demolished and defiled, monasteries disbanded, there was every reason to fear for the continued existence of the Church. Meanwhile, ranks of the clergy were being decimated by mass arrests and the Renovationist schism, and the authorities were waging a campaign of antireligious propaganda in every corner of the country. Not the best time, one would think, to be painting icons.

And yet, in the midst of this orgy of destruction, one young woman artist was thinking only of preserving this precious jewel forged within the womb of the Church over the course of many centuries; thinking of passing on to future generations the spiritual experience encapsulated in this inheritance from ages past. From 1928 to 1929, Maria made numerous trips within Russia to make copies of medieval frescoes. Her travels took her to the ancient cities: Novgorod, Pskov, Yaroslavl, Vologda, and also to

the Ferapontov Monastery complex, among others. It is difficult to even imagine the courage, at the very height of the Soviet state's antireligious campaigns, of this woman visiting shuttered churches and monasteries and openly demonstrating an interest in this "ideologically alien art." But when she saw her country in a state of moral and physical collapse, Maria Sokolova viewed it as her duty, and she made it her personal mission.

Making copies of ancient artifacts is an excellent way to retain a tradition. First of all, cultural gems may end up simply physically disappearing (as indeed often happened during this period). Second, the very process of producing a copy gives the artist the opportunity to fully enter into the tradition, entering into the process that originally produced it. In later years Maria Sokolova noted, "By a process that is almost automatic, making a copy of an icon allows the painter to enter deeply into the multifaceted world inside an icon. One gradually begins to get a feel for the reality of its world, and to recognize the truthfulness of its content. You are struck by the precision of its forms, the inner justification of its details and the genuinely sacred simplicity of its overall artistic expression. But to arrive at an awareness of all this takes time, and often more than a little time at that."[37]

During this period Maria Sokolova was working on a copy of the famous Vladimir Theotokos icon. It was before this very icon—honored as miracle-working by many—that the Russian people have prayed during times of national calamity. It was before this image that Metropolitans of the Russian Church were selected and monarchs crowned. This was also the icon that had blessed the ancient cities of Old Russia—Kiev, Vladimir, and Moscow. For the young artist, making a copy of this icon was no studio exercise: it was an ardent act of prayer to the Intercessor of the Russian land for its spiritual regeneration.

At the same time Maria had more than copying on her mind. Her desire had always been to create new icons. As a person formed by the Church, she knew that, so long as the Orthodox Church exists, there would always be a need for icons. She longed for the walls of churches to be decorated with highly artistic icons exemplifying the highest traditions of the medieval masters. In the early decades of the twentieth century, the styles of Vasnetsov, the Mount Athos school, and Palekh were considered by many to be the very definition of good taste. But Maria preferred the less sentimental

icons of the medieval period, and in particular those by Rublev, Dionisius, and the Moscow school of the fifteenth and sixteenth centuries. Fortunately, in this respect she was not entirely alone. The small circle of icon painters still working at the time included several other lovers of ancient icons.

The apotheosis of antireligious propaganda, and indeed the persecution of any and all independent thought whatsoever, was reached during the 1930s. The government's antireligious five-year plan was accompanied by a promise from the authorities to finally put an end to the Church.

An offensive was launched against Christian believers. In 1934, the Church of Saint Nicholas in Klenniki was closed, its community dispersed. Father Sergei Mechev was sent into exile where he suffered a martyr's death. At the urging of Father Mechev, Maria Sokolova became spiritual mother to the many orphaned parishioners who remained, and who were now forced into an underground, catacomb-like existence. They gathered in private homes to pray, to read together the Scriptures and the lives of saints, and to help each other in the task of day-to-day survival. Throughout these changes, Sokolova continued to paint. Although it was all but impossible to paint inside churches, she painted for friends. For the most part these were small icons: images of Christ, the Mother of God, and patron saints.

In 1934 she made the acquaintance of Afanasy (Sakharov), Bishop of Kovrovsky, who commissioned her to paint what was to become one of her most famous icons—The Council of All Russian Saints.

Bishop Afanasy (1887–1962) was a leading figure in the Church of his day. Educated and broad-minded, in him a penetrating mind was joined by an equally profound spiritual insight. He was arrested by the authorities on eleven separate occasions, spending in the end thirty years of his life in prison camps or exile. And yet, through it all he never lost his faith, his strength of character, or even his sense of humor. The following incident is characteristic of all three. In 1935, when the Moscow Metro opened, many among the Christian faithful were convinced that they should not use the trains, feeling that it would be tantamount to descending into the underworld—into Hades. Others refused to use the Metro for fear that the tunnels would collapse. Bishop Afanasy, taking his "All Saints" icon, hid it in the hollow of his coat and then rode with it from the beginning station to the end of the line. "Don't be afraid," Bishop Afanasy subsequently exclaimed.

"I've blessed the Moscow Metro." After this, most people lost their fear of the Metro.

Afanasy put together a liturgy for the Feast of All Saints and delivered a talk on the theme during the All-Russia Council of the Orthodox Church of 1917–1918, which was when this holy day was officially entered into the church calendar. Even before the Council he had been searching for an iconographer able to paint the icon associated with the new feast, but he couldn't find an artist capable of fulfilling his vision for the work. Almost twenty years after the council, upon meeting Maria Sokolova, Bishop Afanasy realized that he had found the iconographer capable of understanding and implementing his concept.

Sokolova and Bishop Afanasy maintained a close friendship for many years, until his death in 1962. Afanasy was well versed in liturgics, hagiography, and hagiology, and he was intent on creating an illustrated calendar of patron saints. He asked Sokolova to provide model illustrations to help future iconographers discern the unique features of each saint. Afanasy commissioned many icons from Sokolova, including the icon called The Gathering of All Saints of the City of Vladimir, which he dedicated to the 800-year anniversary of the founding of that ancient Russian city.

The Feast of All Russian Saints is celebrated during the second week after Pentecost. The hierarchs of the Russian Orthodox Church introduced this new holy day so as to bolster the faith of the Russian people during the years of trial already looming on the horizon in 1917. And indeed this new religious feast did acquire great significance for Christian believers in Russia. The day Hitler's armies invaded the Soviet Union in 1941 (known as the start of the Great Patriotic War) coincides with the Feast of All Russian Saints. A great many Russians saw in this fact a mystical sign. The words of the popular song, "The war we are fighting is a people's war—a holy war" came about as in the popular consciousness this war truly did acquire a sacred character; many believed that the Russian saints were fighting for their native land.

The victory that arrived four years later was likewise connected with the intercession of Russian saints. The day Berlin capitulated came just two days after the feast of Saint George the Conqueror (May 6), the patron saint of Russian Field Marshall Georgii Zhukov. And during the war itself,

mention of the Church became not merely permissible, but indeed a matter of great public significance. Russians were sure to notice the symbolism in Stalin's new choice of vocabulary. No longer did he address his compatriots as "comrades"; instead, he appealed to them as "my brothers and sisters"—borrowing from the pastoral language used by the Orthodox Church.

The idea of the saints' intercessory protection of Russia is very clearly expressed in the All Russian Saints icon. The icon's composition has provided the model for many later icons on the same theme, including those painted over the years by Maria herself, as well as by her students and other iconographers. The top row of the icon is a kind of deesis—the images of the saints worshiping the Trinity. This symbolizes the universal church triumphant in heaven and is represented in the icon by the Mother of God, John the Baptist, the apostles, and the church fathers.

The main field of the icon resembles a map of Russia, presenting a sort of mystical topography of the Russian land. At the top the land mass opens to the White Sea on the shores of which can be seen the Solovetsky Monastery, together with the saints that were glorified on the Solovetsky islands. In the icon's lower field can be seen caves symbolizing the southernmost boundaries of Russia and reminding us of the saints glorified in the Kiev-Pechersky monastery and caves. Between these two symbolically depicted boundaries we find groups of saints and churches representing the lands and princedoms of ancient Rus', including those of Vladimir, Rostov, Yaroslavl, and Novogorod.

In the center of the icon we find Russia's exquisite palladium, the Vladimir Mother of God icon, placed against the background of the Dormition Cathedral, popularly known as the Home of the Most Holy Mother of God. Alongside the cathedral we find an icon stand with a Bible and hierarchs of the Church holding a prayer service for the salvation of Russia. Sokolova's icon is bright and festive and creates a mood of spiritual unity. It is a hymn to Russian holiness.

In 1939 Maria Sokolova moved from Moscow to the village of Semkhoz not far from Zagorsk (as the town of Sergiyev Posad was renamed during the Soviet era), a settlement not far from the Trinity-Saint Sergius Lavra (monastery)—an institution that Maria remained connected with for the second half of her life. At this point, however, this ancient monastery

complex founded by Saint Sergius of Radonezh was closed; its once magnificent churches had fallen into the "abomination of desolation," and there was nothing to suggest that it would one day come back to life.

During the height of the war, under pressure of circumstances, Stalin reversed his policy toward the Church. In 1943 he gave an order releasing all bishops from exile to participate in a council of the Orthodox Church, which concluded by restoring the patriarchate. Although after this the Church had an easier time, freedom was still a long way off. Nonetheless, for the time being, churches were allowed to reopen throughout the country.

In 1946 the Trinity-Saint Sergius Lavra was returned to the Church. After twenty years of neglect and decay the monastery was in a pitiful state. The churches were knee-deep in muck, and two of them—Pokrovsky and the Refectory Church—had been turned into amusement halls. Garbage was strewn everywhere and the walls and towers were crumbling, in some places already collapsing. By order of the central government a commission was established to restore the entire monastery. Maria Sokolova was invited to participate in the restoration of its artwork.

Maria, along with a group of assistants (young artists and restorers), quickly went to work. With the blessings of His Holiness Patriarch Aleksy I (Simansky), and through the good graces of Abbot Pimen (Izvekov), who would later become patriarch, two side-chapels in honor of Saint Seraphim of Sarov and Saint Joseph Belgorodsky were added to the Refectory Church, with Maria painting the icons for the two chapels.

In the main church she supervised the cleaning and restoration of a medieval painting. The porch of the Dormition Church was repaired. The iconostasis in the Church of Saint John the Baptist and the frescoes in the Church of the Virgin of Smolensk were restored. The frescoes decorating a chapel called Serapion's Tent were painted according to her sketches. Maria also painted the icons for the reliquary and ciborium over the relics of Saint Nikon, the hagiographic icons of Saint Sergius, and also the icons of his followers. She also painted icons for the iconostasis of the Pokrovsky Academic Church and a great many other icons for churches throughout the Lavra and for the monastery's sacristy.

Maria was particularly attracted during this period by the style of Dionisius, in whose work medieval Russian iconography reached its apogee.

The subtle brushwork characteristic of Maria Sokolova traces directly to his influence. This can be seen, for example, in her icon The Appearance of the Most Holy Theotokos to Saint Sergius, painted in the early 1950s. Her inspiration here clearly came from the icon The Life of Saint Sergius, attributed to the school of Dionisius; but more precisely, her inspiration came from scenes depicting the saint's life as painted along this icon's border. Not satisfied merely to copy, however, Maria adds much that is new and uniquely her own.

Greatly indebted to Father Alipy (Voronov, 1914–1975), abbot of the Pskov-Pechersky Monastery, Maria sought his advice on matters pertaining to iconography. Like Archbishop Sergius, he had begun as a monk at the Trinity-Saint Sergius Lavra, but in 1959 he was sent to work on the restoration of the Pskov-Pechersky Monastery, which had been severely damaged during the war.

Known for her work, Maria Sokolova was respected by the leading hierarchs of the Russian Orthodox Church, including patriarchs Aleksy I and Pimen. Both were experts in ecclesial art, and both commissioned icons from Maria, as did bishops, clerics, and various members of the laity.

In 1952, His Eminence Gurii, Bishop of Tashkent, asked Maria to create icons for the iconostasis of the Church of Saint Sergius in Fergana (Uzbekistan). It was Bishop Gurii who had reopened the Trinity Lavra, and indeed he and Maria Sokolova had together taken on the main burden of the restoration work there during the difficult early years. When Bishop Gurii was transferred to the cathedral see of Tashkent, he took on the task of restoring and adorning the local churches. The icons Maria painted for him were done in the style of the medieval iconostasis located in the Lavra's Trinity Church. Given the great distance separating Moscow and Fergana, and the difficulties of delivery, it was decided that the icons should be painted on canvas and rolled up into bolts to be then taken to Central Asia. This also made it easier to avoid run-ins with the authorities, who might have noticed a bulkier wooden icon and have forbidden its delivery to Tashkent. It simply became a matter of two diminutive women traveling with small bundles, which upon arrival they proceeded to unroll and mount on the iconostasis.

Suddenly, the whole church was transformed. Maria had very painstakingly created icons in the style of Andrei Rublev. The whole parish rejoiced

at this new addition to their church. The church's pastor, Father Boris Kholchev—a spiritual son of Father Aleksy Mechev and also well acquainted with Maria—had been assigned to the church by Bishop Gurii. Father Boris endeavored to create here the same close-knit spirit of community that had existed at Father Mechev's church of Saint Nicholas in Moscow.

The repressive political atmosphere created by the Soviet state had proven unequal to the heroism of individual Christians. And so, within these scattered spiritual oases, the life of the Church continued to flicker and glow.

During subsequent years Maria Sokolova's work continued, and in 1952–1953, she painted icons for the Church of Ilya Obydenny in Moscow. With the help of several women students she managed to produce seventeen large icons and twelve smaller images for the royal doors of two iconostases. This church provides concrete testimony to the stubborn persistence of the spiritual life. Even during the harshest years of Stalin's purges, people continued coming here to pray. Memorial and funeral services were held here for victims of the gulag, just as people also prayed here for those still languishing in prison or exile.

Against a background of seemingly limitless terror, despair, and distrust, the Church of Ilya Obydenny was an island of spiritual warmth, a place where one's heart could again be filled with hope. This was a church that also was beloved of Moscow's intelligentsia. After Father Mechev's church of Saint Nicholas on Maroseika Street was shuttered, many members of his parish started attending Ilya Obydenny.

Vital to her prayer life, Russian saints were also a central theme of Sokolova's artistic life. Her icon The Assembly (*Sobor*) of Russian Saints Glorified on Russian Soil was painted initially in the 1930s, and she painted several versions of this icon throughout her creative life. Indeed, she created an entire gallery of images of Russian saints and their sobors (councils or assemblies), among them The Sobor of Saints from the City of Vladimir, The Sobor of Yaroslavl Saints, Holy Hierarchs of Moscow with Icon of the Vladimir Theotokos, and Kievan Hierarchs with Image of Our Lady of Pechersk. For Maria these were not simply works of art, but prayers made flesh. During these difficult years Russia desperately looked to the intercession of its saints, and as Maria painted, every brush stroke became her own ardent prayer.

Although Maria had an overarching interest in Russian saints as such, she had a particular interest in the followers of Saint Sergius of Radonezh. She painted many (but not all) of these images for the Trinity-Saint Sergius Lavra. One sequence that survived intact dealt with individual saints from Saint Sergius's time. Maria felt a great closeness to this circle, which had been active during another troubled time, when Russia was laboring under the yoke of a Mongol horde that, in many ways, resembled Soviet power. The spiritual renaissance experienced by Russia at the turn of the fourteenth and fifteenth centuries came about thanks to these very saints. While painting these images, Maria was prayerfully appealing for the return of that same Russia which had already once before managed to rid itself of the dark night of tyranny.

Among the various hagiographic cycles painted by Sokolova, of particular note is one dedicated to the life and work of Andrei Rublev who, though at this point not yet canonized by the Russian Church, was held by Sokolova in high regard. She, so to speak, created in advance the iconic image of Rublev, thereby easing the task for future generations. I.V. Vatagina used Sokolova's version as her prototype when she painted an icon of Rublev on the occasion of the Council of the Russian Orthodox Church of 1988 at which Rublev was finally canonized.

The creative work of Maria Nikolaevna Sokolova embraces a very long period—from the 1920s to the 1970s. During this period the pendulum of history swung back and forth, from repression to liberalization and then back again. Regardless of outward circumstances, she remained unshakable and faithful to her chosen path: the revival of ancient iconography.

The style of Sokolova's work is highly distinctive, witnessing at once both to her talent as an iconographer and to the character of the time in which it was her lot to live. And even though Maria strove to take leave of her own ego, immerse herself in the canon, and restrain manifestations of artistic self-expression, her own personality nonetheless always shines forth, making her iconographic images easily recognizable. Tranquility along with a mood of recollection and prayer—these are the characteristic qualities of a work by Maria Sokolova.

She took inspiration from the living source of the ancient icons and knew how to learn from the masters, which explains her ability to serve as a wise

guide and teacher for others. She imparted to her students this same love for medieval icons and showed them how to enter deeply into the life of the Church—a necessity for someone wishing to become a true iconographer.

In 1958, Maria organized an icon-painting circle at the Trinity-Saint Sergius Lavra and served as its leader for twenty-three years. Her students included seminarians, monks, priests, and laypersons. She created study guides on the technical aspects of iconography, gave lectures at the seminary, and assisted in setting up the office of ecclesial archaeology within the Theological Academy. She also put together exhibits for students in her study circle. Her own works were regularly published in the *Journal of the Moscow Patriarchate*. The seeds planted by this talented iconographer, wise teacher, and genuinely heroic person of great personal devotion bore a rich harvest. By 1990, her icon-painting circle served as the foundation for the new School of Iconography affiliated with the Moscow Theological Academy, which at present is headed by Abbot Luka (Golovkov).

In 1970, Maria was secretly tonsured a nun, taking the name Juliana in memory of the holy martyr Juliana whose feast day is August 30, which coincides with the day the Church celebrates the memory of another saint— Alipy Pechersky, the first Russian iconographer to be canonized. Today, many in Russia know of her as Mother Juliana, but during Soviet times she was obliged to hide her status and indeed she always strove to blend in with the laypersons around her. Yet, the one thing that Maria Sokolova never hid was a faith in God and love for the Church.

Maria Sokolova passed away in 1981. Her funeral mass was held in the Trinity-Saint Sergius Lavra, where she was memorialized as a nun. His Holiness Patriarch Pimen attended the funeral and the Russian Orthodox Church showered her with awards in honor of her selfless sacrifices made in service to the Church. She was honored with the medal of the Order of Prince Vladimir, third and second degree, the medal of Saint Sergius of Radonezh, as well as three other ecclesial medals.

Gradually, political change was beginning to take root in the country— changes in part grounded in the religious reawakening of the Russian people. Now the laypeople, working from the bottom up, were taking the initiative and not the Church hierarchs who had become deeply dependent on the secular authorities. During the 1980s the iconographic milieu became

energized. It grew not just in number but also in variety and creativity. The role of Maria Sokolova in all this is undisputed. As one of her students wrote, "The majority of our contemporary iconographers working in Russia today are either students of Mother Juliana, or students of her students. But in the beginning it was just Juliana alone."[38]

THE RETURN OF SACRED SITES

The Rebirth of Iconography, 1980–2000

T he "period of stagnation"—the common term to describe the final days of the Soviet Union—was a time associated with the names Leonid Brezhnev and Yuri Andropov, among other Communist Party leaders. In reality, stagnation had affected only the surface of society. Below it, profound shifts were already taking place, although they would only later come to light. One of the more obvious manifestations of the system's stagnation was its heightened sensitivity to every manner of freedom—its attempt, in fact, to simply squash freedom of thought, assembly, and creativity.

The awakening of an independent civic consciousness was a constant source of anxiety for the Communist Party.[39] It was clear that Soviet society had already lost its monolithic character. The thaw of the 1960s had given members of the intelligentsia their first taste of freedom and the experience of at least partially opened borders—and it had given them hope.

Then came the 1970s, with its growing dissident movement, followed by the 1980s, a tumultuous decade that opened with a new wave of anti-church repressions and concluded with a perestroika that had already exhausted its reformist potential. In 1991, the Soviet regime fell. A new, democratic stage in the history of Russia had begun.

The transformation in relations between church, state, and society was particularly striking. This transformation came about not only because the

state had lifted its ideological restrictions, but because the laity and other grassroots forces had already prepared the ground from below. During the Soviet period, the government's relationship with the Russian Orthodox Church had involved a sort of double-dealing. The government was always happy, on the one hand, to make use of the Church's episcopate as an authoritative, supposedly independent, voice in the sphere of foreign policy. But within the Church itself, any movement toward greater freedom was suppressed. Nonetheless, despite the strict ideological controls, the life of the spirit continued uninterrupted, both within the Church as such as well as in circles outside of the church but sympathetic toward it.

This new ferment was particularly striking during the 1970s and 1980s, when young people and members of the intelligentsia first began entering the Church in larger numbers. The impact on the Church's intellectual life was immediate. Suddenly seminars were being held in people's homes; prayer groups were started, along with *samizdat* (self-publishing) and *tamizdat* (publication of forbidden literature abroad). A public raised on atheist ideology began taking an interest in religion. And, as became evident from a series of underground art exhibits, Christianity had become a popular theme in the world of alternative art.

When it came to iconography, however, the situation was more difficult. Under normal circumstances, after all, the Church would be the primary client for new icons, but as it still did not have the resources to commission new works, there was no way to stimulate the development of ecclesial art. New churches were being constructed only rarely, and existing parishes faced both ideological and financial pressures. The typical parish was too poor to finance anything on its own, and it was in any case forbidden by the state to seek outside sponsors. The number of iconographers nonetheless continued to grow, and the tradition continued to develop.

In the 1970s and 1980s, however, iconography had no discernable impact on the country's cultural life. Under the Soviet system iconography was all but illegal. The painting of icons with the intent to sell them was subject to criminal sanctions and was punishable according to article 162 of the Criminal Code of the USSR governing "illegal production and trade." Production of icons for sale was punishable by a prison term of up to four years.

This is why iconography continued as essentially an underground art form, focusing on either restoration work or fulfilling commissions from private individuals. Far from advertising their work, iconographers hid the fact even from their colleagues, lest one of them turned out to be an informer.

With iconographers forced to work under such difficult conditions, it is little wonder that, to the casual gaze, contemporary iconography simply did not exist. But it was precisely during these years of "stagnation" that the innovative masters who define late twentieth-century Russian iconography first began to paint.

To be a living organism, the Church can never simply live off an inheritance from the past—it must, in every age, strive to say something new and bear witness in its own way. And the turning point for modern Russia came in 1988, when the Russian nation celebrated the millennium of the baptism of Russia. Although officially the Soviet regime came to an end only in 1991, it was 1988 that demonstrated that the regime was already dead. The Communist Party, to be sure, still held the reigns of power. And yet despite this fact, the Christian baptism of Russia was celebrated across the entire nation. Soviet officials strove to impart a purely cultural meaning on the event, but the nation's leaders were obliged to acknowledge that Russian culture had itself been formed, to a great extent, by Eastern Christianity.

And so, a new age began. The period of conflict between state and church ended, as did the persecution of individuals for their religious beliefs. Society turned with new interest to the Orthodox Church, and Christians, at long last, received complete freedom. Such a massive turnaround opened many new possibilities for the Church, not the least in the area of ecclesial art.

Even prior to the anniversary celebration of 1988, the state had begun returning some properties to the Church. Among the first of these was the Danilov Monastery, which went on to become the focal point for the nation-wide celebrations. Danilov Monastery was founded in the thirteenth century by the saint Prince Daniil of Moscow. Over the course of its long history, the fortunes of the monastery had waxed and waned, but never, prior to the twentieth century, had it fallen into a state of total collapse. It had met, during the 1930s, with the same fate as every other holy site in Russia. Its monks had been forcibly evicted, the majority of them being sent into exile or prison in the Russian Far North.

Within the monastery's walls Soviet authorities set up a factory and a jail for juvenile delinquents, and the latter continued to function until the 1980s. When the state finally returned the monastery's buildings to their rightful owner, they were practically in ruins. The cemetery had been barbarously vandalized, the walls and towers were in disrepair, and the entire structure was defaced. Indeed, it looked as if it had been attacked by an invading army and, to all appearances, it was going to take more than a single decade to restore it.

Restoration work, though, was completed in record time with the monastery completely restored within five years (1983–1988). The restoration work was overseen by Archimandrite Evlogy (Smirnov), now Archbishop of Suzdal and Vladimir. Iconography work was led by Abbot Zinon, who by this time was already renowned as an important iconographer. They were joined by a whole brigade of artists and restorers, including Alexander Sokolov and Alexander Chashkin (about whom we will hear more below).[40]

The monastery's main church, Trinity Cathedral, was built in 1833–1838 and was the last structure to be designed by the architect O. Bove. It was restored to its original dimensions and form, and new frescoes were painted using the academic style.

The foundation of the Church of the Holy Fathers of the Seven Ecumenical Councils can be traced to early medieval Russia, while the architecture of the upper church retains design features from the seventeenth and eighteenth centuries. It was restored according to the Old Russian style. Father Zinon participated directly in painting the icons for the Pokrov and Prophet Daniel side chapels as well as the icons for the lower church, with the monastery's most prominent icon of Prince Daniil of Moscow also painted by Father Zinon.

The rebirth of Danilov Monastery represented an important step forward in the development of the modern Russian ecclesial tradition. In the first instance, it demonstrated that the Church had managed to revive the spirit of ancient iconography. This set the tone for the entire course of modern Russian iconography, which, from this time forward, would be oriented toward canonical imagery. Later, to be sure, other icons would appear that in purely artistic terms were no doubt more interesting, but Danilov Monastery had taken the first step in the revival of the iconographic tradition, with Father Zinon bearing a large part of the credit.

The icons Father Zinon painted for the monastery were executed in the Moscow school style of the fifteenth and sixteenth centuries. They are distinguished by their disciplined palette, the evenness of the applied gold leaf, and the gentle transitions between colors in the treatment of flesh. The strict formality of the iconostases, taken in combination with the whitewashed (unfrescoed) walls of the church, create an overall atmosphere of restraint and spiritual beauty that corresponds well to the aesthetic of monastic asceticism at the same time that it discloses the essence of the liturgy—an essence defined by joint prayer and sacramental participation in the kingdom of heaven.

This approach to iconography was received by many as something new and innovative: a not entirely surprising response, given the reigning lack of style in the recent past with regard to ecclesial art. In fact Father Zinon's work represented a return to an ancient aesthetic that had been all but forgotten during the Synodal period.

In Soviet Russia, the divine liturgy was performed only in those few churches that managed, sometimes miraculously, to survive the onslaughts of the state. Some of these churches had never closed their doors. Others had opened them during World War II or shortly after it.

In most churches, the decorative elements were a late addition, often from the nineteenth century, and sometimes the changes were gaudy or ill-made. The faithful would often remove icons and other sacred objects from shuttered churches and place them for protection in still-functioning churches, with the end result that the interiors of some churches began to take on the appearance of a warehouse of ill-matched icons and icon boxes.

As every parish was impoverished, it gradually became the norm to use artificial flowers made of tissue paper or tin foil to decorate icons, or to drape them with curtains made of muslin. Walls were typically covered in frescoes and murals of recent origin (and had often suffered from inexpert attempts at restoration) or were decorated with bas-relief sculptural elements crudely covered in oil paint. In some of the Russian provinces, many churches still maintain this look.

"The Soviet-era Orthodox church," the noted ecclesial art expert N.M. Tarabukin wrote,

typically displays an unfortunate mish-mosh of disparate elements. There are a great many gilded metal icon covers that obscure the painted surface of the icons under their metallic armature; then there are the enormous, heavy, and tastelessly designed chandeliers and candelabra. Add to this the artificial flowers made of tissue paper that decorate the church's main doors and the Crucifix; icons draped with muslin veils and similar tawdry finery; electric lights instead of wax candles and oil lanterns . . . saccharine-sweet, sentimentalized icons of the Mother of God, and every other sort of painted art executed in either a naturalistic or the academic style. . . . In sum, what we have in the modern church is little more than a monstrous assemblage of tastelessness, knick-knacks, and anti-art that tramples under foot the original meaning and high purpose of ecclesial majesty.[41]

Although Tarabukin wrote these words in the 1930s, this characterized many of the churches of the 1970s and 1980s.

During the Soviet era, when the Church was under constant pressure, the adornment of churches was for the most part in the hands of the *babushkas*, the older women and grandmothers. Indeed, the authorities kept careful watch over every parish to make sure that younger persons never dared take an active role in parish life. The result was that churchgoers came to accept this "aesthetic of the old ladies."

The Church hierarchy did what it could to counteract these trends. Patriarch Alexei I, for example, repeatedly implored parishioners not to bring artificial flowers into their churches, explaining that "there is no truth in them." But in Soviet times, most people were pleased simply to find a church that was actually open and available for prayer. Aesthetics, one might say, was the least of their worries. But with the return of freedom, the issue of church beautification again came to the fore, and not just in newly constructed churches, but also in churches that had never closed their doors.

When Archimandrite Zinon and his team of iconographers worked on the restoration of Danilov Monastery, they made every effort to have canonical icons confirmed as the accepted norm in ecclesial art, striving to return Russian churches to an ecclesial and authentic aesthetic.

In this same vein Maria Sokolova and her students worked, contributing to the restorations in Danilov Monastery. She set up an iconography atelier in the monastery headed by Irina V. Vatagina, an iconographer who trained during the post-war years under Mother Juliana at the Trinity-Saint Sergius Lavra.

Vatagina's workshop produced icons both for the monastery and for other churches and monasteries. Her workshop painted the icons of the new saints canonized during the 1,000-year anniversary Council of the Russian Orthodox Church that took place in 1988. Together with Sokolova, this workshop created the archetypal images of such saints as Andrei Rublev, Ksenia of Saint Petersburg, Maxim the Greek, and Amvrosy of Optina Monastery among others—the standard from which later artists based their icons.

The iconographers of the 1970s and 1980s worked as pioneers, blazing their way through a spiritual wilderness. And the strong foundation that they created eased the way for those who followed.

An important signpost along the road to restoring the tradition was the "Modern Icon" exhibition held in 1989 in the Znamensky Cathedral in Moscow. Now located on Varvarka Street, in 1989 it was still Razin Street. This was the first exhibition of contemporary church art held during the entire Soviet period. Prior to that, icons had been exhibited only as museum pieces, if they were shown at all, and always only as something from a previous time period, something from before 1917.

The term *modern icon* didn't even exist in the Soviet lexicon. Icons had been treated as though they had no connection with the modern world. But the exhibit on Varvarka Street demonstrated that icons were still a living and developing form. The exhibit provided iconographers newly emerged from the underground with the opportunity to demonstrate their strength. But most of all, the Varvarka Street exhibition showed that the Russian icon, while connected to the past, also had a future.

It is interesting to note that this exhibition, which brought to society's notice the fact of contemporary iconography, took place on the very street where, in 1913 (on Delovoi Square, across from Znamensky Cathedral) an icon exhibition was also held, this one dedicated to the 300-year anniversary of the House of Romanov. Both were received as heralding a rediscovery of the icon.

But whereas the earlier exhibition had been associated with the rediscovery of the ancient icon, the later one was associated with the discovery of the new. In a peculiar symmetry of these two events, the century that had begun with the discovery of, and heightened interest in, icons closed with the rediscovery of icons and another wave of interest in them.

The "Modern Icon" exhibit included works by more than one hundred modern iconographers. In a review written at the time, M. Gusev commented on the event's significance.

> The exhibitors and organizers of this exhibition had no consciously formulated goals. The simple fact that it was now possible to assemble, within four walls, works by all the nation's leading iconographers—this was already for them something of a miracle. This exhibit could not provide an exhaustive survey of the current state of ecclesial art. What we see here are icons that are new, or that were accidentally left behind in a studio, or that a priest permitted to temporarily take leave from its rightful place inside a church. Nonetheless, even such a limited cross-section of the field suffices to demonstrate the existence of a variety of schools and different artistic trends—and it is also clear which of these styles and trends are in the forefront. This latter point is made the more significant by the circumstance that many of the participants gathered here are relatively young. Their average age is thirty. The future of Russia's ecclesial art is in their hands.

As it turned out, this reviewer was right. Most of the participants in this exhibition are still actively working today. Their number includes Alexander Sokolov, Alexander Lavdansky, Alexei Vronsky, Andrei Bubnov-Petrov, Sergei Cherny, Vladimir Sidel'nikov, Ilya Kruchinin, Ksenia Pokrovsky, and Olga Klodt, among others. And these are the iconographers who are defining the main trends in Russian iconography.

All but a few of them have by now created their own atelier where they continue to train apprentice iconographers, who further demonstrate the great breadth of this modern renaissance of the icon.

When Father Anatoly Volgin formally opened the "Modern Icon" exhibition, he surveyed the current state of Russian iconography and set

forth several tasks that still needed to be addressed. "Twenty years ago, when we first began to paint, we were completely alone," he said.

> It is a joyful thing to see that, far from dying out, the art of iconography has continued to develop. . . . We who have dedicated ourselves to icons, as people of faith, realize that Orthodoxy and the Church are simply unthinkable in their absence. At the same time, a serious lack of education among many Church people has put iconography in a most ill-defined and confused condition. Speaking as a priest, it seems to me that our most important task is, first, to improve the language of iconography, and second, to improve our ability to explain that language. . . . But whether we are icon painters or persons who simply have an interest in icons, our main task is to improve our understanding of icons' language and symbolism.[42]

It is true that many iconographers began painting icons without any prior instruction, studying on their own and learning the craft as best they could. This in turn led to the widespread perception that the new iconography had arisen out of a vacuum. The "Modern Icon" exhibit proved that this was not entirely accurate. The master iconographers presenting their work at this exhibit somehow had come into contact with the bearers of the tradition.

With this exhibition, the days of the solitary artist were now gone. The Izograph Society played an important role in the new community of iconographers. Izograph, the first organized iconographic arts group, defined two goals for itself: restoring the iconographic tradition and providing concrete practical assistance to iconographers. Many icon painters joined, and Father Anatoly, who participated in the first exhibit, was chosen as its president. And even as it formed an important landmark in the development of twentieth-century Russian iconography, the organization did not survive.

But icons and iconography continued on many levels, establishing the canon and educating those inside and outside the Church. At the end of the same year that the "Modern Icon" exhibit closed, another exhibit opened: "Christian Art: Tradition and the Modern World" (in Moscow, Manezh Hall,

December 1989 through January 1990). And similar exhibits followed on its heels, with, today, exhibits of modern ecclesial art becoming a regular and widespread part of Russian culture, held in places like St. Petersburg, Nizhny Novgorod, Samara, and Pskov, and indeed in cities throughout the world.

By the mid-1990s, there was something more than a heightened interest in icons. There was a veritable icon boom—society's way of responding to what had formerly been taboo. By the beginning of the twenty-first century, however, the boom had waned. Icons were no longer something exotic. They had become part of the mainstream of Russian culture.

The primary developmental problems experienced by iconography during the final two decades of the twentieth century were problems of growth. With every passing year, the number of newly constructed or restored churches and monasteries was growing. The demand for iconographers was far outstripping the supply: there simply were not enough master iconographers to go around. As a result, individuals without ecclesial background or lacking the artistic education presented themselves as iconographers. Now, iconography seemed to be growing in breadth more than in depth.

Nonetheless, there were also positive developments. It was clear that the needs of the Church called for something more than isolated artists working on projects. The needs of a growing Church demanded of iconographers that they organize new forms of labor, and they responded by creating unions of workers, work brigades, and production teams. Some of these groups were officially incorporated into the Moscow Patriarchate (the Sofrino Company, for example, is an iconography studio attached to the Theology Academy of the Moscow Patriarchate), which conferred certain privileges and benefits. Others remained independent of the patriarchate, and they too, without enjoying any special privileges, still received orders from both churches and private individuals.

By the end of the 1990s, in Moscow alone there were more than twenty iconography studios and production teams fulfilling contracts for the Church. Teams formed in other cities as well. To be sure, as the number of such production organizations grew, their skill levels and the quality of their work did not always maintain a high level. Many iconography studios came together in the 1990s, a number of which are still in existence, some developing a particularly distinctive style.

The concept of an iconographic production association (or team) is a very old one in Russia, with roots going back to ancient Rus'. Without assistance from a team, a single artist could not possibly handle such a large job as an iconostasis, or frescoes for an entire church. The master artisan at the head of a production association would, instead, work in close collaboration with other skilled artists and craftsmen such as icon painters, carvers, and architects.

In Old Russia the process of training new iconographers took place in guildlike production associations. The student worked his way through all the stages, from junior apprentice to master iconographer, all the while working as a member of the team, with no strict demarcation line between education and labor.

Today, iconographers are increasingly conscious of the need for serious training. It is now normally expected that an iconographer will have completed an undergraduate degree in fine art. Indeed, some university art faculties already have programs in icon painting as such.

As the twentieth century came to an end, the iconographic tradition was becoming ever more varied. Many of its characteristics are typical of an age of transition and the rebuilding of lost traditions. Perhaps the most prominent of these characteristics is modern iconography's continuing search for a style and a language.

The dominant tendency continues to be modeling new icons after others already considered canonical. This is both a blessing and a curse. The majority of iconographers working today allow themselves to be imprisoned by tradition. Instead of approaching tradition creatively so as to develop it, they too often more or less blindly copy tradition instead. And yet, an image that is not the product of the artist's own inward spiritual experience cannot be received as a revelation by the viewer.

Yet more and more iconographers are currently coming on the scene who do understand that authentic tradition is not about making stylized copies of older works, understanding as well that there is no tradition without creative freedom. These iconographers have grasped, moreover, that authentic freedom consists not in scorning the canon, but in creatively mastering it. Speaking broadly, and bearing in mind the hazards of a merely stylized traditionalism, the most important achievement of iconography

during the last two decades of the twentieth century has nonetheless been its eager return to the deep roots of tradition.

So where do we begin to assess the authenticity of an icon? One important criterion is the extent to which an icon has entered into the life of the Church: the warmth of an icon's reception by the faithful—only not in terms of aesthetic pleasure, but on the level of prayerful contact. The Inexhaustible Chalice icon, painted by Alexander Sokolov in 1992 for the Serpukhovsky-Vysotsky Monastery, presents a striking example of such authenticity. Today, it is popularly considered miracle-working. Thousands journey every year to see this icon and pray before it for healing from the terrible disease of alcoholism. This happens not because this illness is so widespread in Russia—after all, a number of other icons on this same theme exist in Russia—but because this particular icon disposes the viewer to prayer. Sokolov's icon invites you to open your heart to the Mother of God. Such an enthusiastic reception by the faithful is rare for a new icon. Today, just as in centuries past, many in the Church are far more ready to put their trust in an old icon than in a new one.

The renewal of the Russian Church is now a fact of history. That Russian Orthodox culture as a whole is also enjoying a period of revival is likewise evident, seen in the number of churches under construction, the reopening of monasteries, and the increasing participation of the Church in social and cultural spheres.

By the turn of the twentieth century the new iconic tradition was already well defined. A professional milieu of artists became involved in ecclesial art, and iconography had itself become an important influence on the world of Russian art, both within churches and without.

The 1990s were a time for training and recharging. At the very outset of the decade, Ksenia Pokrovsky, one of Russia's leading master iconographers, reflected on the tradition's prospects. "Today," she wrote, "we are standing at the edge of a dried up puddle, even though, drop by drop, iconographers are refilling it. But only when that puddle has filled to overflowing, and there are thousands of iconographers (good, bad, heretical, traditional), and the puddle has become an ocean, with waves, and the waves have acquired crests—only then, through that sort of conciliar, creative effort will it become possible to create something truly new. And we won't notice the moment of its arrival."[43]

By the end of the 1990s, a large body of water had already formed, and by the early twenty-first century it was already possible to speak of a tradition the size of a sea so large that at times its opposite shore was no longer visible. By the turn of the new century, the peaks and valleys in the sea of iconography could also already be discerned; it was clear who the true master iconographers were, and who were the obvious imitators. It was likewise becoming clear which of the new trends point to endless horizons or to dead ends.

When we use the word *tradition*, we speak of an entire stratum of culture whose overall character is defined by the work of many. And yet it sometimes happens that the creative path of a single individual defines the main currents of an entire artistic tradition and thereby creates paths for others to follow. Such an artist is Archimandrite Zinon, the most prominent iconographer working in Russia today.

In the 1990s, some of Father Zinon's reflections on the meaning of tradition were published in a book called *Conversations with an Iconographer*. He wrote,

It is difficult today to speak about the continuation of the tradition, or of some new word that has been spoken in the realm of ecclesial art. Not enough time has passed. Twenty or thirty years is not really enough. We had been completely uprooted from tradition, and now it will take much time and effort. Many factors will prove important here. If we continue developing as we have been, it may so happen that what is called a "school" will come together, and people will be able to differentiate between twentieth and early twenty-first century icons with the same ease as we presently distinguish icons painted in the sixteenth from those painted in the seventeenth century. And bear in mind that iconographers working in those days were not focusing on creating something new and unusual, or something that had never been created before. They simply did their work in a natural way, striving to create beauty in accordance with their own understanding of beauty. . . . True creativity is possible only within the framework of a tradition, and it takes time and effort to get on a first-name basis with a tradition. Learning the craft aspect is not enough. One has

to become so thoroughly immersed in the ecclesial spirit of authentic Orthodoxy that it becomes possible, while still making use of our vast inheritance from the past, to somehow transform it and pass it through the filter of our contemporary Church self-understanding. Only then can something new appear. So far we have been simply engaging in experimentation. An iconographer who takes this work seriously knows that he, or she, is just an apprentice in training. And nothing more.[44]

Archimandrite Zinon considers himself a student studying at the feet of the old masters, even though he himself has been the teacher of a great many iconographers. His creative path provides eloquent testimony to what it means to "get on a first-name basis" with tradition, what it means to truly master the tradition. Only if one goes deeply, after all, does one penetrate to the roots that nourish the life of a new tree. Father Zinon is today the most renowned of all Russian iconographers, and his art continues to influence developments in iconography both in Russia and abroad.

The Way of a Master

Archimandrite (Vladimir Teodor) Zinon was born in Olviopol, a southern Ukrainian city founded by the Greeks. The year of his birth, 1953, was also the year of Stalin's death. From his mother and grandmother he learned at an early age to feel at home in the church. When he studied at the Academy of Fine Arts in Odessa, he became acquainted with icons and frescoes.

The artists under whom he was working had no special training in iconography. Their style was painterly. But as it was the canonical style that most attracted the future iconographer, he decided to study it on his own without a teacher. At first he made copies of the old icons, most often from reproductions. In Odessa, as elsewhere in the south of Ukraine, old icons are a rarity. There are practically none to be found in local churches, and art collections in provincial museums are poor. The young Vladimir Teodor realized early on that to truly master the art of iconography, he would have to dedicate his whole life to it. In 1976, with the blessing of his spiritual father Archimandrite Serafim (Tyapochkin),[45] he was tonsured a monk, taking the monastic name Zinon, and entered the Pskov-Pechersk Monastery.

Pskov-Pechersk Monastery was renowned for its iconographic traditions. The monastery's abbot, Archimandrite Alipy (Voronov), was both an expert in and a lover of the arts who had a wonderful collection of Russian and Western European art and early icons. He himself was a fine iconographer, and his icons and frescoes continue to beautify the monastery. It was through Abbot Alipy's efforts that the monastery as a whole, in the postwar years, was transformed from ruins into a little corner of heaven.

Even in Soviet times tourists to the area were often amazed at the contrast between the city of Pechersk, gray and dusty like most provincial Soviet towns, and the monastery of Pechersk, appearing as if out of nowhere, like the fairytale city of Kitezh of Russian folklore. Whether it was the lawns and flowerbeds, the deep blue cupolas ornamented with stars, or the brightly decorated frescoes against a background of freshly whitewashed walls—here, everything was lovingly cared for.

And this, naturally, was a constant thorn in the side for Soviet ideologues who made repeated efforts to close the place on one pretext or another. But even during the worst years of Khrushchev's antireligion campaigns, Abbot Alipy managed to keep the monastery open. For iconographers, the conditions here were close to ideal, all the more so as Abbot Alipy actively encouraged artistic creativity and the further development of iconography.

Sadly, a year before the time Father Zinon entered the monastery, Father Alipy had passed away. The two never met. And so, entering the monastery, Father Zinon was obliged to pick up the wisdom of iconography on his own. Fortunately, Father Zinon benefited from the receptive atmosphere that the good abbot had created for iconography. He was immediately given a workshop and was allowed to paint for the Church.

Early on the young iconographer's work attracted the notice of the Church hierarchy. In 1979, Patriarch Pimen called Father Zinon to the Trinity-Saint Sergius Lavra where his talents were put to use fulfilling many orders for the patriarch. He painted the iconostasis for the crypt of the Dormition (Uspensky) Cathedral along with many individual icons. Patriarch Pimen, who was an expert in the early icon, held the young artist in high regard and in 1983 put him in charge of icon painting at Danilov Monastery.

In parallel with his work at the monastery, Father Zinon continued to fulfill commissions from others. In 1985, he painted icons for Saint Parasceve Church in the Vladimir region, where the dean of the church was Father Anatoly Jacobin, who tragically died in 2001. A remarkable person whose entire life was an exemplary confession of faith, Father Anatoly was a pastor in the truest sense of the word. He brought to his parish elderly nuns from monasteries scattered throughout Russia that many years earlier had been closed by the authorities. The nuns lived in his parish as a tiny monastic community.[46] Such an act of charity, during Soviet times, was dangerous, risking the forfeiture of Father Anatoly's parish as well as accusations of anti-Soviet agitation for setting up an unsanctioned monastery. Such a charge was punishable by imprisonment and exile. But Father Anatoly was fearless, believing God would watch over him.

During the difficult 1970s and 1980s, when it was all but impossible for most iconographers to get any work, Father Anatoly gave them invaluable material support by commissioning from them works for his own church— thereby giving them the means to survive. As a result, today Saint Parasceve Church is a veritable museum of iconographic art from the 1970s and 1980s. The wooden church is like a jewelry box. Here one can find icons by Alexander Sokolov, Father Andrei Davydov, and other now well-known iconographers—notably including Father Zinon. Thanks in large part to him, and others like him, the iconographic tradition managed to survive the final decades of the Soviet regime.

To be sure, Father Zinon was not entirely dependent on his work for Saint Parasceve Church, as from the 1980s and early 1990s he continued to work in the Pskov-Pechersk Monastery creating iconostases for the Church of the Holy Martyr Cornelius (1985), the Pokrov (Holy Protection) Cathedral, and the Church of Pechersk Saints on the Mount (1989–1991). He also created icons for the iconostasis of the lower church in Trinity Cathedral (Pskov), dedicated to Saint Serafim of Sarov.

In 1994, the ancient Spas-Preobrazhensky (Christ's Transfiguration) Mirozhsky Monastery, located in Pskov, was transferred to the Russian Orthodox Church, and an international school for iconography was founded there, headed by Father Zinon. Here he was assisted in this work by several monks and novices, some specializing in preparing the boards, others in painting icons.

In this way, the inhabitants of this monastery formed not simply a monastic community, but a fraternity of iconographers—a wholly unique phenomenon in Russia. Little by little, through the efforts of this fraternity, the monastery, formerly in a state of utter collapse, began to revive. Among other achievements, these iconographers restored the Church of Saint Stefan the New Martyr. Father Zinon constructed an original stone iconostasis for it and painted icons of the Savior, the Theotokos, and several saints in medallion (circular or oval-shaped) icons. Over the course of three years, dozens of artists completed apprenticeships there and many icons were painted. The school became a focus of the iconographic renaissance and acquired an international reputation. In 1995, Father Zinon, in recognition of his mastery of the art of iconography, was awarded the State Medal of Russia.

However, in 1997, Bishop Eusebius, the ruling hierarch of Pskov and Prilutsky, placed a disciplinary ban on Abbot Zinon and his brothers, forcing Father Zinon to depart from Mirozhsky Monastery. In the absence of its founder, the school was hard pressed to continue functioning. Father Zinon moved, along with a handful of other monks, to the village of Gverston, located in the west of Pskov oblast (region). He lives there until this day.

Starting in the 1990s Father Zinon began receiving invitations to work in a variety of other countries, including France, Finland, Belgium, and Italy. And regardless of which country he was working in, throughout this entire time he continued his search for a modern iconographic language.

Abbot Zinon's early work (1970s and 1980s) focused on mastering the Russian tradition, and primarily that of the Moscow school of the fifteenth and sixteenth centuries. These were the years when he worked in Pskov-Pechersk Monastery, the Trinity-Saint Sergius Lavra, and in Danilov Monastery. The icons of this period have all the characteristics of the golden age of Russian iconography: the warmth of the palette, the softness in the handling of color, flowing lines, faces of imperturbable calmness, images that are uplifting and prayerful. To an extent, Father Zinon was influenced by his interaction with Maria Sokolova (Mother Juliana), who during the 1970s had worked in the Trinity Lavra where he too had been invited to work by Patriarch Pimen. Sokolova, who esteemed before all else the Moscow school of the days of Rublev and Dionisius, considered this period not only the

high point in medieval Russian art, but the gold standard for iconography of any time or place. This was likewise Abbot Zinon's initial point of reference. And his work in Moscow was oriented toward Andrei Rublev in a natural and organic way. This can be seen, for example, in his icon of Saint Daniil of Moscow painted for the Saint Daniil Monastery.

But even during this Moscow phase we can see, in certain of his icons, that Father Zinon was drawn to an even earlier style, evident in icons such as The Baptism of Russia, created for the millennial celebration of 1988. Now decorative elements typical of the Russian school of the pre-Mongol invasion period are integrated into his treatment of the painted surface. The composition has become more dynamic than before, the colors more intense, the decorative elements, more active.

In his Pskov icons Father Zinon made a dramatic departure from the lyricism of the Moscow school. He adapted a more energetic painterly manner: his painting became sharper, imbued with an internal tension. And here is what we find in his icons produced for the Pskov-Pechersk Monastery: now the drawn lines strike a note like a taut chord; the intensity of the color is supported and balanced by the brightness of the gold; the forms are enlarged; and the faces remind us of images from the pre-Mongol period. In his iconostasis for the Saint Serafim of Sarov side chapel of the Trinity Cathedral in Pskov, we find this same movement toward the monumental style of the twelfth century. The forms have become more generalized, the large facial features tensely expressive. The use of *basma* (wrought silver) in the background and of ornament on the flat iconostasis frame serves to strengthen the noble solemnity of the ensemble. The central image of the Savior, Christ in Majesty, is clearly modeled after the famous twelfth-century Sinai icon. It rises like a jewel set in the middle of the iconostasis. The dark blue background with gold stars, and the gold assist on Christ's robes immediately draw the attention of anyone entering the church.

Father Zinon's gradual retreat from the generally accepted, more-or-less standardized iconographic style allowed him to develop an understanding for the stylistic traits of other iconographic schools. In the book *Conversations with an Iconographer* Father Zinon explains why it is so necessary to constantly look to the experience of previous ages: "There is no such thing as creativity outside of a connection with a living tradition. But for us, the

living tradition of ecclesial art was cut off. . . . That is why we have to follow the same path as was taken by Russian iconographers after the acceptance of Christianity by ancient Rus! Except that, whereas for them the Byzantine icon served as the model, for us, it is our inheritance from ancient Rus!"

The master iconographer didn't stop here, however. Starting in the mid-1990s he began taking Byzantine and early Christian art as his point of reference. Hence, in the iconostasis for the Church of Saint Stefan the First Martyr, located in Mirozhsky Monastery, we find an image of Christ inspired by the Ravenna (Italy) mosaics (even the face of the Savior has been made youthful, as was the accepted practice in the pre-iconoclastic period). And the image of the Mother of God on her throne recalls the early Roman icons. There are also a number of medallions depicting the saints. These have been painted boldly and energetically, and even with a degree of naturalism, as was typical for early Byzantine frescoes and encaustic icons.

The iconostasis, assembled from roughly cut stone and with deep niches for the icons, was modeled after the altar barriers found in some Greek churches. All of this speaks eloquently of the artist's high degree of freedom and mastery of form. Having fully absorbed one or another style, he did not imitate specific works of art from a given historic epoch; instead, he so mastered the idiom that it became something organic to him, becoming his own manner, his own means of expressing theological and aesthetic ideas.

Unity of dynamism and statics within a single composition is characteristic of Father Zinon's style during this period. The images are deeply contemplative and yet, at the same time, charged with an electrifying energy just waiting to burst forth from the depths of that calm. This is particularly evident in the artist's most recent works. Take, for example, his icon The Baptism of Christ, where the fast flowing waters of the Jordan wash over the figure of Christ who stands in the stream like an unmovable rock. Here the river represents the chaos of worldly elements. The Savior, who has taken upon himself the sins of the world so as to absolve humankind, has entered that river and withstands it by the force of his love and sacrifice, and by his humble obedience and self-offering into the hands of the Father. This is what we find presented to us in this magnificent, calm figure of the Savior standing in the water, painted as it is in accordance with all the rules of classical iconography.

Father Zinon's images of saints amaze the viewer by their ability to combine profound tranquility with a sense of constant activity within the soul. A noble beauty combines with authentic wisdom; a prayerful inwardness, with an active and lively gaze. Great eloquence takes form in the faces, gestures, and postures of these figures, but their pursed lips testify to their preservation of what cannot be spoken in words; behind this meaningful silence hide the great mysteries of God to which this world does not have access. Father Zinon's saints are endowed with mystical vision: in their eyes we see the reflected light of the divine realm, in their joyful postures, reverential protection of the sacred. Light—the content of both their souls and their bodies—gives the saints their statuary quality, and lends an architectural feel to the folds of their clothing.

Father Zinon's aesthetic is flawless and precise without becoming a goal in itself: beauty serves only to reveal the meaning of the image. Every artistic device, accent, and nuance, every choice of the image itself and its complement of stylistic elements is dictated by the theological, homiletic, or prayerful idea to which, in the final analysis, every icon refers.

The majority of iconography practitioners today are likewise concerned with the aesthetic dimensions of their art, but, as a rule, give rather less thought to the theological meaning of the icon. It is this relative carelessness about a correspondence between meaning and form that produces the great variety of trends and orientations observable within contemporary iconography. For most artists, it is, at best, simply their own personal taste that dictates their choice of imagery. In the worst case, their choices are dictated simply by the wishes of the client, or by market demand, which explains why the form of their icons does not express meaningful content, but instead simply packages it.

Archimandrite Zinon is convinced that at the root of this trend lies a fundamental misunderstanding of the essential meaning of the icon itself. In *Conversations with an Iconographer* he writes, "Today, icons do not occupy their rightful place within the divine liturgy." What is more, he continues, "Icons have become simply an illustration of the event being celebrated, which is why their form is not considered important, and this explains why any image, even a photographic one, is honored today as if it were an icon. We forgot long ago how to look upon icons as a theology written in colors, and we no longer even suspect that they can distort the faith just as readily as words can; that, instead of testifying to the Truth, they can bear false witness."

The general trend of Father Zinon's creative search is a movement toward the very heart of Church tradition, toward those early sources of holy tradition within which lie hidden a great many possibilities of which history has never made use. Contemporary iconographers, he believes, should once again go through the steps of mastering their Byzantine heritage, just as was done at the dawn of Russian iconography. This, he now believes, is the only path that can lead, in the end, to the creation of something authentic—that will lead to an iconographic style adequate to today's faith, instead of a mindless reproduction of prior patterns.

Toward the end of the 1990s, though the spectrum of artistic exploration narrowed, Father Zinon's style acquired a degree of freedom and completeness that makes appropriate the use of the word "authorial" (*auteur*) to describe it. His Byzantine foundation was evident, without it being in any way slavish or imitative. There is a striving for classical cleanness of line and clarity of plastic form, and in every work the master aimed at giving precise expression to the image's spiritual meaning.

The virtuosity of his drawing assists him in this task, as does the precision of his proportions, the rhythmic construction of his composition, and the intensity of his palette. The saturated depth of his colors is further intensified by the smooth gold surface of their background. The intensity and refinement of his colors call to mind the image of a Byzantine mosaic shimmering in the light like scattered semi-precious stones. During the Middle Ages mosaics were a symbol of the heavenly Jerusalem, which, according to the Revelation of Saint John the Theologian, is paved with shining precious stones, pure gold, and transparent glass. The Byzantine masters strove to achieve this effect by decorating their churches with mosaics that, with their glittering gold and shimmering hues of deep blues, reds, and greens, created an unearthly beauty apparently imbued with the uncreated light. Although it is much more difficult to achieve this degree of luminosity in tempera, Father Zinon makes his colors ring out loudly and festively, as if these were truly the precious stones of the heavenly city, with light streaming off a gold so bathing everything in its glow that the entire icon becomes lightbearing.

One of Father Zinon's most recent works, painted in 2002–2004, is a two-tiered frescoed iconostasis prepared for the Church of Saint Sergius of Radonezh in the village of Semkhoz (not far from Sergiev Posad). This church

was raised on the place where Father Alexander Men was murdered in 1990. In profound respect for this pastor, preacher, and theologian, Father Zinon created an iconostasis whose overall plan is laconic, each detail aesthetically flawless, the colors decorative, its composition restrained. This, together with the plasticity of its general form and the individual character he lends to its images, make this iconostasis highly original.

The artistry of Archimandrite Zinon occupies an important place in the Russian iconographic tradition. His authority is recognized, even by those who do not agree with his theology or the direction taken by his creativity. His great achievement is having been the first to blaze a path forward during the tumultuous and chaotic process of reviving Russia's iconographic tradition.

He is still active today. His current work provides ongoing grounds for optimism about the future of Russian iconography. The creative output of this master iconographer, the level of which surpasses the work of ordinary iconographers, demonstrates that the ancient art of the icon—whose roots reach so deeply into the traditions of the past—is still capable of speaking in a modern idiom.

Many people say that traditional Christianity has fallen into a state of crisis, but this is not entirely accurate. Over against this common assertion there stands the icon. And right here in this modern world we have an art form rooted in the canon, an art expressive of the very depths of Orthodox Christian tradition that is nonetheless spreading across the entire globe, both Old World and New, and across Christian traditions. Russian iconographers have already played, and will continue to play, no small role in this.

In recent years the icon has come to be recognized as the common cultural inheritance of Christian culture as such. What is more, the language of the icon is no longer seen as something exclusively archaic: the icon is clearly fully capable of speaking directly to modernity. In a world where words have been debased and cheapened, where people forget to listen to one another, or neglect to take written texts seriously, visual images shine forth more effectively than the word. The icon's language of symbol and sign, the fruit of centuries of development, is altogether timely in our modern world. Today, just as during the early centuries of Christianity, the unutterable Word of God once again is being spoken to us through the beauty of the icon.

NEW RUSSIAN ICONOGRAPHERS

Leading Artists and Developments of the New Millennium

The iconographic tradition, after being rescued from non-existence at the twentieth century's close, had already gotten firmly back on its feet as the new twenty-first century began. Its most striking characteristic is its ever-increasing diversity—which also makes it difficult to describe.

If, by contrast, we were to describe one of the medieval iconographic traditions—whether that of Byzantium or Ancient Rus'—we would use the term *school.* When we speak of the Byzantine or Russian or Georgian traditions, we have in mind a collection of stylistic traits used by many artists within the given region. And within a given regional school we can distinguish between various local schools. For example, within the Russian school there are also subschools pertaining to the cities of Moscow, Novgorod, Pskov, Tversk, and so forth, each with its own quite distinctive style. Over time, these various schools evolved and changed, but certain deeply rooted characteristics of each remained in place.

Today, however, the concept of a school is practically inapplicable. Modern iconographers are no longer trained in local centers whose traditions they carry on. Instead, each iconographer tends to start from a blank slate without a teacher to guide his or her choice of direction, much less to assure that a given local tradition is maintained. The inevitable result is that everything, including which epoch the artist chooses as a personal point of

reference, becomes a matter of individual choice and personal style. Maria Sokolova (Mother Juliana), for example, felt that the fifteenth century was the appropriate place to pick up the severed thread of iconographic tradition: here was that high point of Russian iconographic tradition after which a gradual drift away from the canon began.

Archimandrite Zinon, however, finds the Byzantine tradition to be the best starting point. After all, here is the source of all iconography, and the great iconographers of ancient Russia studied under Byzantine masters.

But quite a few iconographers say that the medieval idiom is no longer understandable to modern people. The world has changed too radically. Better, they say, to use as our touchstone the seventeenth century, at which point the traditions of ancient Russia were modernized by an influx of new ideas from Western Europe. There are also iconographers who look to the iconographic styles of the eighteenth and nineteenth centuries, and they too fit into the world of modern ecclesial art, right alongside iconographers who follow the traditional canon. The range of opinions is so widely scattered today that one cannot even talk of a unified trend of artistic development, much less of a single, unified iconographic style.

This absence of a unified style or direction is interpreted by many as a sign of decline. They see this diversity as bespeaking a crisis of the traditional consciousness brought forth by a postmodernity devoid of any common criteria of judgment and for that very reason incapable of arriving at any sort of unity of style. At the same time, as this new century gets under way, it is clear that iconographers are paying more attention than ever before to the artistic language of the icon. A vigorous search is under way for the right pictorial language, the right medium, to use in creating an iconographic style.

In considering the work of contemporary iconographers, the first thing to note is that they have more freedom than any previous generation of artists—and they are also better informed. Modern means of communication—whether print, audio-visual, or media—provide the artist with almost unlimited opportunities to learn about preexisting traditions. Artists today can bring into their studios the complete spectrum of iconographic models that have ever been created in every different region or time period, whereas iconographers in ages past were limited to their local school, or at most to the small number of icons that might happen to find their way into their

village or city of residence. Nor is this the only characteristic of the new that will bring about a further development of tradition. There is every reason to expect the unexpected. Let's take a look at the characteristics of what is newest in modern iconography.

The Auteur *Icon*

One innovation in contemporary iconography is the authorial, or *auteur-*type icon. The term may seem to contradict the very notion of the icon: after all, ecclesial artwork is not created for the sake of self-expression.

Prior to the modern period, icon painting was by definition an anonymous activity. Iconographers in ancient Rus' and Byzantium never signed their icons because artists were simply playing their part in the joint expression, in their case through the use of colors and paints, of what is confessed by the church as a whole. One of the cardinal principles of medieval art was anonymity. The individual (authorial) principal should dissolve within something larger such as the shop, the guild, the nation, or the church.

To an extent this idea is retained by Orthodox art to this day, inasmuch as the iconographer does not take his own imagination and personal vision as his starting point when painting an icon. The iconographer's job is to express through colors the faith of the church. According to the Seventh Ecumenical Council (in 787), which set forth church doctrine as regards the veneration of icons, "the Church Fathers are the authors of icons; the iconographers' task has to do with execution." In Russia it is still considered bad form to sign an icon, although in Greece and on Mount Athos the practice of signing icons has been around already for several centuries. And yet the Greeks also understand icons to be an expression of the conciliar confession of the church as a whole.

And indeed, the icon is a product of the church, but it is still created by the hands of a specific artist, and a great deal about that icon depends on the given artist's talent, technical mastery, depth of faith, and insight into the meaning of the likeness being portrayed.

When icons are placed in a church, whether in an iconostasis, on the wall, or on an icon shelf, there is no need to know the author of the icon—a church is not a museum, after all. It would be unthinkable to print a little

tag with the name of the iconographer and place it next to the icon. From the point of view of the person who comes to pray, this information is also of very little importance. What matters is that the icon should be sufficiently profound in its basic conception and as an aid to prayer.

Nonetheless, even in ancient times the names of the most talented master iconographers became universally known. In written records from the medieval period, such as monastery chronicles and patericons, we do find names of specific iconographers. This is, in fact, precisely how we learned of Andrei Rublev, Theophanes the Greek, Dionisius, and other master iconographers.

Among contemporary iconographers there are also more than a few who will be remembered by posterity, and even if their icons are not signed, they deserve to be known both by their contemporaries and by future generations. These leading iconographers are the ones who are defining the character of iconography during this new century.

One of these master iconographers with a highly distinct authorial style is Alexander Lavdansky. His style is original and easily recognizable. He has an astonishing sense of measure and harmony. Using no bright colors, his color scheme is slightly muted with its soft highlights, but despite this the colors are still beautiful and resonant. The figures in his icons are well proportioned and precisely placed. One immediately perceives their classical provenance.

Lavdansky's preference for the classical style of both Russia and Byzantium is clearly evident, but he avoids slipping into conventionalism or imitativeness. The prototypes that he makes use of are thoroughly and intuitively reworked, so the final result never seems derivative. The faces in his icons draw the viewer's gaze and practically demand an active engagement with the icon, as though the viewer were being asked to enter into a dialogue with them, even as they preserve a sense of mystery that we are left to wonder about.

The faces drawn by many contemporary iconographers are often lacking in expressiveness. There seems to be a reluctance to bring a saint's individuality to the fore, with the result that we then meet a sort of homogenized face that expresses neither emotion nor thought nor warmth.

Lavdansky's faces, by contrast, are very much alive. They are almost portraitlike without being naturalistic. The artist's striving for harmony and

balance prevents him from veering too far from the safe shores of the canon. His icons are noteworthy for their emotional restraint, prayerful inwardness, and nobility. The saints in his icons are peaceful, meditative, and filled with a quiet, inner joy.

At the same time, Alexander Lavdansky's manner is not static. To the contrary, it is full of movement and dynamism. He moves his brush with a sketchlike rapidity. The painted surface is never left solidly flat and even. His color vibrates. He applies his paint variously, sometimes in broad swipes, sometimes with almost impressionistic dabs, and he makes frequent use of glazes.

Perhaps these characteristics of the artist are explained by the fact that he frequently paints on the monumental scale; sketchlike quality and freedom of brushstroke are often associated with the technique of fresco painting. In a classical fresco the artist lays down a layer of wet plaster, and this requires working fast and making use of improvisation. Ideally, the brushwork should be fast, accurate, and expressive. With icon painting an artist can patch mistakes, paint over them, if necessary wash them off or even simply lay down a new layer. When an artist is frescoing, everything has to be done right the first time and quickly.

One of Lavdansky's most recent works is the iconostasis for the Church of Christ the Savior in Kaliningrad (formerly Königsburg). The scale of the church is not much smaller than that of Christ the Savior Church in Moscow. Its main iconostasis is seven meters (twenty-three feet) high. The central icons, located on either side of the royal doors, depict Christ and the Mother of God, and are each two and a half meters (eight feet) tall. Lavdansky painted them in a very modern, although at the same time canonically correct, style. The background of each icon is gold, but at the base we find easily recognizable landscape scenes.

On the icon of Christ there are scenes of Moscow, including the Church of Christ the Savior, the Kremlin, and other structures, while on the icon of the Mother of God the equivalent scenes are taken from Kaliningrad. These icons were commissioned by His Eminence Kirill, Metropolitan of Smolensk and Kaliningrad, which explains the presence of these specific illustrations. After all, Kaliningrad is one of the capital cities in his diocese, and Metropolitan Kirill is also the chairman of the Department for External Church Relations of the Moscow Patriarchate, and his residency is located

in Moscow. Hence the desire to unite Moscow and Kaliningrad. In this way, Lavdansky has managed to give form to the special wish of his client while maintaining interest and canonical integrity.

Another example of an iconographer with an authorial style is Father Andrei Davydov. His style—rough, almost grotesque in manner—differs sharply from Lavdansky's, however. The shapes are heavy, the plastic form is harsh, and the icon carries an internal tension. The massive figures depicted in his icons appear motionless, almost frozen. But in their large-featured faces with their widely opened eyes we detect traces of astonishment, as though these eyes were witnesses to something that surpasses all understanding. A heightened decorativeness of coloration and a frequent use of ornament underline the monumental scale of these images.

Unlike Lavdansky, Davydov does not strive for the classical, with its cult of harmony and balance. To the contrary, his point of reference is Eastern iconography (from Syria, Cappadocia, and Georgia), which managed to achieve a maximum of expressiveness through its transformations of form. This iconographer is clearly distant from any conception of the icon as some splendid object whose goal is to calm and pacify the viewer.

Davydov steps well back from the commonly accepted notions of beauty and goodness that most iconographers apply to their work. Such notions, to be sure, elicit no protest—and yet, at the same time, they can often leave the viewer altogether indifferent. Davydov's images, by contrast, grab hold of their viewers, even shock them, stopping them dead in their tracks and obliging an entry into dialogue with them. Such intimate contact with them is difficult—it borders on a sense of confrontation. There is something impenetrable here, something mysterious.

These icons tell us right off that all our modern conceptions about the other world (and, after all, that is the subject matter of these icons) are very far from the mark. The world that the saints dwell in is not the same as the world that surrounds us. That is why these icons—or rather, the world presented by them—brings us more questions than answers. It demands that we look inside ourselves to find answers instead of only seeking answers from without. In the eyes of their author, these odd, sometimes exaggerated artistic forms respond to modernity. Ours is a time that demands a form of conversation stripped of smooth, nonconfrontational formulas that, in the

final analysis, mean nothing. Questions such as human's relation to God, or the relationship between spirit and matter or between the eternal and the temporal, need to be posed boldly and sharply. By making use of these deeply buried strata of tradition, Andrei Davydov has managed to return us to problems being discussed during the early ecumenical councils, when fundamental dogmas of the church had yet to be formulated and a lively search was underway for the right forms of faith and word and art.

Every age is called to interpret anew the foundations of faith. If this happens Christianity becomes a living spiritual tradition instead of a museum of treasures from ages past.

Byzantium or Russia?

In the world of iconography, we frequently come across debates between proponents of the Russian and the Byzantine (Greek) styles about which style or school is more appropriate or relevant to contemporary iconography. To be sure, within the Orthodox world they were never seen as being in opposition. After all, the art of Old Russia was born out of the Byzantine canon, and only over time acquired its own style and personality. What is more, Greek art has always been valued in Russia, just as Greek icons were always held in high esteem. Even after the fall of the Byzantine Empire Russian iconographers continued to look up to and learn from Greek master iconographers.

For complex historical reasons, the iconographic canon came together and received its further development within the world of Byzantine art. Byzantium was the center of Eastern Christianity up until the fifteenth century. And it was in Byzantium, or, to put it more precisely, in the eastern half of the Roman Empire, that the ecumenical councils took place that formulated the fundamental articles of the faith, which subsequently defined the entire architecture of church life within Orthodox Christianity.

The art of Byzantium was understood to be a continuation of theology by other means: it was a nonverbal sermon, a speculation in colors, a form of embodied prayer. The influence of Byzantine art was enormous. What is more, Greek artists worked all over the world, from Italy to Georgia. As a result, Byzantium influenced the development of many different local

traditions, even though different countries felt this influence in their own way, and in the end the style of the students was unlike that of their teachers.

Today the choice for Byzantium or ancient Rus' amounts essentially to an aesthetic preference. Some artists prefer the classical precision of the Byzantine style, others the gentle colors and softness of the Old Russian style. Arguments about which is better become pointless because in the end it is the talent of the individual artist that is all-defining. To explore this further, I would like to describe two master iconographers whose styles are far apart, but who have both done much to define the modern iconographic tradition. Both are endowed with such a high degree of artistic freedom that each has also mastered both the Byzantine *and* the Russian styles and makes use of either style as appropriate for the given task.

Alexei Vronsky is known as a prominent representative of the Russian style in contemporary iconography.[47] Subtlety and elegance of drawing; an ability to use nuance in the tonal modeling of the painted surface; love for detail, but never at the expense of the unity of the whole—these are the qualities that set him apart from other iconographers. He is firmly committed to the canon but is drawn to the style of Russian iconography between the twelfth and fifteenth centuries. The icons he creates are noble, refined, and elegant, at times slightly mannered, but the artist's innate sense of harmony preserves him from ever slipping into sentimentality or excess.

His drawing is always precise and elegant and almost overly refined; the bodily proportions are elongated, the saints' faces are noble and inspired, and, although somewhat aloof, are also deeply meditative. His works are noteworthy for their refined sense of color. Vronsky applies paint that is bright and saturated with color, but he arranges these colors harmoniously and festively. He uses gold freely but with great delicacy, drawing the fine rays of gold assist with great subtlety. He combines semitransparent light overtones with elegant but fantastical ornamentation. All this creates the sensation that we are looking at shining jewels: the finery and the beauty of another world. Vronsky's most recent icons were painted for the iconostasis of the Moscow Church of the Holy Trinity in Golenishchevo. And yet, Vronsky sometimes makes use of the Byzantine tradition—as he did, for example, in his icons of Christ and the Theotokos Enthroned for the church of Saint John the Theologian in Yamburg, Russia.

An adherent to the Byzantine style can be found in Alexander Chashkin. Chashkin is a born monumentalist. Though he paints both frescoes and icons, even when painting wall-mounted icons he feels drawn to largeness and monumentalism in his forms. The drawing of this master iconographer is precise, his colors are bright and open, and he is not opposed to decorativeness. A somewhat over-emphasized didacticism in his work is compensated for by its sincerity and openness. His icons' main ideas are transmitted by their form, which is molded energetically and with great plasticity, and the viewer feels this energy.

In his early period Chashkin worked in the Old Russian style, but he later came to prefer the Byzantine style, finding in it a greater depth of theological content as well as a clear expression of that content in its form. He nonetheless remains a Russian artist because during his search for aesthetic perfection he never renounces the element of emotional expressiveness that has always been so valued by Russian iconography. This latter quality is particularly evident in his most recent work, for example, in his icons and frescoes for the Church of the Mother of God, Joy of All Who Sorrow.

Another of the leading iconographers at work today is Alexander Sokolov, who is drawn to the classical and the universal. He chooses neither the Byzantine nor the Old Russian tradition, striving instead to find a middle ground between them. He is multitalented in many fields and media. He creates icons in tempera, paints frescoes, makes mosaics and jeweled artwork; and he also leads brigades for creating monumental artwork in churches.

Known for his fidelity to tradition and conscientious attention to the canon, Sokolov manages to marry this discipline to a sense of artistic freedom and a living relationship with his creations. Unlike many of his contemporaries, he manages to combine an authorial individuality of style with a strict adherence to the canon. His drawn outlines are precise, but without any rigidity of line. The flexibility of the silhouette is combined with lightness in the movement and gestures of his subjects.

In his faces we find a strict iconographic solemnity combined with warmth of human feeling—one senses in them a unity of spirit and soulfulness—such that his likenesses manage to be free from passions without being free of emotion. This purity and refinement of emotion resounds like a

pure note in his work, a result further facilitated by the soft light that washes over the entire spatial surface of his icons.

Alexander Sokolov strives to make clear to the viewer that saints are living, flesh-and-blood people, but they live within an inapproachable light, and it is by this same light that they have been illumined and transfigured. At the same time, this iconographer is never imitative or stylized in his approach to the ancient icon. To the contrary, the freedom and even virtuosity with which he commands the ancient iconographic language and its techniques that have been honed over centuries allows him to create images that are entirely modern. His icons are altogether sincere, at once filled with inner substance and open to the viewer. In the end, what most specially characterizes the icons painted by Sokolov is spiritual balance, their inner sense of measure and artistic harmony.

The works of Sokolov stand as a brilliant testimony to the ability of modern icons to acquire a voice of their own. The icon, after all, is a testimony to the faith of those living *today*, in the modern world, even if it is also true that they appeal to us from the perspective of eternity.

<p style="text-align:center">⚜</p>

Most of the major icongraphers at work today are from Moscow. People talk today of the Moscow school (despite all the caveats that must surround any use of this term, as noted at the outset of this chapter) being the leading school in the world of Russian iconography. Perhaps this is explained, at least for the most part, by the fact that the rebirth of the iconographic tradition got an earlier start in the Russian capital than elsewhere.

What is more, the major Russian art institutes are located in Moscow, not to mention the majority of icon restoration studios and museums—in short, a wealth of resources reside in this city. At work throughout Russia as well as beyond Russia's borders, Muscovite iconographers are stimulating the further development of the art, particularly in the Russian provinces. For this reason, at least, we may refer to the Muscovite school that has exerted great influence on the Russian "school" overall.

Although a number of local master iconographers are at work in the Russian provinces, some for long periods of time, and several with interesting

and original work, their artistry in general is not of comparable level, and some still lack experience. Many have studied in Moscow or under the tutelage of a Moscow master iconographer, and they often continue to work in collaboration with their teachers.

All over Russia we see similar processes at work. For example, in St. Petersburg iconographers can also be divided into the Byzantine group and the Old Russia group. Comparing the art of the two cities, the difference between the Moscow and St. Petersburg schools readily becomes apparent. While it is much more characteristic for Muscovite iconographers to embrace artistic freedom and renounce the direct copying of the ancient models, St. Petersburg artists are more deeply steeped in their academic training. This prevents them from moving too far away from their source material and produces a marked preference for the canon over the personal in their art.

Among those producing interesting work in St. Petersburg are Natalia and Nikolai Bogdanov. This team (a married couple) is among the most consistent followers of Byzantium. Their works display a high level of mastery, exhibiting subtle technique and precision in their drawn lines. Their compositions are well assembled and imbued with an obvious care for every detail. Their choice of color is varied and achieves an enamel-like brilliancy that forms a very lovely contrast with the shimmering of the gold. All this makes the Bogdanovs' icons bright and memorable.

On the other hand, the viewer might feel in their icons a certain distance, a certain impenetrability and aloofness as though the artists, distracted by the virtuosity of their own technique, have lost sight of the devotional purpose of their iconography—forgetting that icons are created not to elicit aesthetic pleasure but to facilitate prayer.

Another master iconographer from St. Petersburg, Georgii Gashev, works in the Old Russian tradition. He characteristically turns for inspiration to the golden age of Russian icon painting—the fifteenth century, the time of Andrei Rublev and Dionisius. Gashev's handling demonstrates a subtle understanding of the medieval Russian aesthetic: sonorous lines and elegant drawing produce refined figures, with spiritual faces. His noble compositions are animated by a palette of resonant colors with the warm tones predominant.

Nonetheless, in certain images created by Gashev the softness of line and warmth of color appears to mask an inner hardness, as if one has run into a closed door behind the velvet curtain, and this hinders prayerful contact. This is most clear in his icons of the Savior and of certain saints. Once the iconographic devices become aestheticized, they no longer serve to convey meaning but become instead a self-sufficient artistic task and a display of artistic virtuosity. More successful are his icons of the Mother of God, including his Vladimir Theotokos, Our Lady of the Don, Theotokos of the Passion, Our Lady of Pimen, and Theotokos of Iversk icons. A mere aestheticism would be altogether inappropriate here, and the artist's characteristic lyricism now becomes filled with a soulful warmth. It is interesting to note that Gashev's preference for the Old Russian style leads the artist to rework even those of his icons that are based on a Byzantine prototype, and he moves them much closer to a Russian school stylistic.

Women Iconographers

As noted before, in ancient Rus' just as in the Byzantine Empire, iconography was a strictly masculine activity. Women did not paint icons. Women were normally involved in the production of embroidered icons, shrouds, processional banners, veils, vestments (which in earlier times were often decorated with embroidered icons), and similar ecclesial articles. To be sure, embroidered icons were treated as devotional objects, but it remains the case that iconography, not only as an art form but even more important as a means of theological expression, was considered outside of women's province. Today, many women have become iconographers, achieving success on the professional level and moving beyond copying of prototypes and into development of new icons of their own.

A participant in the first exhibit of modern iconography in 1989, Olga Volodna-Klodt currently lives and works in Moscow. She has worked in the field for more than a quarter-century, and her icons can be found in churches in Moscow and beyond as well as internationally. Her works are remarkable for the precision of their use of the iconographic language. Although faithful to the canon, she does not follow it slavishly, instead making use of it in a spirit of respectful freedom. Other noteworthy

characteristics of her work include sonorous colors and flexibility of line, softness in the application of color, disciplined use of ornament, and images that are warm, spiritually recollected, and meditative.

Her icons are very well suited to the atmosphere of a church, even if other icons made in a different style are already present. In the context of a multitiered iconostasis, her icons harmonize well with one another. For the most part Olga Klodt orients her work to the Old Russian tradition, albeit in a modern interpretation. She has taught iconography for many years. Many of her students are already working independently.

In the town of Rostov is yet another master iconographer, Tatiana Sannikova. Even though her point of reference is Byzantine and post-Byzantine art, she subjects these classical forms to her own rather drastic reinterpretation. Her bright and richly saturated colors and her abundantly detailed yet nonetheless harmonious compositions conspire to create an impression of joy and celebration. Her works are also quite representational. One can feel the solidity and monumentality of her saints as well as their nobility and genuinely regal dignity. No fleshless visions, here we have pillars of the faith, rock-solid foundations of the heavenly kingdom. Their faces reflect light from a heavenly source and are not without natural beauty.

Fifteen years ago Tatiana Sannikova moved from Moscow to the city of Rostov, where her husband is a priest. There she organized a school for iconography and trained students. A number of these now assist her in assembling large iconostases. Most of Sannikova's works are in churches within the parish of Rostov, although some can be found in Moscow and a few have even made their way overseas, including to the United States.

The Rebirth of the Iconographic Production Team

In Old Russia, it was rare for an iconographer to work alone; more often he would work as part of a production association or team. There is nothing unusual in this, as single artists would have had difficulty managing even a single large iconostasis, to say nothing of an entire church. The iconography team was a community of artists who organized themselves along the lines of a production shop with a strict segregation of labor. Different groups would specialize in preparation of the boards, application

of the layers of white gesso, grinding paints, application of the gold leaf, the drawing of the supporting elements (hills, trees, tents, clothing, and so forth), and, finally, the master iconographer would draw the main figures and faces. This sort of division of labor was particularly useful when working on a monumental scale or when creating icons for an iconostasis.

It is obvious that this style of work would tend to whittle away at the authorial principle, even though the influence of the lead master iconographer would still be felt throughout. Certain icons would be painted only by the master iconographer from start to finish, in which case one can speak with greater confidence about individual styles.

Modern production teams are usually organized differently. Today they are free associations of iconographers with each artist drawing his or her own icons, even if it is to be placed into an iconostasis. While this makes it easier to preserve an author's identity, on the other hand, combining dozens of different icons produced in several authorial styles within a single iconostasis challenges stylistic unity. In such cases the production team develops what might be called the group style of the association as a whole, and then the individual artists subordinate their individual look to this unified conception. Work in a production team is not unlike singing in a choir, in the sense that all the voices need to combine into a single sound, although even in a choir there can be parts for soloists.

In Russia today there are many iconography production teams, although few have spanned the decades. Indeed, they have a tendency to fall apart, precisely because too many individual iconographers insist on the role of soloist within the choir. Sometimes a production team will come together for some limited purpose, such as the painting of a church, and disperse immediately afterward. But some teams that came together as creative art studios have survived for a number of years and have had a more or less stable membership. These are the ones that manage to create a personality and look all of their own, precisely as a production team.

One such team is the Stolichny ("Capital City") Iconographic Studio. Founded fifteen years ago in Moscow by Tatiana Trubnikova, its artistic director is Kira Georgievna Tikhomirova, the well-known Russian conservator and iconographer. The team has a long-standing relationship with the Andrei Rublev Museum of Ancient Russian Culture and Art. Originally, the

studio was created for the purpose of training iconographers, but after the students were trained, they began taking on commissions from the church. With time, the studio developed a style, honed its artistry, and acquired a real personality of its own. Now this studio has become prestigious and has a wide clientele. This in turn keeps the studio stable with a good work rhythm that provides excellent opportunities for continuous development.

The Stolichny Studio functions as a collaborative association of iconographers who see their task as disclosing the spiritual meaning of the icon for the modern person. Alongside the studio's ongoing work of painting icons, its team members also continuously engage in study of the tradition, even though the studio continues to orient itself to the style of the Moscow school of the fifteenth to sixteenth centuries. In making choices of subject matter, the studio's artists try to avoid limiting themselves to just the well known, textbook choices, instead making every effort to stretch the iconographic spectrum. And this may mean turning to Byzantine Greek art, or icons from Mount Athos, the Sinai, or Serbia. Whether it is the choice of the iconographic prototype or the way the team works with it, they proceed creatively and with attention to the meaning and the demands of the given context—for example, the architecture of a given church, or the icon's purpose, the nature of the parish community, and even the tastes of the client. Over the fifteen years that the Stolichny Studio has been in existence, it has produced a great many icons and iconostases for churches in Russia and in countries all over the world.

The Revival of Monastery Iconography

Another place that modern Russia is experiencing a major revival is in the monastery. Over the past twenty years hundreds of monasteries and hermitages have been revived. Many arose literally on top of their own ruins, as everything had to be rebuilt. Neither walls nor support structures nor even the church buildings had been left standing. Today, the traditional monastic arts-and-craft traditions are also being revived. And in many monasteries—including the Optina Hermitage near Kozelsk, Novospassky Monastery in Moscow, and the Saint John the Theologian Monastery in Ryazan—so too is the monastic iconographic tradition.

The Novo-Tikhvinsky Monastery in Ekaterinburg is particularly successful in this regard. Founded in 1810, then shuttered in the 1920s, the monastery was reopened again in 1994. The residents include more than 150 sisters, of whom five have reached the rank of the Great Schema and forty-eight are novices. The former traditions are gradually being restored here. There is a monastery choir and there are studios for iconography and embroidery work. Monastic iconographers here produce individual icons and have created several entire iconostases. They have also set up a large workshop for sewing and embroidery work; the sisters manufacture clothing for the clergy, vestments for church use, monastic garments, and everything else that such a large monastic community needs.

The earliest traditions of liturgical chant are also being reborn within this monastery, as the sisters are studying *znamenny* chant.[48] Prior to the revolution there were some one hundred sisters at work in the Novo-Tikhvinsky iconography studio. The icons created by the nuns, as well as their handmade miniatures and painted souvenirs, were very widely known, and sometimes even given as gifts to members of the royal family. Today there are seven nuns at work in the convent's iconography workshop.

The iconographic works created by the Novo-Tikhvinsky sisters show the influence both of the canonical foundations of the icon—with special attention to the classical Byzantine prototypes—and of the folk art aesthetic, for which ornament and decoration are of such great importance: hence the use of various stones, enamel, silver basma, and so forth. As a rule in these icons, the central image will be surrounded by marginal depictions of saints or angels. The form of the margin will likewise be more elaborate in their icons than is the norm for classical icons. Great attention is given to folding icons, such as triptychs and diptychs, as well as to the manufacture of beautiful icon-cases. In sum, the elegant iconographic style of the women artists at Novo-Tikhvinsky Monastery represents a revival of the tradition within the full integrity of its varied aesthetic achievements.

New Forms of Iconography

Over the past two decades a great many new images have made their appearance within Russian ecclesial art. This has happened because the church now has the freedom—of which it had been deprived for many years—to canonize saints, and it is now working actively to make up for lost time. During the councils held over the course of the 1980s and 1990s, dozens of persons were canonized. And during the Jubilee Council of Bishops of the Russian Orthodox Church in the year 2000, some 1,154 new saints were sanctified, most of whom were either new martyrs or confessors who suffered through the Soviet period of 1917–1991.[49] Tradition dictates that a new icon be created for every saint. It is difficult for the Church to keep up with this sudden large increase in the number of saints and to properly study the person and personality of each of them. Never a hurried, assembly-line affair, the creation of new icons takes time. It especially takes time for these new saints to find their proper fullness of veneration within the ranks of the laity.

Not every iconographer is capable of creating a new icon; indeed, quite the contrary. This is a task reserved only for the most accomplished of master iconographers. It requires fluent command of the iconographic language, profound theological knowledge, and a certain depth of spiritual understanding and attainment. Only such an iconographer is capable of using color and line to give form to personal holiness and true theological content. In order to create a new icon, an iconographer must have a broad understanding not only in the realm of art, but also in Church dogmatics, the history of the Church, hagiography, liturgics, and more.

To take on such a difficult and important task requires courage and even a certain audacity. It means that the master iconographer may have to go beyond his or her predecessors. An ability to think independently is required. At the same time, there is no place here for individualism or self-expression for its own sake. The iconographer is expected to be willing and ready to absorb the entire catholic (*soborny*) experience of the Church, in all its depth, and transfer that experience to the icon board or the wall of the church.

Unfortunately, not every modern iconographer has this depth or the skill to fulfill the task. Some, fearful lest they violate the canon, strive to keep their work within the strictures of solid, respectable handicraft and live by the principle, "Who are we, in these times, to dare having views of our own?"[50]

Others go to the opposite extreme. Acknowledging no outside authority of any sort, they consider their iconographic creativity to be wholly a matter of their own artistic prerogative. This is why some of these new icons elicit astonishment and, on occasion, even bitter argument.

The twentieth century confronted modern iconographers with a number of challenges that simply did not exist for earlier generations. And many of these challenges have to do with the creation of representations of the new saints. There is, first of all, the problem that in most cases the faces of these saints are well known. Take, for example, the case of Saint Tikhon, Patriarch of the Russian Church. We have inherited a great quantity of photographs taken during his lifetime, not to mention portraits and even movie reels with images of the patriarch. One might think that this would ease the task of the iconographer. In point of fact, it has the opposite result. The superabundance of information serves mainly to hypnotize contemporary artists, binding their hands. Anxious to create a recognizable image, the artist finds it almost impossible to avoid lifelike realism, the imitation of earthly realities. At times she may even slip into crude naturalism. By now we have accumulated quite a few icons of Saint Tikhon, but only rarely do they match up on levels canonical, spiritual, and aesthetic.

The newly painted icons of Patriarch Tikhon often fail to reach that level of canonical idealization called for by the Byzantine and Old Russian tradition. Several of them are not quite iconographic—but more like portraits. The viewer has no feeling of an encounter with the saint's essence as it exists in the kingdom of heaven and finds no evidence of the miracle of transfiguration. In other cases, we notice a different extreme: in an effort to create generalization of the image the artist falls into abstractionism. The saint's well-known face is distorted to the point that it is no longer even recognizable. The holy countenance has been transformed into a mask. The viewer finds it difficult to feel an inner connection with such an icon, and it fails as an aid to prayer because no connection is made with the true

prototype. Somehow the iconographer must find his or her way through these contradictory temptations in order to create an authentic new icon. And only very few succeed.

The greatest problem for modern Russian iconography, however, is the depiction of the royal martyrs, or passion-bearers, as the martyred members of the Tsar Nicholas II's family are known. Even with the many varied depictions of the royal family, there's no sense of agreement that a canonical (in the sense of generally accepted) likeness has been created yet, even as several relatively successful icons of new saints have been written, and in future there undoubtedly will be many more.

Besides the new martyrs, various narrative compositions have recently become popular. For the most part, these depict scenes from the lives of saints. Stories of the lives of saints have always been a favorite reading material in Orthodox cultures. In the modern world, however, the interest in the lives of saints has taken on an added dimension. The modern person seeks in the image of a great saint more than a model for imitation; the contemporary seeker looks for a person capable of answering questions posed by his own life in today's world. And lately, new icons dedicated to saints depict hallmark scenes in the saint's life. A particularly striking example of this can be found in the icon of Saint Seraphim of Sarov (1754–1833) produced by the studio of the Muscovite iconographer Pavel Busalaev.

Saint Seraphim presents an apt object of iconic veneration: he is said to have sometimes been transfigured by the divine light while at prayer, such that his face shone like the sun. Indeed, the saint, a practitioner of hesychasm, spent many years immersed in prayer while living as a hermit in the northern Russian forests. On one occasion a passerby saw him calmly feeding morsels of dry bread to a hungry bear. Much loved in his own lifetime, Saint Seraphim's inspiration has had a continuing impact on Russian culture. Icons of this saint, it is worth noting, have historical basis, as a portrait of Saint Seraphim was painted by an artist (later a monk) named Serebriakov five years before the saint passed away.

The names and examples cited in this chapter represent a few key names in the formation of the modern Russian iconographic milieu. There are many more master iconographers, each unique and with an inimitable style of his or her own. This variation witnesses not only to God's inexhaustible generosity toward Russia, but also to an increase in artistic freedom—the necessary condition of all creativity, including in the ecclesial sphere. Freedom that lives within the framework of a canon is the most difficult of all freedoms, but it is also the principle that the masters of the past so brilliantly embodied in their work.

BEAUTY SAVING THE WORLD

The Icon Outside of Russia

momentous meeting between the West and the Russian icon took place at the outset of the twentieth century, when the French painter Henri Matisse traveled to Russia. At an exhibition of ancient icons, Matisse had his first encounter with icons painted by the Old Russian masters. The father of the European avant-garde discovered there everything modern art had been strenuously seeking—color applied locally, linear composition, expressive silhouettes, two dimensionality, image as sign. Subsequently, many twentieth-century artists began to style their works in imitation of the icon, with some even titling artworks "modern icons" or "the new icon."

As we saw in chapter 4, a second momentous encounter between the icon and the West took place with the postrevolution Russian emigration, which overturned many of the West's preconceptions about Russia. In this appendix we meet some of the more important artists, both Russian and non-Russian, who are the modern beneficiaries of these earlier encounters.

In the 1920s and 1930s centers of Orthodox culture appeared in the West—centers that helped preserve Russia's literary, scientific, and philosophical heritage at the same time that they gave rise to a new school of iconography—the Paris school. This contact of Russian culture with the West went beyond mere aesthetic delight in the exotic. The icon was becoming an authentic presence in Western culture, initially, to be sure, in

the form of an Orthodox subculture, but later becoming an integral part of everyday European—and, after the war, American—life.

The collapse of the iron curtain gave rise to yet another upsurge in Russia's cultural presence in the West. Now, however, it was no longer a matter of exiles and emigrés obliged to live outside their native land, but of professionals choosing to travel outside of Russia, or to work in Europe, America, Japan, Australia, and throughout the entire world. Prior to World War II, Western society had little familiarity with Eastern Orthodoxy. This is illustrated by an amusing incident in the life of the Russian theologian Sergei Bulgakov, who emigrated to the West in 1922. At one point, in the early 1930s, he was traveling on business in England and, as was his habit, was wearing his priestly robes and a cross. A fellow passenger on the train became curious about his unusual dress and decided to make some inquiries:

"Excuse me," the passenger asked. "Could you tell me who you are?"

"I'm a priest," Father Bulgakov answered.

"Of what religion?" the passenger asked.

"Orthodox," Father Bulgakov replied.

"You mean you're Jewish?" the passenger replied, incredulous.

"No, I'm a Christian," Father Bulgakov answered, pointing to his cross.

"Oh, so you must be Greek."

"No, I'm Russian."

"What, you mean to tell me that Russians are Christians?!"

Such was the average European's knowledge about Russian culture and religion. But that changed dramatically after the war. World War II encouraged the West to look with new interest toward the East, as their countries cooperated in the struggle against Nazism. And after the war, the Orthodox Christian community became more cognizant of the need for unity in the search for foundations of the faith that could be held in common by all Christians. The search was joined by the World Council of Churches, theological commissions, and international conferences on interdenominational dialogue. Activities such as these helped stimulate Western receptivity to the traditions and culture of their Eastern brothers and sisters.

The East, the cradle of Christianity, became the main inspiration for twentieth-century theology. As early as the interwar years a new generation

of theologians had become interested in the Eastern fathers and the spirituality of the Eastern Church. Such theologians as Henri de Lubac, Hans Urs von Balthasar, Jean Danièlou, Marie-Dominique Chenu, and Christoph Schönborn, among others, became knowledgeable scholars of the patristic sources, and a new published series called *Sources Chrétiens* (Christian sources) presented, together with commentaries, translations of the writings of the Eastern and Western fathers of the church.

As a result, Western readers were given the opportunity to become acquainted with the theological classics of the Eastern Church. This "pilgrimage to the East" also served as a forerunner of the Second Vatican Council, which, among much else, reassessed relations between the Roman Catholic Church and the Eastern—and especially the Orthodox—Churches. It is of undoubted significance that many of these same theologians were active participants in that council and were the authors of its most important documents.

The Icon in Europe

For European Christianity, the twentieth century was a time of experimentation and crisis. Thousands of people left the church and mass culture became cut off from Europe's Christian roots. And yet, at the same time, a new spiritual consciousness was forming, one that sensed with new urgency the need to seek out the foundations of faith and to reach out to other Christian denominations. Even as the percentage of believers in the population had shrunk and churches in urban centers often stood empty, nevertheless, places of renewal were appearing in many European countries where Christians were seeking new forms of spiritual life along with the renewal of Christianity as a whole. In this search and renewal, icons played a vital role.

Thanks to the Russian emigration, educated European society became aware of Russian religious philosophy, Orthodox culture, icons, and the liturgical richness of Eastern Orthodoxy. Churches of various denominations, including some that had never done so in the past, began to display icons, as did museums and many secular individuals. While this was considered fashionable by some, a serious spiritual interest accompanied this new

awareness. Vladimir Ryabushinsky, the Paris-based organizer of the Icon Society and a promoter of icons, referred to this upsurge in interest as "the icon movement." Writing for the journal *Vozrozhdenie* (Renaissance) in 1955, he noted:

> The icon movement in French and Belgian Catholicism (we will limit ourselves to these two countries) is not a single current, but consists of a number of different streams and streamlets. . . . Among the most prominent of these is the work of the Benedictine Monastery of Chevetogne in Belgium.[51] This monastery produces a large quantity of reproductions of Russian Orthodox icons; it tries to select only the best icons, the older ones, and distributes them to Catholic churches all over the world. In theory, Catholicism has always recognized the validity of Orthodox icons, but in practice they are only very rarely met with inside a Catholic church. This is what makes the work of the Benedictines so significant: they are, so to speak, constantly reminding the Catholic world about the dignity and holiness of the icon.

Ryabushinsky believed that the icon movement came as a response to the West's uprootedness from its own Christian sources. The icon seemed to point a way out of the resulting spiritual crisis. He welcomed this Roman Catholic interest in the icon as the reflection of a spiritual beauty and witness to truth, as a way of reuniting the spiritual paths of East and West.

And today, at the opening of the third millennium, the Benedictine Monastery of the Elevation of the Cross remains the largest center in Europe occupied with integrating the spiritual experience of the East into the cultural life of the West. The founders of this center looked to the meaning and importance of returning to the united Christianity that can be found in our church's first millennium.

Including both the Byzantine and the Latin rites in its liturgical life, the monastery has a unique vocation.[52] Not only is there a great deal of scholarly activity at the monastery (conferences, colloquia, and publication of the journal *Irenikon*), but their network of contacts contributes in facilitating mutual understanding between Christians. The monks living at Chevetogne,

among them Father Emmanuel, paint icons and regularly invite well-known iconographers from Greece and Russia to visit the monastery. During the 1990s, Father Zinon came from Russia and worked there for a time.

Icons themselves assist in opening doors for different traditions to meet. A Westerner taking an interest in iconography and studying iconography as either a painter or a scholar almost inevitably arrives at an understanding of one of the essential aspects of Eastern Orthodoxy: the confession of Christ as divine beauty. And other European centers have begun integrating the Eastern tradition into their practice, among them the abbey at Niederaltaich (Germany) and the Taizé community (France).

Even as a certain number of spiritual centers oriented toward interdenominational dialogue and training in iconography have grown, others have closed. One such center was located in the suburbs of Paris, at the Centre Saint George in Meudon. At the time of its founding before the Second World War, the center had been organized by Jesuit priests as a shelter for orphaned Russian children. The introduction of Orthodox culture had been seen as a necessary aspect of raising these children. An Orthodox church was built on the hermitage's grounds, and it was decorated by the Russian émigré iconographer Georgii Morozov.

After the Centre Saint George was given the personal library of Prince I. Gagarin, a center for research and education was organized, which in turn published the journal *Symbol* and offered classes in Russian language and culture. Saint George was also renowned for its iconography school. Every year, hundreds of students traveled from around the world to study icon painting at Saint George. In 2003, however, the center was closed.[53]

Even as some Christian centers disappear from the map of Europe, others arise, renewing the flame of spiritual life and continuing their pursuit of beauty and meaning. Of all West European countries the one with the largest spiritual centers is Italy. The Russia Cristiana Foundation, headquartered in Milan, was founded in 1957 by Father Romano Scalfi as a center for prayer on behalf of persecuted Christians in the Soviet Union. After the fall of the Soviet regime, Russia Cristiana reoriented its mission and now operates as an educational foundation with its own research center and publishing house. Russia Cristiana now sees its mission as familiarizing the West with the experience of the Christian East as a means of reviving

the West's own deepest spiritual traditions, whose roots are in the first millennium church, a church undivided.

And one of those treasures which arose from the early church, and continues to unify the church, is the icon. The icon first came into existence, after all, within the womb of the united Christian tradition, and although iconic art was subsequently largely forgotten in the West, it continued to be preserved in the East. For Italian Christians, the icon is much more accessible than it is to Christians from other countries, because Italian culture was built on the foundations of the classical tradition. Examples of art from antiquity and early Christianity are easy to find in Rome or Ravenna, or other Italian cities. For Italians, the icon is not something that relates only to the East or to Russia. Today, perhaps not without influence from Russian artists, Italians are returning to their spiritual sources and restoring their own iconographic tradition. Russia Cristiana has operated its iconography school since 1982 in the Villa Ambiveri in Seriate. A variety of different iconographers have taught there, some Italian, others Russian, including Adolf Nikolaevich Ovchinnikov and Archimandrite Zinon.

Seriate also has its own master iconographers, most important of these being Paola Cortese, who has been involved with iconography for twenty years, studying under both Ovchinnikov and Father Zinon, and now herself a teacher. Grounded in the Byzantine canon, Cortese's work reflects the softness, lyricism, and naturalism characteristic of Italian art. Despite the apparent strictness of the iconographic canon, it continues to allow for the expression of the iconographer's own national characteristics and approach to piety.

Another important Italian spiritual center is Bose, a monastic community that received its name from a village located not far from Magnano.[54] In 1965, Enzo Bianchi, a young man who had just recently graduated from the University of Turin, came to the rundown village of Bose and began living there as a hermit. Over the next three years several others joined him, and a community was formed. In 1973, the brothers were tonsured as monks. Today in Bose there are two monastic communities, one for monks and the other for nuns, and the community is ecumenical, with many Roman Catholics, a few Protestants, and even one retired Orthodox bishop. The community's goal is to revive monastic life, to engage in a deep reading of

the Scriptures (Enzo Bianchi's method being *lectio divina*) and in a thorough study of church traditions both East and West.

Icons hold an important place in the life of this monastic community. Several monks and nuns, having mastered the essentials of iconography, use the monastery's icon workshop. They continue to work on deepening their understanding of the artistic and theological language of the icon. Russian iconographers visit regularly, and members of the Bose community sometimes travel to Russia to learn more about the Old Russian iconographic traditions.

One monk says of the icon that it "is an image of unearthly beauty that brings us closer to heaven." Meanwhile, the monastery itself creates the impression of being a little corner of heaven. It is located in the mountains in a picturesque locale, and every detail seems to have been thought through with subtlety and taste, whether it is a courtyard adjoining the refectory, or stones placed along a pathway to the church, or a sundial built into the slope of a hill. It is in this monastic setting that members of the community try to perceive the primary, uncreated, and divine beauty. The icon helps them to achieve this.

The iconographers at the Bose monastery paint in a wide variety of styles—Old Russian, Coptic, Ethiopian, Romanesque, Gothic, and in the style of the early Italian masters prior to Giotto. From this monastery's point of view, all these divergent styles are simply different dialects of the one language spoken by the church prior to the schism of the early church.

The fascination with icons has also made its way to the Roman Catholic Church's center, the Vatican. As early as the 1930s Russian icons have been created here, including the iconostasis for the Papal Oriental Institute (Russicum). And in the late 1990s, at the request of Pope John Paul II, the Moscow artist Alexander Kornoukhov created mosaics for the Vatican's Mater Redemptoris Chapel.

Every year, prominent Russian iconographers travel to Italy and work in various cities. The St. Petersburg artist Alexander Stal'nov received his first invitation from the Icona Association to visit the Italian city of Bologna in 1993; ever since, he has offered a regular series of icon painting classes there. In 1996, Stal'nov became head of the Bologna Association of Iconographers. A noteworthy artist, he works equally fluently in the Old Russian and the

Byzantine manner and sometimes turns for inspiration to the early Italian masters. His approach to the canonical models is fairly strict, even though he does not simply copy icons; he strives to make his images more easily readable by a modern sensibility through lightening his palette, making changes to the stylistic treatment of the face and body, and adding a variety of decorative elements.

In Italy, with its Roman Catholic culture and immense artistic tradition—notably including, both in the north and in the Greek-dominated south, some of the finest examples of Byzantine art anywhere—it is hardly surprising that still today there exists a widespread interest in icons. In northern Europe, by contrast, a Protestant culture had to emerge from a lengthy period of iconoclastic rejection of ecclesial art. A rather stark difference—nonetheless, even the countries of northern Europe have witnessed a dramatic upsurge of interest in icons during the twentieth century.

England became acquainted with icons to a great extent through the efforts of an Orthodox-Anglican brotherhood called the Fellowship of Saint Alban and Saint Sergius, founded in 1928. Several prominent Russian émigré theologians and philosophers were among its founders, including Father Sergei Bulgakov, Father George Florovsky, and N.M. Zernov. Noticing a need for both dialogue and a search for their common spiritual foundations, a number of Orthodox and Anglican Christians gathered to get to know one another and jointly organize educational and spiritually oriented programs.

While defending what is basic to both traditions, the fellowship aims to be a witness to the world that the Orthodox and Anglican traditions, despite all that separates them in terms of their historical paths, are nonetheless branches of one church. From its beginnings, the arts, especially music and iconography, have always been of central importance, and in the 1930s the fellowship acquired Saint Basil House in London, where a chapel was created, and the iconographer Sister Joanna (Julia Reitlinger) was invited to paint its interior.

N.M. Zernov, who participated in the decoration of the chapel, described the process in his personal journal:

> The home chapel was meant to be the fellowship's center of prayer
> for Christian unity. We decided to create it as an expression of our

artistic preferences. To assist with this, Joanna Reitlinger, one of Father Sergei Bulgakov's spiritual daughters, came to us from Paris. . . . She painted the whole interior using variations on a single theme: the mystery of the Church. Her image of the Savior in the iconostasis is a masterpiece of modern iconography. The five main panels of the lower row of wall murals present the visual manifestations of the Church. We find here groups of saints—Byzantine, Latin, British, Russian, and from the Near East—each against an appropriate architectural background. The upper row of murals depicts the heavenly destiny of the Church. . . . The chapel has both an Orthodox altar and an Anglican altar table, to perform the services of both churches. In this respect, it is a unique church.[55]

Regrettably, Saint Basil House no longer exists, but the Fellowship of Saint Alban and Saint Sergius continues its activities as well as its interest in icons.[56]

Over the years, this interest in icons in England has not faded. In the 1960s–1980s, the best-known iconographers in England were Mariamna Fortunatto and Patricia Fostiropoulos, both students of Leonid Ouspensky. Their icons beautify the Cathedral of the Dormition of the Mother of God in London. And students of these two iconographers now work throughout England and include both Orthodox Christians and Anglicans. Worthy of special note is the iconographer Edith Reyntiens, who painted icons of British saints for the cathedral in Durham, England. In addition to English iconographers, there are also English theologians who have taken a serious interest in icons, including Rowan Williams, the Archbishop of Canterbury, who takes up the question of icons and their veneration in a number of his books.

Russian iconographers began to travel regularly to England starting in the early 1990s, for exhibitions and individual commissions, and from time to time to paint churches. The Moscow iconographer Olga Klodt spent several years fulfilling one such commission, and the Russian iconographer Sergei Fedorov, now living in England, enjoys popularity with several of his icons hanging in Westminster Abbey.

The Russian diaspora in Europe is fairly sizable, having been formed by three separate waves of emigration, from the first wave immediately after the

revolution, followed by the post–World War II emigration, and finally by the 1970s wave, with additional Russians coming to Europe, now, for a variety of reasons. This has led to the growth of Orthodox parishes and their churches, which often commission Russian iconographers for these churches.

In these instances, the artistic task is complex: such icons must be at once appropriate for an Orthodox place of worship that, at the same time, is also located in a different cultural milieu. Most of the parishioners are descendents of earlier Russian emigrations and are often no longer fluent in the Russian language or deeply conversant in Russian culture. And, in recent years, Orthodox churches are attracting many new converts who have no roots in Russia at all, and who have chosen Orthodoxy in pursuit of their personal convictions. In this context, icons á la Russe—however much homesick Russians of the first or subsequent immigration waves admired them—are no longer appropriate.

More fitting are icons with a more modern interpretation. An impressive example of this can be found in an Orthodox church located in Zurich, Switzerland, whose entire interior was designed and built by Muscovite artists. The monumentalist artist Alexander Kornoukhov created the church's altar mosaic, and its marble altar barrier was designed in the Byzantine style by architect Irina Rodionova. Ilya Kruchinin painted the church's icons. Right from the start there was very little of the traditional in this church, whose parish was given a flat-roofed structure—an unusual form in the Orthodox world—for its liturgical space. To instill such a building with a liturgical atmosphere, the artistic forms needed to be quite active, and this is precisely what the Moscow artists managed to accomplish.

The iconographer Ilya Kruchinin, a master iconographer, has been involved in ecclesial art for over twenty years. His style is highly expressive, his images distinctive and individual. The monumentality combined with a certain brutalism, even, of his images gives them a modern look far removed from the stylizations and imitativeness met elsewhere. And yet at the same time, his images manage to remain faithful to tradition even to an extreme degree. By combining elements of both modernity and the iconographic canon, Kruchinin has found an idiom that allows him to communicate with a contemporary world, one that finds it hard to relate to what might be considered the external prettiness of the more traditional icons.

A more recent example of reconciling branches of the church can be found in the rapprochement of the Russian Church Outside of Russia (ROCOR) and the Moscow Patriarchate—the two halves of the single Russian Orthodox Church sundered by the revolution. Agreement has been reached on Eucharistic union and the con-celebration of the liturgy—a process that demonstrates the healing of historical wounds. Across Europe, ROCOR's hundreds of parishes have developed certain traditions of their own, and this includes iconography. This tradition has evolved over decades within the context of a constant struggle for survival, and it is noticeably more conservative than the iconographic art being brought to Europe by artists from post-Soviet Russia, but something new will no doubt arise from the intersection of these two Russian traditions in dialogue once again.

The Icon in America

Over the past several decades icons have gained a more prominent place also further west, in American culture, again due to the expansion of Orthodoxy in North America. When the second wave of Russian émigrés arrived on western shores in the middle of the twentieth century, they filled in the ranks of an Eastern Orthodox milieu already occupied by Ukrainians, Greeks, Serbs, Romanians, Syrians, and others.

Since 1970, the Orthodox Church in America—most of whose members self-identify as Americans (as opposed to some other ethnicity)—has had independent, or autocephalous, status as a national church. Though Orthodoxy in America is steadily becoming less ethnically homogenous, it remains inextricably linked with the icon. Unlike Europe, with its 2,000-year-old tradition of Christianity, America's Christian culture is nearly four centuries old, and no doubt this explains iconography's different course of development here. For most Americans, iconography represents not a return to the source, but a new form of art whose roots in the culture are not yet quite established. Nonetheless, America is developing its own iconographic tradition. Although it is still far too early to speak of an American school, we can nonetheless already distinguish American characteristics and directions.

Among the pillars of American iconography is Archimandrite Kyprian Pyzhov, who came to America after World War II and began working in Jordanville, New York. As the Russian Church abroad is well known for its conservatism in matters of liturgy and theology, and this goes for its iconography as well, it is natural that Father Kyprian's work has an observable strictness of style and insistence on the canon. He avoids any departure from accepted norms. To all appearances, his teachers were Greeks and Russian Old Believers. From the former, he inherited strictly defined forms and sharpness of drawn outlines, and from the latter, subtlety of facial features, a relative dryness of color treatment, and a love for ornament.

Father Kyprian's style combines asceticism with decorativeness, severity with an almost gaudy colorfulness—yet all this is done without losing a sense of the organic whole; and indeed, the final effect is almost naïve. In the artist's icons and frescoes we find depictions of heaven that appear similar to Russian fairytale descriptions of "a world far, far away . . ." At the same time, in the faces of his saints we meet the presence of a veritable fortress of faith that stands as a defense against the temptations of this world—temptations not altogether unrelated to the fruits of civilization.

The Trinity Monastery in Jordanville was built as a spiritual oasis within a desert. But while monasteries in ages past formed in the deserts of natural landscapes, as with Judea or Nitria, for these monks of the twentieth century the desert they face is of a spiritual variety—an industrial society where spiritual values have lost their force. To a great extent, Russian immigrants understood the challenge they faced as one requiring a form of aesthetic resistance, and they resisted by preserving the image of beauty that had been cultivated within the world of Russian art over the course of many centuries.

As the founder of the Jordanville school of iconography, Father Kyprian trained iconographers now working across the United States. Since his passing, his student Father Andrei Erastov has been considered Jordanville's leading iconographer. Father Andrei came to the United States from the Soviet Union in the 1970s at a young age and was raised by Father Kyprian. Compared with his mentor's style, however, Father Andrei's is far softer, more lyrical, free, and painterly in spirit. He has a brightness and intensity of color, and a decorative use of light, that give his works a festiveness and openness. Father Andrei is a man of the new generation, one that no longer perceives American culture as

hostile, even if he does live as a monk in a monastery, carrying out his obligations of obedience and observation of the monastic rules.

The Jordanville school is a monastic school, of course. But meanwhile, parish churches in America have developed iconographic traditions of their own, although here the process is a slower one, transpiring within the memory of a single generation. A particularly good example of the parish tradition can be found in the Church of Saint John the Baptist in Washington, D.C. The parish itself was founded in 1949 by Bishop John Maximovich, and at the initiative of Father Dmitry Alexandrov (now Bishop Daniil), the church was built in 1975–1980 following the pattern of the seventeenth-century Moscow-Yaroslavl school of church architecture.

Father Dmitry also created the concept for decorating the church's interior, and here again he chose to follow the seventeenth-century style, with its festive formality, colorfulness, and particular love of ornament. The painting of the icons and frescoes took place over the final two decades of the twentieth century, and contributing artists included Father Fedor Kufos, Victor Kazanin, Lidia Rodionova, and Alexander Chistik, and Father Fedor Yurevich (Erie, Pennsylvania), who painted the icons for the iconostasis. The final note in this symphony was played in 2000, when Alexander Sokolov came from Moscow to create the mosaic depicting Saint John the Baptist that now adorns the church entrance.

Every American church has its own unique elements, because each is the expression of the needs and capacities of a given parish community. There are no authorities dictating a uniform style of architecture or iconography. The one limitation to this freedom, however, is whether or not a given parish can find an artist capable of implementing its vision. So, even though the number of iconographers steadily increases in America, few are truly masters of the art, with the typical range of ecclesial artists being relative beginners, amateurs, or professional artists who nonetheless have little background in the Church. And yet there are also iconographers working in America who are both professional artists and who are well respected as knowledgeable members of the Church. Among them is the iconographer Ksenia Pokrovsky. When she moved to America from Russia in the early 1990s she was already an accomplished master iconographer. Now she works from Boston, and her icons can be found in churches and private collection all over the world.

Ksenia Mikhailovna Pokrovsky began her career as an iconographer in the 1960s—a time when iconography was still banned, and when the few individuals actually painting icons had no hope for either creative or commercial success. She received no systematic artistic education. Indeed, during her student years, she studied physics and was already beginning to work on her PhD dissertation when she encountered the Church and left academia to focus on icon painting. This was a difficult time for the Orthodox Church. Places of worship were gradually disappearing; churchgoers were treated like pariahs. Many assumed that painting icons was an artistic form without a future. But it was Ksenia's spiritual father, the priest Alexander Men, who encouraged her to follow this path, giving her his blessing. Study iconography, he told her, because twenty years from now there will be a tremendous interest in this art. Many people will begin painting icons and there will be a need for teachers. "You will teach others," he told her, demonstrating prophetic insight. And during the 1980s, a circle of artists interested in becoming iconographers formed around Ksenia.

As for Ksenia Pokrovsky herself, she was obliged to learn the secrets of iconography almost entirely on her own, without the aid of teachers. During the 1970s she made the acquaintance of Maria Sokolova (they had rented summer cottages next door to one another), and she observed her at work. They spent many hours discussing iconography, the meaning of its subject matter, as well as questions of technique, materials, and style. These meetings gave Ksenia a great storehouse of knowledge, though a master-student relationship did not form, in that traditional sense. Sokolova's work-style, based on making precise copies, could not have satisfied Ksenia's artistic temperament that, even then, was inclined to creating a new iconography and new icons. What is more, Sokolova painted with synthetic pigments, making use of gouache and factory-produced casein tempera. Ksenia, by contrast, felt drawn from the very beginning to the use of the same hand-ground natural pigments employed by the old masters.

In the 1960s and 1970s, the iconography world in Russia was of course still narrow and sparsely populated, with no teachers, no schools, and, to all appearances, no future. But gradually this small circle inside Russia began to expand, and those who had followed this road to the very end and had achieved

mastery started to pick up steam. They began sharing their knowledge with others. By the 1980s, the world of iconography has expanded greatly, and many of the students that Pokrovsky taught are still working today.

In 1989, Ksenia Pokrovsky and her students participated in the first exhibition of modern icons at Znamensky Cathedral in Moscow, which did not go unnoticed by M. Gusev, who commented at length on the Pokrovsky school in his review of the event.

> The largest school represented at the exhibition is that of Ksenia Pokrovsky and her students. As a first approximation, one could describe their basic concept like this—the icon as celebration or holiday. Here we have the spiritual world presented in the transfigured aspect of an unearthly beauty and a play of light and form that lies beyond the dimensions of our own earthly existence. The icons of this school are very beautiful, at times even too beautiful. The dominant theme of unearthly beauty brings these iconographers to the very threshold beyond which biblical history is transformed into a wonderful fairytale and the dream of a lost Paradise. High professionalism and aesthetic daring—these are the two most striking characteristics of this school.

Before arriving in the United States in the early 1990s, Ksenia was not at all certain that there would be any need for her iconography. She grabbed her paints, brushes, and boards almost as an afterthought. But it turned out her icons did get notice, and she began receiving commissions for her work, as well as acquiring new students.

Just as in Moscow, Ksenia Pokrovsky was soon surrounded by a new circle of iconographers attracted by her talent for pedagogy. Her students are never carbon copies of their teacher. Rather than imposing her own style and understanding of the subject on them, she helps students unveil their own God-given talent. What she does try to impart to each of her students is the energy with which she works, her creative optimism, and her artistic sensitivity.

In describing her work in an interview with me for the Italian magazine *New Europe,* she said the following:

[When I came to America] I was traveling into a black hole that I knew nothing about, without any understanding, without knowing English, and without any clear comprehension even of what I was going to be doing there. But somehow everything gradually fell into place. At first I painted icons for myself, simply because I am incapable of not painting icons. A priest that I knew already owned some of my icons. I explained my situation to him and he bought a few more. This was the first financial assistance my family received. . . . How I got my first students is very interesting. By way of advertising [at a local bazaar], the woman who ran the stall added some information about me to her display. A few days later a young woman, an Italian from Verona named Adriana, came up to me and said, "I want to take lessons from you." In reply, I said, "How can I teach you when I can't even speak English—(in those days I couldn't speak at all)—to say nothing of Italian?" But she replied, "That's OK, I'll teach you English, and you can teach me to paint icons."

Ksenia Pokrovsky herself paints brightly and expressively. In stylistic terms, she is mostly oriented to Russian iconography of the fifteenth through seventeenth centuries, even as she sometimes inserts decorative elements characteristic of the Stroganov school or the masters of the Kremlin Armory Chamber, which gives her icons a festive, elegant look. While remaining true to the canon, Ksenia strives to make her icons accessible and interesting to the modern viewer. She uses English lettering and some of her icons include scenes from American history; an example of this is in her icon of Saint Tikhon, Patriarch of Moscow. The main field of the icon is surrounded by what is called a "ladder" in iconography— scenes in the shape of medallions relate individual episodes of a saint's life. These are stacked around the periphery of the central image, depicting scenes from the American period of the holy bishop's life when he was bishop of Alaska.

Ksenia frequently paints icons of American saints, including her icon The Synaxis of All Saints Who Have Shone Forth in North America. Sometimes she creates iconography that is wholly new; at other times she makes variations on traditional subjects, adding new scenes to them, as often done in her

folding icons—all demonstrating that the icon is fully capable of adapting to new cultural conditions. Ksenia Pokrovsky fulfills orders for both private clients as well as the Church, and her icons can be found in the Church of the Holy Trinity in Boston, in the Cathedral of Christ the Savior in New Jersey, in Saint Vladimir's Orthodox Seminary in New York, in a Methodist seminary, and in a Franciscan order Catholic monastery. Ksenia Pokrovsky represents our most convincing contemporary witness to the icon's ability to unify Christians of different denominations.

Although the majority of iconographers living in America today follow "high tradition" (as it is called) by taking the iconography of Old Russia as their model, there are other American trends. Andrew Tregubov, for example, has taken up the tradition begun by the outstanding iconographer of the Paris school, Father Gregory Kroug, and indeed has made this the leitmotif of his creative output. He believes that modern iconography can find new paths of development on the basis of Father Gregory's synthesis of the traditional icon and Russian art nouveau. Father Andrew's book about Gregory Kroug's iconography, *The Light of Christ* (published in 1990), acquainted American readers with the art of this first-rate Russian iconographer. Through his work, Father Andrew seeks to build a bridge between the Paris school, which made quite a name for itself in the middle of the past century, and the new American iconographic tradition, which will only truly come into its own in the twentieth century.

Andrew Tregubov moved to the United States from Russia in 1975, completing his studies at Saint Vladimir's Orthodox Theological Seminary in New York, and in 1979 he was ordained a priest. At present he serves in New Hampshire where his creative work in the area of iconography forms an integral part of his priestly service. He paints icons, carves and chisels crosses of wood and stone, and creates liturgical vessels and other ecclesial art. He is regularly approached by those seeking training in iconography. In response, he seeks to give his students both the needed technical skills and an insight into the beauty of that transfigured world where material reality becomes permeated with spirit, making it lightbearing. Father Andrew has also introduced his wife, Galina, and his daughter, Elizabeth, to the world of iconography. Galina now embroiders icons, shrouds, and processional banners, and Elizabeth paints icons. One could say that New Hampshire is

well on its way to developing its own tradition. Father Andrew Tregubov's work is well-known throughout the United States.[57]

With every passing year the iconographic milieu in America is becoming more varied. There are a number of interesting master iconographers, and indeed there are whole iconography studios operating, including several in monasteries attached to one or another of the Orthodox Christian jurisdictions. More recently, Roman Catholics and Protestants are also become actively involved in icon painting. It is too early to speak of a national style or even the leading trends. Today's iconographic milieu is made up of the sum of its individual master iconographers, each of whom is developing his or her own facet of the art. Besides those artists already named, there are other noteworthy iconographers, among them: Father John Matusiak (New Jersey), Dmitry Shkolnik (California), and Vladimir Grigorenko (Dallas, Texas).

What is more, since the early 1990s a number of Russia's leading iconographers—including Alexander Sokolov, Alexander Chashkin, Evgenii Maximov, and Alexander Lavdansky—have been invited to America to work on specific projects. And these master artists have also made a contribution to the developing American tradition, and one key example of that is the work of Alexander Chashkin in Washington, DC. Chashkin was part of a team of iconographers invited to paint frescoes and icons for the interior walls of Saint Nicholas Cathedral in the nation's capital. Initiated in 1992, the project took four years to complete. The church itself, modeled after the famous Saint Demetrius Cathedral in the city of Vladimir, was constructed in 1962. Funds for the project were collected from parishioners and immigrants with Russian roots from all across America. A memorial plaque attached to the church notes that it was built as a memorial to those Orthodox Christians who lost their lives in the cause of freedom.

In response to the church's request, Chashkin created a mural on the west wall of the church depicting the victims of the Communist regime. Here we see depicted not only the many bishops, priests, and members of the tsar's family who number among the new martyrs of the Church, but also faces of persons who have never been canonized: Admiral Kolchak, the poet Anna Akhmatova, and the writer Fyodor Dostoevsky as well as others. What we find here is, after a manner, an icon of Russia itself—suffering on this earth, but glorified in heaven.

On the lower portion of the western wall we find murals showing scenes from the early history of the Orthodox Church in America, including in Alaska. On the eastern wall, in the apse of the church, hangs an impressive fresco of the Mother of God "Orans" (praying with arms outstretched). Against a background of gold rises the Mother's towering figure—a symbol of the church that brings Christ into the world. If the iconography on the western wall is distinctly modern, what we find at the altar is clearly rooted in the traditions of Ancient Rus' and indeed points even further back to the pre-Mongolian invasion churches of Kiev, especially Saint Sophia Cathedral.

The iconostasis of Saint Nicholas Cathedral is Old Russian and Byzantine in its basic stylistics but is given a somewhat modernized interpretation. The figures are precisely articulated and well proportioned; the faces are energetically molded; the overall impression is bright and decorative. The ensemble gives the viewer a sense of the closeness of the kingdom of heaven, a sense that the saints are actually assembled together here in joint prayer.

During the first half of the twentieth century, it was, for the most part, Russians whom the winds of fate forced into emigration who shouldered the task of continuing the tradition of iconography. Today the borders between countries have become transparent, and Russian master iconographers work and travel throughout the whole world, in other cultures and traditions, helping bring access to the rich heritage of the Orthodox tradition. And yet, iconographic art no longer belongs just to Russians or Greeks, or even just to the Christian East.

DIRECTION, TRAINING, AND WORKSHOPS

Iconography Programs

istinguished iconography programs can be found at the Surikov Institute of Fine Arts, where it is part of the Department of Monumental Art (chaired by E.N. Maksimov) as well as at the Palekh and Kholuiskoe Art Academy, although there are also others.

Iconographers are now also trained in theological institutions of higher education—for example, the program at Saint Tikhon's Orthodox University for the Humanities, or the Saint John the Theologian Theological Academy. Seminaries and theological institutes in Moscow, St. Petersburg, Smolensk, Kursk, and Tobolsk (among others) have also organized programs in iconography.

A number of churches and monasteries have their own icon painting studios. In Moscow, such studios can be found at the Church of Saint Nicholas in Klenniki, Novospassky Church, Vysokopetrovsky Church, and Zachatevsky (Conception) Monastery, among the most prominent. The Optina Hermitage is an important center for iconography today, as is the Novo-Tikhvinsky Monastery in Ekaterinburg. For several years there was a successful international school for iconography affiliated with the Spaso-Mirozhsky Monastery in Pskov. It was directed by Archimandrite Zinon.

Various iconographers mentioned in the text have websites, offering details on icon painting workshops in the United States. Websites such as hexaemeron.org and iconofile.com offer information on training, studios, and workshops with iconographers mentioned in this book.

ACKNOWLEDGMENTS

The publisher would like to thank the following:

St. Isaac of Syria Skete, Dr. Wendy Salmond, Paul Grenier

Ksenia Pokrovsky, Marek Czarnecki

and the host of others who contributed with images, reading, reviewing, and correcting this work.

ILLUSTRATION CREDITS

We would like to thank the following for their permission to use the photos of the icons and other images listed below in the order they appear between pages 84 and 85.

1. *Vladimir Mother of God*. Saint Isaac of Syria Skete, www.skete.com.
2. *The Saviour Among the Heavenly Powers*. Saint Isaac of Syria Skete.
3. *Nativity of the Lord*. Saint Isaac of Syria Skete.
4. *The Holy Trinity*. Saint Isaac of Syria Skete.
5. *Deesis Mother of God*. The Museum of Russian Icons, Clinton, Massachusetts.
6. *Saint George*. The Museum of Russian Icons, Clinton, Massachusetts.
7. Photograph of icons loaded on cart. Associated Press Photo, used by permission.
8. Photograph of Sister Joanna Reitlinger courtesy of Christ the Saviour Monastic Trust, West Sussex, United Kingdom.
9. *Nativity*. Father Andrew Tregubov and Mat. Galina Tregubov. Photographer: Father Andrew Tregubov.
10. *Theothany*. Father Andrew Tregubov and Mat. Galina Tregubov. Photographer: Father Andrew Tregubov.
11. Ouspensky, Carved Altar Cross. Father Andrew Tregubov and Mat. Galina Tregubov. Photographer: Father Andrew Tregubov.
12. *The Departure of Old Russia*. Irina Yazykova. Photographer: Irina Yazykova.
13. *The Angel of the Book of Revelation*. Photographer: Antoine Arjakovsky.
14. Photograph of Mother Juliana. Photo collection of Natalia Aldoshina.
15. *The Assembly of Russian Saints Glorified on Russian Soil*. Igor Vladimirovich Melnikov, "Nash Izograf" Publisher.
16. Iconostasis in The Church of Saint Sergius of Radonezh. Irina Yazykova. Photographer: Irina Yazykova.
17. *St. Isaac the Syrian*. Irina Yazykova. Photographer: Irina Yazykova.

18. *Mother of God Joy of All Who Sorrow.* Irina Yazykova.
 Photographer: Maxim Lavdansky.
19. *Saint Ignatius the God-Bearer.* Irina Yazykova.
 Photographer: Andrei Davydov.
20. *The Iverskaya Theotokos.* Irina Yazykova.
 Photographer: Alexei Vronsky.
21. *The Resurrection of Christ.* Irina Yazykova.
 Photographer: Alexander Sokolov.
22. *The Holy Bishop Nicholas, the Miracle-Worker of Myra.* Irina Yazykova.
 Photographer: Olga Klodt.
23. *Christ Enthroned.* Irina Yazykova.
 Photographer: Andrei Bubnov-Petrosian.
24. *The Fathers of the Seven Ecumenical Councils.* Irina Yazykova.
25. *St. Seraphim of Sarov.* Irina Yazykova. Photographer: Pavel Busalaev.
26. *The Mother of God (Theotokos).* Irina Yazykova.
 Photographer: Ilya Kruchinin.
27. *St. Seraphim of Sarov.* Holy Trinity Monastery, Jordanville, NY.
28. *Transfiguration.* Father Andrew Tregubov and Mat. Galina Tregubov.
 Photographer: Father Andrew Tregubov.
29. *Shroud of the Dormition of the Theotokos.* Father Andrew Tregubov
 and Mat. Galina Tregubov. Photographer: Father Andrew Tregubov.
30. *True Vine.* Ksenia Pokrovsky. Photographer: Sr. Faith Riccio.
31. *New Martyrs of Russia.* Photographer: Alexey Tolchinsky

Introduction

1. In Russian, the word "face" (*lik*) and the word "personal" (*lichnoe*) are closely related etymologically. Both Russian theology and Russian art often reflect on this linkage between the human face and the essence of the human personality.

Chapter 1

2. Nilus of Sinai, quoted in L.A. Ouspensky, *Theology of the Icon of the Orthodox Church* [Bogoslovie ikony pravoslavnoi Tservkvi] (Paris, 1989), 54.

3. The letter by Eusebius has been preserved only in documents from the time of the iconoclasts, as retold by others, including in part by the Patriarch Nikiforus. The excerpt used here is taken from C. Shonboern's *The Icon of Christ: Theological Foundations* [Ikona Khrista: Bogoslovskiie osnovy] (Milan-Moscow), 61.

4. Saint Gregory of Nyssa's eulogy from Ouspensky, *Theology of the Icon of the Orthodox Church*, 53.

5. In the discussion of icons, these Latin terms are paired together, *latria/dulia*. They are derived from Greek and are used to differentiate the difference between worship (given to God alone) and veneration (respect shown to the saints or an image).

6. From Sergei Bulgakov, *The Icon and Its Veneration* [Ikona i ikonopochitanie] (Moscow, 1996), 7-8.

7. Tempera (from the Latin *temperare*, to mix) is a paint made of natural pigments in which the binding medium is an emulsion of egg yolk plus plant-based gums or resins (for example from the cherry tree). In Russia, tempera was made of egg diluted with *kvass*, a fermented, cereal-based drink.

Chapter 2

8. Although some historians make use of the word "Russia" even when referring to the early Kievan state, others insist on the use of the word "Rus'," especially when referring to the Kievan period. Use of the term "Russian state" is completely uncontroversial only when referring to the time of Peter the Great, that is, from the close of the seventeenth century and thereafter. Of course this state, under Peter, had also become an enormous empire. Between the Kievan state (ninth through mid-thirteenth centuries) and the Muscovite consolidation

(roughly 1500), there existed not so much a politically unified Russia as an amalgamation of separate principalities, city states (for instance, Novgorod), and smaller holdings by individual princes. Whether one names this rather ill-defined region Russia or Rus', it seems clear enough that the reference here is not so much to a *political* as to a *cultural* unity, one inspired in large part by its common Kievan, Byzantine, and of course Christian heritage.

For the purposes of the present volume we use the word Rus' as an inclusive term, one comprising everything from Kievan Rus' right through to the rise of modern Russia. But here we must add a further nuance by defining modern Russia more precisely. It was noted above that the modern Russian state began with the reign of Peter the Great. For political purposes, such a categorization suffices. But this is a book about art and iconography, and therefore cultural changes trump political ones. Russian art shifted decisively toward the West starting from the beginning of the seventeenth century. The art and culture of Rus'—or what is sometimes called medieval Russia—had by the seventeenth century come to an end.

9. Historian Serge Zenkovsky notes that the "chronicles," or annals (as they consisted of annual entries and were organized chronologically) were extremely heterogeneous. "Along with concise entries giving in one or several lines information on a ruler or an event in a city, there can be found various historical and diplomatic documents, treaties, and admonitions, as well as longer stories about the deeds, adventures, and campaigns of a prince or the prose recordings of heroic legends." See, in the English translation, Serge Zenkovsky, *Medieval Russia's Epics, Chronicles, and Tales* (New York: Plume, 1974), 11.

10. The phrase "beauty will save the world" can be found in Dostoevsky's novel *The Idiot*. A minor character begins teasing the Christlike hero of the novel, Prince Myshkin, after hearing that Myshkin had said "beauty will save the world." It must mean that Prince Myshkin is in love, he declares. In point of fact, Prince Myshkin is in love, and he flushes with embarrassment upon hearing this explanation. Analysis of Dostoevsky's larger body of work lends support to a variety of possible interpretations of the word "beauty" in this context. Was he referring in fact to feminine beauty, or to the spiritual beauty of Christ? These two interpretations may be complementary, rather than opposed: for insight into the relationship, in Russian culture, between spiritual redemption and a "mysterious feminine force," see James Billington, *The Icon and the Axe: An Interpretive History of Russian Culture* (New York: Vintage, 1970), 557.

11. This directive from the Hundred Chapters Council is cited by Leonid Ouspensky in his *Theology of the Icon* (Crestwood, NY: Saint Vladimir's Seminary Press, 1978), 13.

12. The examples provided here on the new Western influences on Russian culture are taken from Nicholas Riasanovsky, *A History of Russia* (New York: Oxford University Press, 2000). In addition to the changes already noted,

Riasanovsky adds that Western clothing also became popular, and "some audacious persons also trimmed their hair and beards," 208.

13. The concept of a canon, although central to the very idea of iconography, cannot be easily captured by reference to a prescribed list or rule. It is primarily an organic, cultural memory—it is a way of doing things that is accepted as truly Orthodox. But what does this mean? Russian theologian Leonid Ouspensky insists that the "seemingly imprecise" formulation from early councils of the Russian Church that defined "correct" iconography as that which is oriented to the ancient and holy iconographers is the best possible definition. Ouspensky fleshes out this view by drawing analogies with Saint Paul's famous admonition: "Be imitators of me . . . as I am of Christ" (1 Corinthians 11:1). In other words, the canonical icon should be true to ancient tradition, while also being a living extension of that tradition—animated by "imitation" not of previous icons only, but also of Christ.

14. Catherine the Great's portrait was also used as a model for icons of the Mother of God and of Saint Catherine.

Chapter 3

15. E. Trubetskoi, *Umozrenie v kraskakh*, in N. K. Gavriushin, ed., *Filosofiia russkogo religioznogo iskusstva XVI-XX vv.* (Moscow: Progress.Kul'tura, 1993).

16. The restoration of the office of the patriarch, after a 200-year hiatus, was indeed a monumental event in the history of the Russian Church. When, in 1700, Patriarch Hadrian died, Peter the Great kept the seat vacant. After twenty years of rule by a "temporary" *locum tenens*, the Church was finally given a new system of governance under the Spiritual Reglament of 1721. Under the new system, there would no longer be a patriarch; instead, the Holy Synod, consisting of ten (later twelve) clerics, would rule over the church in conciliar manner. Notably, a lay official called the Ober-Procurator of the Holy Synod would be appointed by the tsar to oversee the synod. Although, as Riasanovsky points out in his *History of Russia*, the emperor did not acquire any *spiritual* authority under this new system, it nonetheless did give the state de facto control over church organization and policy. There can be no doubt that the new system served the interests of the reformist tsar. At the same time, it should be added that the conciliar principle is nonetheless entirely in keeping with the traditions of the Eastern Orthodox branch of Christianity and was accepted by other Eastern patriarchs.

17. A lavra is a major monastery.

18. M.V. Nesterov. *Iz pisem* (Leningrad: Iskusstvo, 1968).

19. The Russian word for painting and pictorial art is *zhivopis'*. The word *zhivopis'* can be broken down into its component parts of *zhivo* (live, or vivid) and *pis'* (or writing).

20. A.M. Mikhailov, *Nesterov. Zhizn' i tvorchestvo* (Moscow, 1958), 90.

Chapter 4

21. These are just a few of the many illustrious intellectuals ejected by Lenin's government in the early 1920s, after which time departure from Russia became increasingly problematic. The phrase "philosophers' steamer" is sometimes used as a shorthand reference to the several steamers and trains sent out of Russia during this period carrying a good portion of the nation's intellectual elite. Of the group named, the Christian personalist philosopher Nicholas Berdyaev (1874–1948) is the best known in the West. An essayist who was somewhat meandering in approach, he wrote at length on such themes as "The Russian Idea," creativity, and freedom. Sergei (Sergius) Bulgakov, often considered the foremost Orthodox theologian of the twentieth century, was certainly among the most controversial. Bulgakov's doctrine of the divine Sophia (the wisdom of God) was widely criticized by Orthodox theologians. It was also widely misunderstood. The most complete exposition of Bulgakov's Sophia idea can be found in his *The Bride of the Lamb* (Grand Rapids, MI: Eerdmans, 2002). Philosopher Semyon Frank (1877–1950) is undeservedly little known in the West. Like Berdyaev and Bulgakov, he began as a Marxist before rejecting Marxism in favor of Christian philosophy—albeit a Christian philosophy highly colored by the free-thinking Christian Platonist Vladimir Solovyov (1853–1900). An excellent introduction to Frank's thought can be found in his *Spiritual Foundations of Society: An Introduction to Social Philosophy* (Athens: Ohio University Press, 1987). All of the above were among the last representatives of that flowering of Russian intellectual life and culture at the end of the nineteenth and beginning of the twentieth centuries usually known as the Russian Silver Age.

22. The author is referring here, not without irony, to a phrase that gained currency in mid-nineteenth-century Russia to describe a certain literary type. The "superfluous man" was a member of Russia's landed gentry, a person of education and culture, who, finding no meaningful role to play in a society dominated by the centralized tsarist apparatus, descended into cynicism and alienation. Classic examples type can be found in the eponymous hero of Alexander Pushkin's novel in verse, *Eugene Onegin* (1837), or Grigory Pechorin, the protagonist of Mikhail Lermontov's *A Hero of Our Time* (1841). Ivan Turgenev's *Diary of a Superfluous Man* (1850) gave the phrase marquee status. It should be noted that the author is underlining, by her use of the term here, that these leading Russian intellectuals were "superfluous" only from the narrow point of view of the Soviet state.

23. N.A. Kul'man, "Khram Sergievskogo Podvor'ia," in G.I. Vzdornov, Z.E. Zalesskaia, and O.V. Lelekova, *Obshchestvo "Ikona" v Parizhe*, v. 1 (Moscow-Paris, 2002), 142.

24. L.A. Zander, "V obiteli prepodobnogo Sergiia (Khram Sergievskogo podvor'ia)," in *Sviato-Sergievskoe podvor'e. K 75-letiiu osnovaniia* (Paris-St. Petersburg, 1999) 67.

25. S. K. Makovsky, *Na Parnase Serebrianogo veka* (Munich, 1962).

26. It should be remembered that "modernity" reached Russia later than the rest of Europe, and that even in Western Europe, as late as the nineteenth century it was still considered shocking for a woman to author a novel, for example. Be that as it may, Russia appears to be making up for lost time: as subsequent pages and chapters amply demonstrate, women now number among the most prominent iconographers—both in and outside of Russia.

27. *Umnoe nebo. Perepiska protoiereia Aleksandra Menia s monakhinei Ioannoi* (Iu. N. Reitlinger). (Moscow, 2002).

28. Quoted in T. Emel'ianova, "Piatidesiatnitsa Materi Marii, *"Istina i zhizn',* No. 9 (1998), 38.

29. Mat' Mariia (Elizaveta Kuz'mina-Karavaeva), *Zhatva dukha. Religiozno-filosofskie sochineniia* (St. Petersburg, 2004).

30. Mother Maria was sent to the death camp for having harbored and protected persons of Jewish origin from the Nazi occupiers of France.

31. Mysli ob ikone. (Paris: YMCA Press, 1979).

32. *Essai sur la theologie de l'icone dans l'eglise orthodoxe* was first published in English in 1978 under the title *Theology of the Icon* (Crestwood: St. Vladimir's). The translation of the citation from this work is based, albeit with some changes, on this prior English translation.

33. This institute, which was founded by the brotherhood of Saint Photius, falls under the jurisdiction of the West-European exarchate of the Moscow Patriarchate.

Chapter 5

34. www.xxc.ru

35. The full text of this letter was published in *Zlatoust. Dukhovno-prosvetitel'skii zhurnal Tovarishchestva russkikh khudozhnikov* (Moscow, 1993), No. 2, 252-263.

36. Quoted in A.N. Strizhev, ed., *Pravoslavnaiia ikona. Kanon i stil'. K Bogoslovskomu rassmotreniiu obraza* (Moscow: Pravoslavnyi palomnik, 1998), 150-159.

37. M.N. Sokolova (Mother Juliana). *Trud ikonopistsa* (Moscow: Sviato-Troitskaia Sergieva Lavra, 1997).

38. From the memoirs of I.V. Vatagina. Quoted in *Trud ikonopistsa,* 34.

Chapter 6

39. In the decades immediately following the Second World War, the greater challenges came from outside the Soviet Union, although within the Soviet bloc. What spooked Soviet leaders most were the events in Poland of the early

1980s with the Solidarity Worker's Union and the election of a Polish pope, but still earlier there were the mass rebellions in Prague in 1968, and in Hungary in 1956. Such events caused real anxiety and tensions within the Politburo, even as they attracted the sympathy and interest of Russian intellectuals.

40. Other prominent members of this team were Andrei Alekseev, Father Evgenii Filatov, Father Vyacheslav Savinykh, Andrei Bubnov, and the woodcarver Andrei Fekhner.

41. N.M. Tarabukin. *Smysl ikony* (Moscow: Pravoslavnoe Bratstvo Sviatitelia Filareta Moskovskogo, 2001).

42. M. Gusev, "Vystavka 'Sovremennaia ikona'," *Khram,* 1991, No. 1, 16.

43. K.M. Pokrovskaya. "Kogda eto stanet okeanom …," *Tvorchestvo,* 1991, No. 1, 5-7.

44. Archimandrite Zinon. *Besedy ikonopistsa* (Pskov: Izdatel'stvo zhurnala "Nashe Nasledie," 2003).

45. Archimandrite Serafim (1894–1982, born Dmitry Alexandrovich Tyapochkin) is considered a saint by many Orthodox Russians, and during his lifetime people traveled long distances to see him. At the time of Archimandrite Serafim's death, the authorities temporarily suspended public transportation lines to the village of Rakitnoe (where Serafim's burial was to take place) so as to prevent crowds of mourners from assembling.

46. The sisters of the Diveyev Monastery, for example, lived out their days in this small community founded by Father Anatoly.

Appendix A

47. Born in Moscow in 1964, Alexei Vronsky completed art school in the town of Khokhly and has painted icons since the late 1980s. Sometime working with the iconographer Alexander Lavdansky, Vronksy began his career in Danilov Monastery. He has worked on churches in the village of Golenishchevo, in the Svyatogorsk Monastery, and also in the village of Komunarka near Moscow. His works can also be found in the Church of All Saints on the Kulichki, the Church of Saint John the Theologian, the Church of the Trinity in Khokhly (all in Moscow) as well as in the Church of Dmitry the Martyr in the town of Ruza (Moscow region), and beyond Moscow, in the Church of Saint John the Theologian in Yamburg, and the Church of Christ the Savior in Kaliningrad, among others.

48. A form of chant in the Russian Orthodox Church with roots in the tenth-century Byzantine liturgy, *znamenny* chant is considered to have reached its highest stage in the fifteenth through seventeenth centuries.

49. In the eastern Church, a confessor, in this context, refers to an individual who was forced to suffer painful persecution but was not killed by his or her tormenters.

50. An allusion to the nineteenth century comic play "Woe from Wit" by Aleksandr Griboyedov.

Appendix B

51. The monastery was founded in 1925 by Father Lambert Beaudoin. Initially located at Amay-sur-Meuse (Belgium), in 1939 the community moved to Chevetogne where it is located today.

52. Regarding the importance of Eastern liturgics, Father Thaddeus Barnas, one of the oldest monks living in the monastery, had this to say: "For many of us, and for me personally, the Eastern Church's liturgical experience opens the road to understanding the witness not only of Orthodox Christians, but of all Christians. It takes much discipline, patience and endurance, however, to fully absorb the complex symbolism of the Byzantine liturgy."[58]

53. The center had been headed by Father Egon Sendler. As to why the site was closed, apparently the directors of the Jesuit order decided that, given the arrival of religious freedom in Russia, such a center was no longer necessary. But Father Sendler still teaches iconography in France.

54. This beautiful center is located in the Piedmont region of northern Italy. For the past fifteen years the Bose community has held annual scholarly conferences on Eastern Orthodox spirituality, primarily that of Russia and Greece.

55. N.M. Zernov, "Sodruzhestvo sviatogo muchenika Albaniia i prepodobnogo Sergiia. Istoricheskii ocherk," in *Sobornost'. Stat'i iz zhurnala Sodruzhestva sv. Albaniia i prep. Sergiia* (Moscow: BBI [Bibleisko-bogoslovskii institut sviatogo apostola Andreia], 1998).

56. The fellowship exists to this day. At one point its president was Metropolitan Anthony (Bloom) of Sourozh (1914–2003), head of the Russian Orthodox Church in Great Britain and Ireland.

57. His icons can be found in the Churches of Saint Nicholas (Norwich, CT), Christ the Savior (Cincinnati, OH), Saint John of the Ladder (Greenville, SC), Holy Resurrection (Clinton, MS) and Saint Andrew (Delta, CO) as well as in the monastery at New Skete (Cambridge, NY), and in Saint Vladimir's Seminary (Crestwood, NY).

Notes

58. Fr. Thaddeus Barnas, "Istoriia i prizvanie Sheveton'skogo monastyria," in *Primirenie* (Moscow: BBI, 1997), 26.

SELECTED BIBLIOGRAPHY
OF ENGLISH-LANGUAGE SOURCES

An Icon Painter's Notebook: The Bolshakov Edition. (An Anthology of Source Materials). Translated and edited by Gregory Melnick. Torrance, CA: Oakwood, 1995.

An Iconographer's Pattern Book: The Stroganov Tradition. Translated and edited by Fr. Christopher P. Kelley. Torrance, CA: Oakwood, 1992.

Alpatov, Mikhail Vladimirovich. *Treasures of Russian Art in the 11th-16th Centuries*. Leningrad: Aurora Art Publishers, 1971.

Anisimov, Aleksandr Ivanovich. *Our Lady of Vladimir*. Translated by N. G. Yaschwill and T. N. Rodzianko. Prague: Seminarium Kondakovianum, 1928.

Baggley, John. *Doors of Perception. Icons and Their Spiritual Significance*. Crestwood, NJ: St. Vladimir's Seminary Press, 1988.

Barns, John R. *Icon Collections in the United States*. Torrance, CA: Oakwood, 1991.

Belting, Hans (Edmund Jephcott, tr.). *Likeness and Presence: A History of the Image before the Era of Art*. Chicago, IL: University of Chicago Press, 1997.

Bigham, Steven. The *Image of God the Father in Orthodox Theology and Iconography*. Redondo Beach, CA: Oakwood, 1995.

Bobrov, Yury. *A Catalogue of the Russian Icons in the British Museum*. Edited by Chris Entwistle [online catalogue].

Cormack, Robin. *Icons*. Cambridge, MA: Harvard University Press, 2007.

Cormack, Robin, and Delia Gaze, eds. *The Art of Holy Russia: Icons from . Moscow, 1400-1660*. London: Royal Academy of Arts, 1998.

Evseyeva, L., et al., *A History of Icon Painting*. Moscow: Grand Holdings Publishers, 2005.

Florensky, Pavel. *Iconostasis*. Translated by Donald Sheehan and Olga Andrejev. Crestwood, NY: St. Vladimir's Seminary Press, 1996.

Hancock, Paula Marlais, Carolyn S. Vigtel, and Margaret Wallace. *The Sacred Art of Russia from Ivan the Terrible to Peter the Great*. Atlanta, GA: Georgia International Cultural Exchange, 1995.

Grierson, Roderick, ed. *Gates of Mystery: The Art of Holy Russia.* Fort Worth, TX: InterCultura and the State Russian Museum, 1998.

Grindenko, Anatoly, and A. N. Ovchinnikov. *Divine Harmony: The Music and Icons of Early Russia.* Paris: Opus 111, 1998.

St. John of Damascus. *On the Divine Images: Three Apologies Against those Who Attack the Divine Images* Crestwood, NJ: St. Vladimir's Seminary Press, 1980.

Kondakov, Nikodim Pavlovich. *The Russian Icon.* Translated by Ellis H. Minns. Oxford: Clarendon, 1927.

Lazarev, Viktor. *Studies in Early Russian Art.* London: Pindar, 2000.

Miliayeva, Liudmila. *The Ukrainian Icon.* Bournemouth: Parkstone; St Petersburg: Aurora Art Publishers, 1996.

Minto, Marilyn. *Windows into Heaven: An Introduction to the Russian Icon.* Cardiff: Aureus, 1996.

Muratoff, Paul. *Thirty Five Russian Primitives: Jacques Zolotnitzky's collection.* Preface by Henri Focillon. Paris: A la Vieille Russie, 1931.

Onasch, Konrad. *Russian Icons.* Translated by I. Grafe. Oxford: Phaidon, 1977.

Ouspensky, Leonid, and Vladimir Lossky. *The Meaning of Icons.* Translated by G.E.H. Palmer and E. Kadloubovsky. Crestwood, NY: St. Vladimir's Seminary Press, 1982.

Quenot, Michel. *The Icon: Window on the Kingdom.* Crestwood, NY: St. Vladimir's Seminary Press, 1991.

Rice, David Talbot. *The Beginnings of Russian Icon Painting, Being the Ilchester Lecture Delivered in the Taylor Institute.* London: Oxford University Press, H. Milford, 1938.

Rice, David Talbot. *Icons and Their History.* Woodstock, NY: Overlook Press, 1974.

Rice, Tamara Talbot. *Icons.* London, Batchworth, 1958.

Salmond, Wendy R. *Tradition in Transition: Icons in the Age of the Romanovs.* Washington, DC: Hillwood Museum and Gardens, 2004.

Sendler, Egon. *The Icon, Image of the Invisible: Elements of Theology, Aesthetics, and Technique.* Redondo Beach, CA: Oakwood Publications, 1988.

Smirnova, E.S. *Moscow Icons: 14th-17th centuries.* Oxford: Phaidon, 1989.

Soloukhin, Vladimir. *Searching for Icons in Russia.* Harcourt Brace Jovanovich, 1972.

Spira, Andrew. *The Avant-garde Icon: Russian Avant-garde Art and the Icon Painting Tradition*. Aldershot: Lund Humphries/Ashgate, 2008.

The State Russian Museum: From the Icon to Modernism. St. Petersburg: Palace Editions, 2005.

Stuart, John. *Ikons*. London: Faber, 1976.

Tarasov, Oleg. *Icon and Devotion: Sacred Spaces in Imperial Russia*. London: Reaktion, 2002.

Temple, Richard. *Icons: Divine Beauty*. London: Saqi/The Temple Gallery, 2004.

Timchenko, S.V. *Russian Church Art Today: Modern Orthodox Icons and Religious Painting*. Moscow: Klyuch, 1993.

Ugolnik, Anthony. *The Illuminating Icon*. Grand Rapids, MI: Eerdmans, 1989.

Uspenskii, Boris. *The Semiotics of the Russian Icon*. Lisse: Peter de Ridder, 1976.

Vikan, Gary. *Icon*. Washington, DC: The Trust for Museum Exhibitions; Baltimore: The Walters Art Gallery, 1988.

Weitzmann, Kurt. *The Icon*. New York: Knopf; distributed by Random House, 1982.

St. John of Damascus. *On the Divine Images: Three Apologies Against Those Who Attack the Divine Images*. Crestwood, NJ: St. Vladimir's Seminary Press, 1980.